D1478139

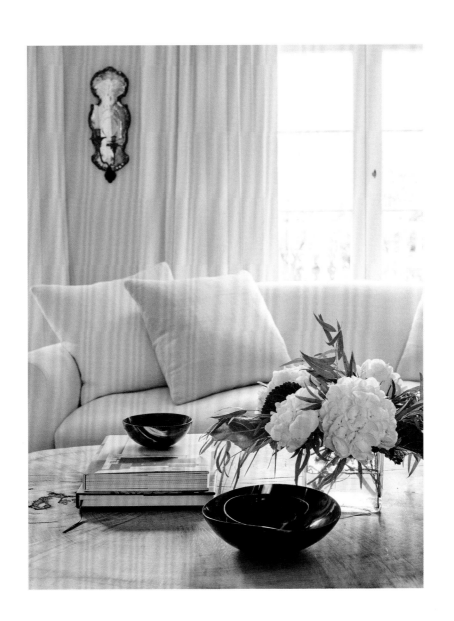

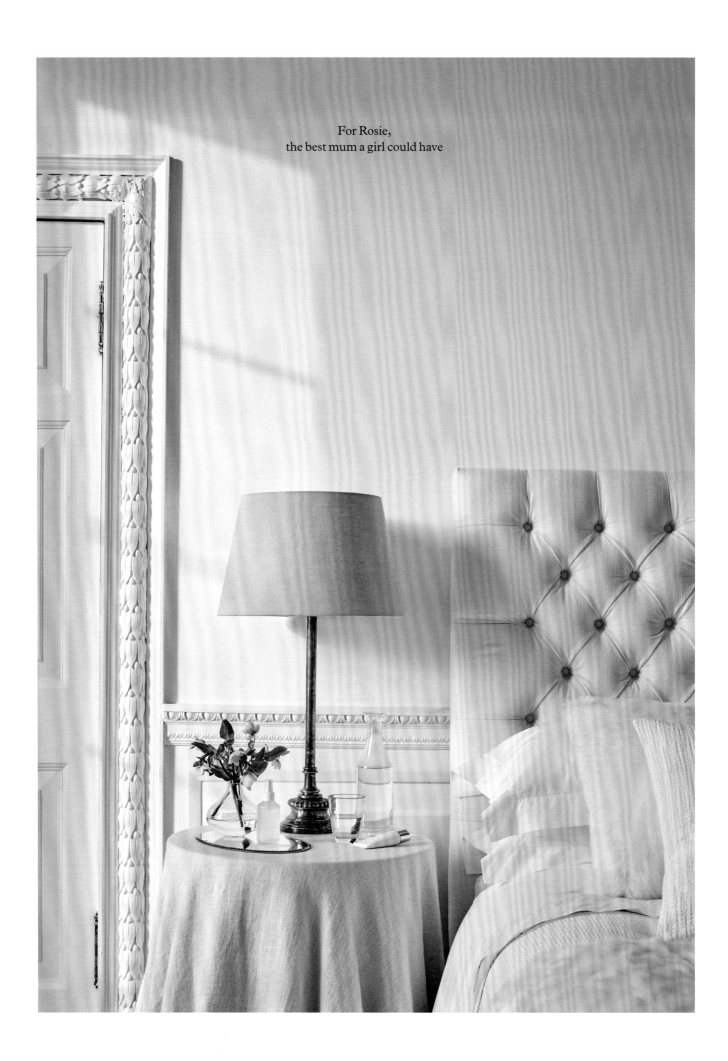

For Rosie,
the best mum a girl could have

THE WHITE COMPANY
LONDON

for the love of

WHITE

THE WHITE & NEUTRAL HOME

CHRISSIE RUCKER

CONTRIBUTING EDITOR: DOMINIC BRADBURY

HARPER
DESIGN
An Imprint of HarperCollinsPublishers

Contents

Introduction

— BY CHRISSIE RUCKER —

My real love of white began more than 25 years ago, when my boyfriend
Nick bought his first home in London. The day he moved in, he owned
a bed, a few kitchen chairs and some old green towels. His linen was
burgundy and when you opened the kitchen cupboards, there were just a
few plates and four chipped mugs. We had been together for four years and,
sadly, there had been no sign of a proposal. So, when he asked if I could help,
I thought, yes, this is my chance, I can show him I could be excellent wife
material – by making his home look beautiful!

At the time, I was working at *Harpers & Queen* and had spent a wonderful
five years on magazines such as *Brides*, *GQ* and *Vogue*. It was an incredible
experience where I learned so much. I could research an article, organize
a shoot, style a picture, and I always loved looking at layouts in the art
department. So, setting up a house would be easy.

But when I set off to start the task, it was a disaster. There was just too
much choice, so many bright colours and so much manic pattern. I was
completely overwhelmed and had a major confidence crisis – it just didn't
feel right. For me, home has always been such a special place, somewhere
we can close the door from the outside world and feel instantly calm and
cosseted. I started to think about what makes a great image for a magazine
and reflected that simple is often best and less is often more.

It struck me that white in the home is like the perfect little black dress.
It's simple yet effortlessly stylish, modern yet classic. It also has a magical,
calming, spa-like quality – and it just works. So, I decided to look for all the
essentials in lovely, calming white, but it wasn't easy and I found there was
a clear gap in the market. At one end of the scale, there were beautifully
designed, great quality 'designer' pieces that were lovely, but very expensive.
And at the other end, it was much more affordable, but the quality was poor
with no real design.

The next weekend we caught up with Nick's sister Susie, who had also
just moved. She had found the same challenge and we ended up wishing
for 'a company that offered the key white essentials – that were beautifully
designed and affordable'. That was the beginning of The White Company.

Nick and I married a year later (the white approach worked!) and, over the years, we have created a number of homes as our family has grown. For us, white has always played a key role in creating spaces that feel light and airy, yet comfortable, inviting and warm. So, as we arrive at The White Company's 25th birthday, we thought we would celebrate it by sharing some of our favourite white homes.

As The White Company has evolved and as we have moved house, I have been lucky enough to work with some incredible stylists and designers. What I have learned is that there are many simple decorating and styling tricks that make such a difference to how a white home can look and feel.

We are not interior designers, but we are often inspired by a beautifully curated white home as a starting point for a new collection of linens, towels, china, home accessories and scents. When I think of my favourite white spaces, I think of the spa-like feel of an inviting bathroom, layered with soft white towels and flickering with candlelight. I imagine a kitchen full of sunlight, where the cupboards hide neat stacks of pure white china all ready to go. I picture a wonderful bedroom, a true retreat that offers perfect comfort and vital rest at the end of a busy day, and, of course, comfortable, inviting living spaces with a roaring log fire and cosy seating.

But white spaces need careful thought and planning. Thinking through the layout and flow of the rooms, and including adjustable lighting to ensure they don't become too bright or sterile, is essential. It is also important to incorporate plenty of storage to reduce clutter and create a sense of order, while 'engine rooms', such as laundry areas and larders, even on the smallest scale, will ensure a home runs smoothly.

I always choose a soft, soothing palette of whites, off-whites and neutrals, remembering that white is not one colour but a thousand tones and shades, all slightly and subtly different from each other. White paints and pigments not only bring rooms to life, but they also accentuate architectural details, mouldings and woodwork beautifully.

These beautiful, sharp white spaces are then ready to be layered up with tactile furniture, textured fabrics and soft linen curtains to create softness and warmth. Neutral and natural tones from timber, stone and sisal floors to touches of greenery bring in hints of the outside world. And the real joy of a white and neutral home is that it provides the perfect canvas against which art, antiques and other discoveries can stand out.

Across the pages of this book you will see my own homes, together with the homes and havens of other designers, architects and creative thinkers whom we admire and who have used white in their own unique way. These open and welcoming spaces in towns and the country, as well as by the sea, speak of quiet and calm, but also suggest the breadth and depth of living with white.

Our love of white is stronger than ever. In our hectic age – an era of constant connectivity – the idea of creating a peaceful white home and its relationship with calm and well-being seem more valuable than ever.

For me and my family, home is everything and white is our faithful foundation stone. I hope you will love the following pages as much as we do and that they inspire you with some exciting, new ideas for your own home.

I

TOWN

Urban Haven

— QUIET SPACES AT THE CITY'S HEART —

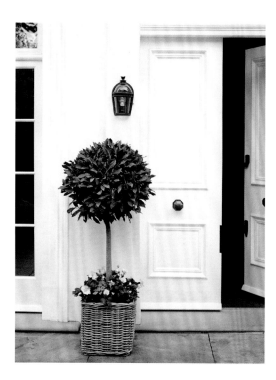

Although Chrissie Rucker's London home is centrally located, close
to the heart of everything, it is also an urban retreat. A terraced garden
at the front of the Georgian building acts as a green buffer between
the city beyond and the house itself, with its façade a combination of
characterful brick and crisp white detailing around the generously sized
windows and original, double-width front door.

'We loved the fact that it was stepped back from the main road and much
quieter than you might imagine,' says Chrissie, who has shared the house
with her husband Nick and their four children for many years. 'We don't
really hear the traffic because of the garden, with its trees and greenery.
We also loved that all the main family rooms are on the same level, rather
than on top of one another, and that sense of connected, lateral space is
quite unusual for London.'

Above – The double-sized front door,
painted a crisp white, offers a warm
welcome and sits comfortably alongside
the neat period detailing of the façade.
The greenery of the bay tree and its base
planting work beautifully against the
ordered backdrop.

Opposite – The entrance hallway sets
the tone for the house as a whole, with
lightly washed oak floorboards and a
black and white colour scheme. The
graphic artwork is by American sculptor
Louise Nevelson. The console and
lantern are from Rose Uniacke.

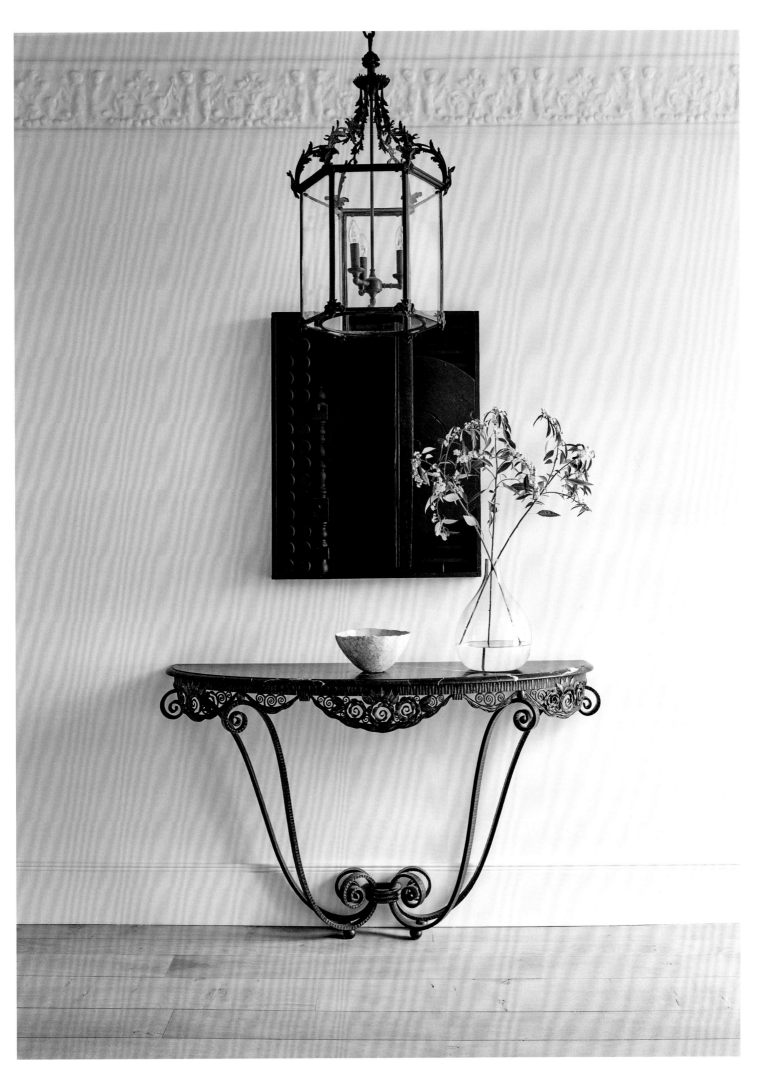

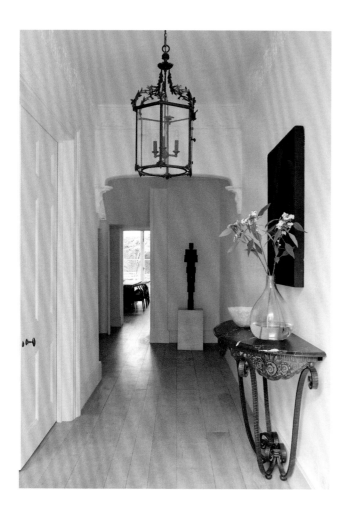

Above left – The original, ornate detailing in the entrance hall was carefully restored and softened with white, while the glimpse through to the dining area and kitchen offers an open invitation into the heart of the home. The figurative sculpture on the plinth is by Antony Gormley.

Above right, opposite & overleaf – The painting by Lee Ufan above the Neville Stephens fireplace forms a vital focal point, surrounded by a combination of sofas and chairs arranged on a sisal rug, which appears to float on the wooden floor. This creates a series of sympathetic textures, together with the natural finish of the central oak-topped coffee table.

The house has been the family's London home for more than 20 years and has been through a couple of incarnations during that time. Recently, the house has been redecorated with the help of interior designer Rose Uniacke, and many of the key living spaces were adjusted and opened up a little further to create a fluid circulation pattern.

The entrance hall sets the tone, with its inviting combination of old and new. Oak floors, with a touch of grey wash to soften the colour, help to tie the hall and the living spaces on the ground floor together, while ornate period cornices and other original detailing have been restored and softened in white. Dark artworks by Louise Nevelson and Antony Gormley create a simple, strong impact against the neutral backdrop, as well as establishing a black and white theme that reappears a number of times throughout the house. Yet, at the same time, there are softer and more rustic textures. Lighting is subtle and soothing, sourced from a mixture of wall lights, lamps and the central chandelier.

'I love everything to feel very natural and it's always wonderful to have a fire,' says Chrissie.

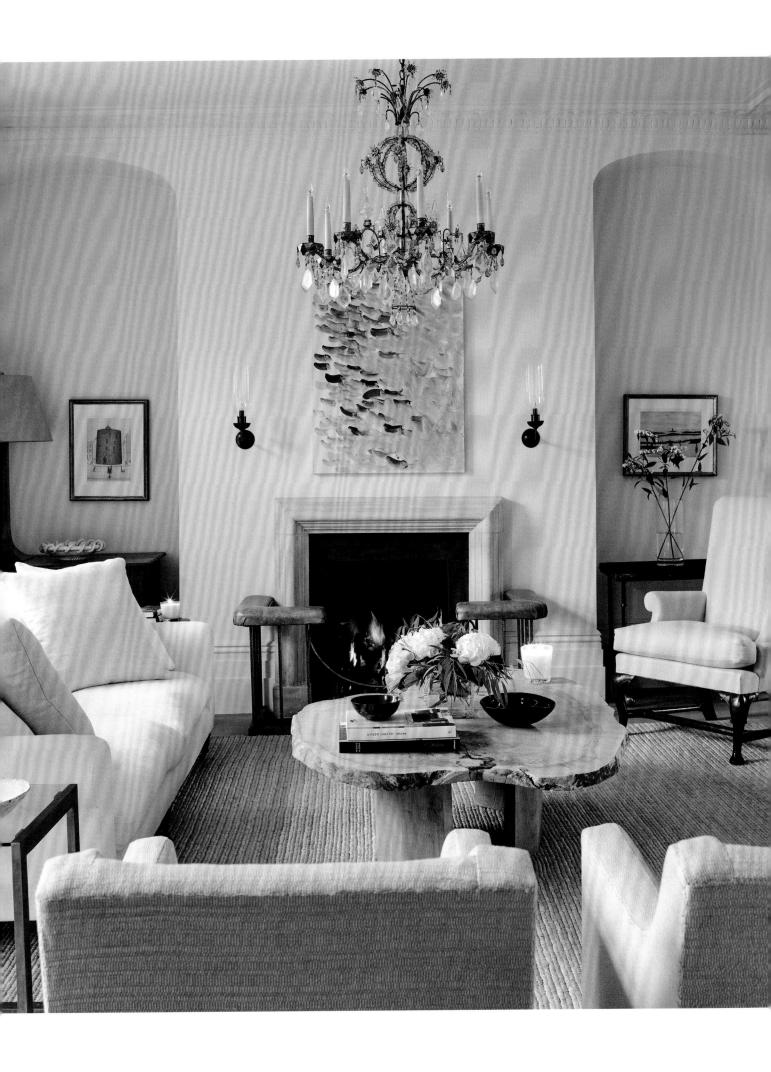

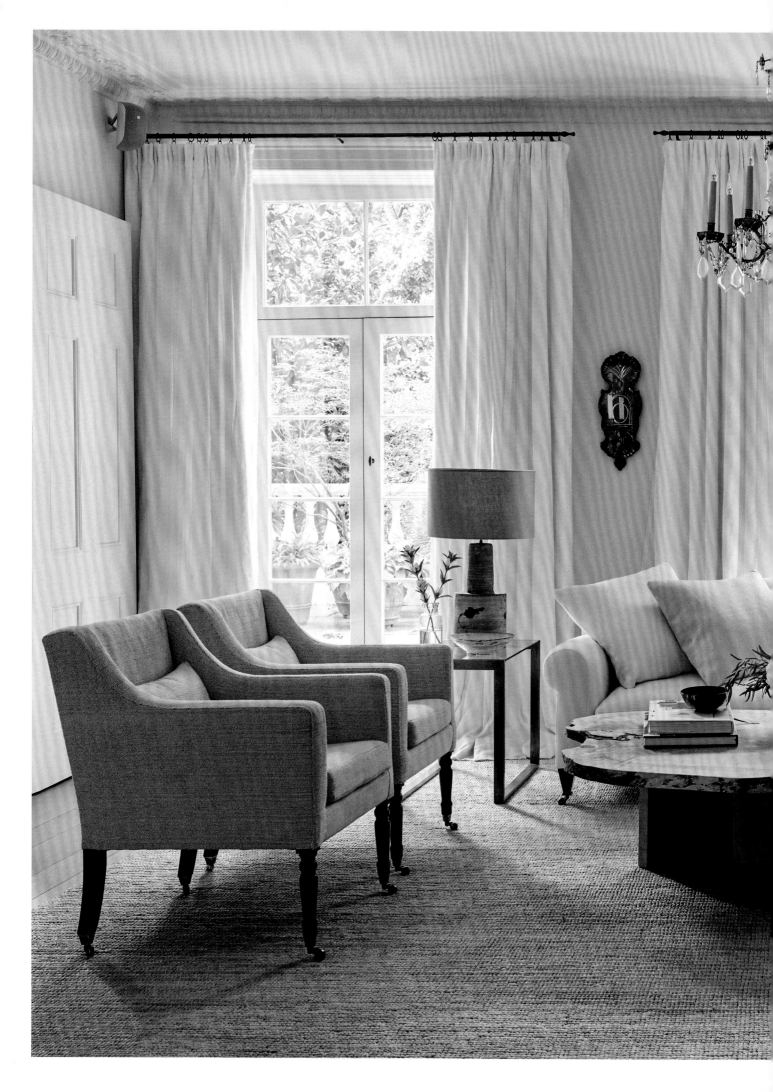

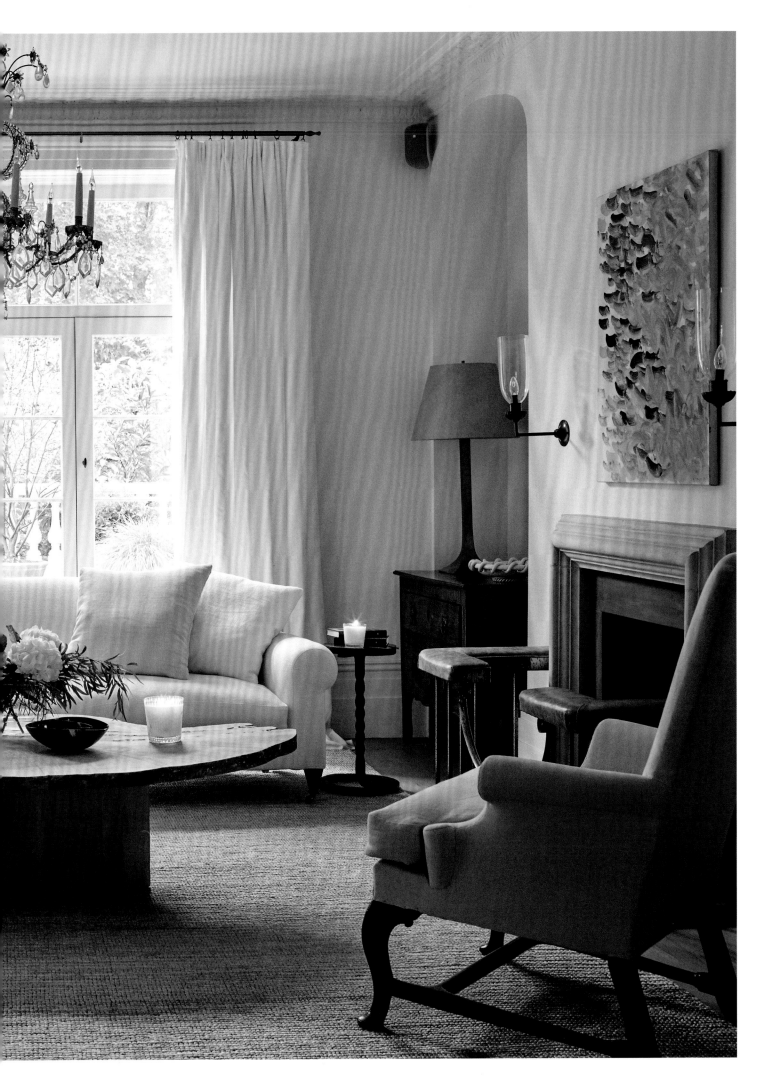

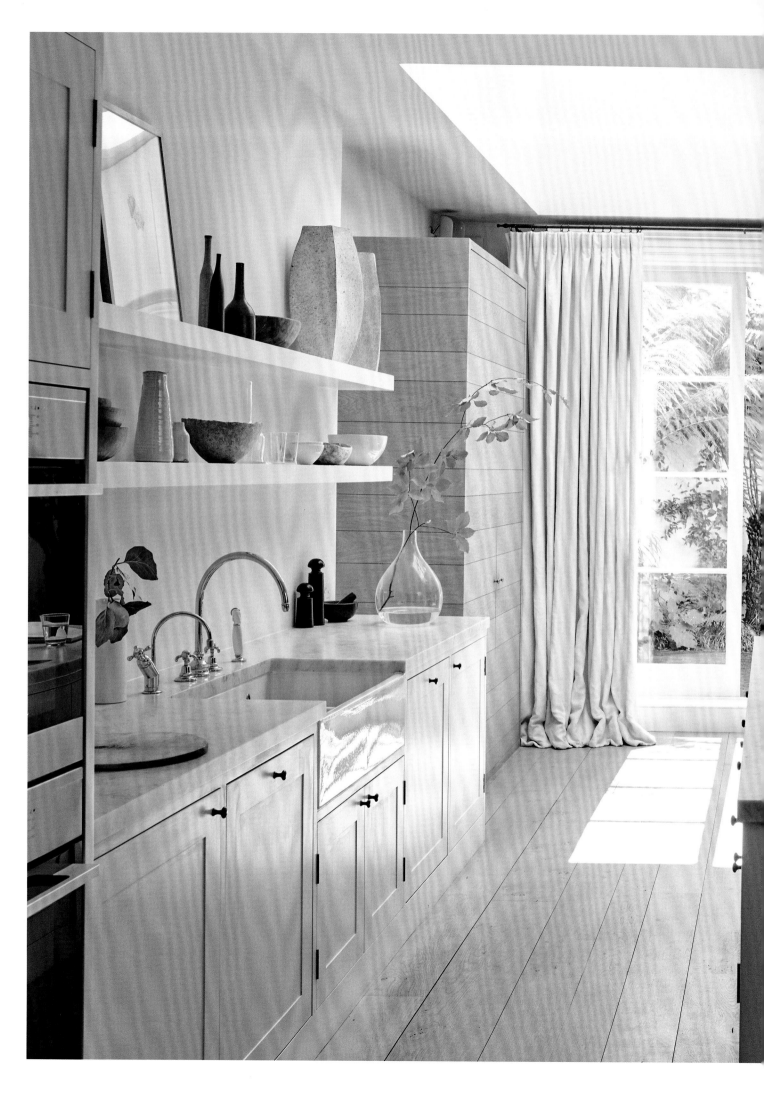

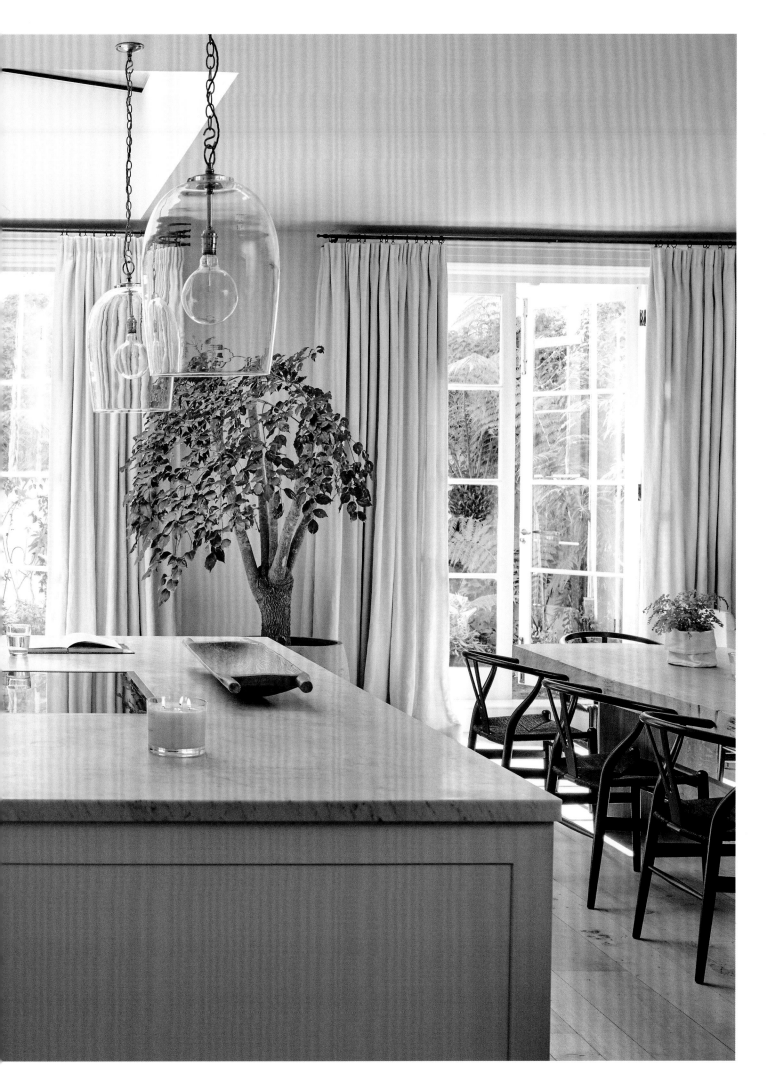

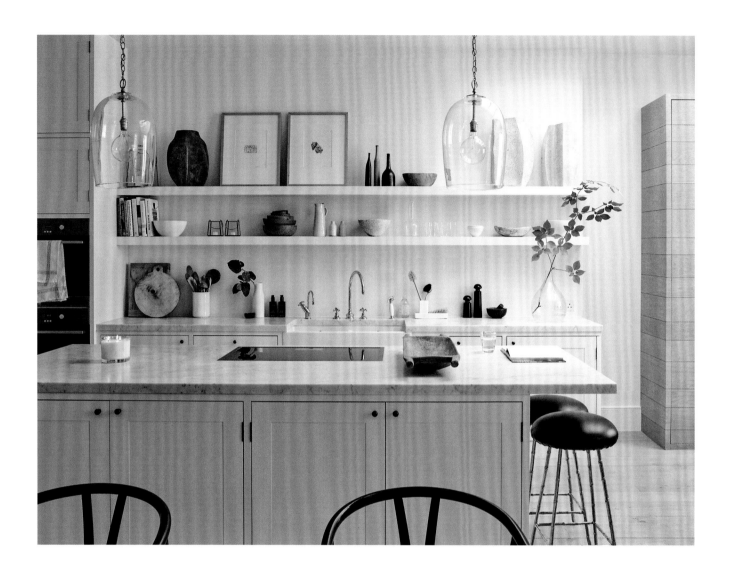

Previous pages & above– The new kitchen, designed by Rose Uniacke, is the main family hub, neatly subdivided into a run of side units and work surfaces and a marble-topped island in the centre. French doors lead out to a rear courtyard, and large skylights let the light flood in, to enhance the tones and textures throughout.

Opposite – Chrissie prefers the simplicity of cupboards to drawers, because 'they give better storage space', and wanted two large wooden cupboards. One of these is for larder storage, while the other houses a secret breakfast bar, with a coffee machine, a toaster and other essentials. When not in use, the cupboard closes and the bar disappears, restoring the clean lines and controlled aesthetic of the room.

The kitchen and dining area at the rear of the house was completely remodelled. This is a light and inviting garden room, and a true family hub. Twin French doors open on to a small courtyard planted with ferns and vines, which really comes into its own in the summer, while daylight streams through large skylights and picks out the neutral textures featured throughout the space.

The dining table, made from a single piece of oak, seats up to 10 by the fireplace. Highlights of black on a white theme continue here with the Hans Wegner Wishbone chairs in black. Rose Uniacke designed the kitchen and its island, as well as two large stand-alone units, faced in oak, which provide generous extra storage.

'The simple, panelled doors of the kitchen units have no unnecessary details and a shallow profile, drawing on the Shaker style,' says Rose. 'It [the kitchen] needed to be white, of course, so I wanted the style of it to feel as pure and unadorned as the colour white does, but also to reflect the period of the house.'

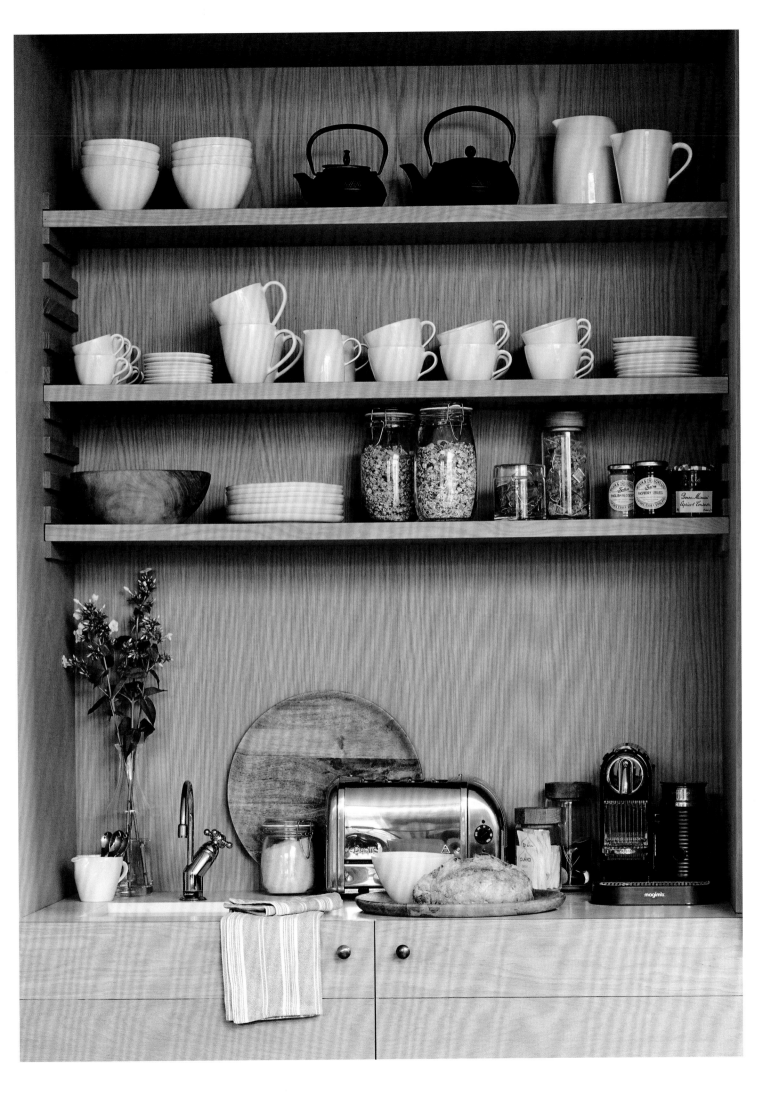

Styling details

— IN THE KITCHEN —

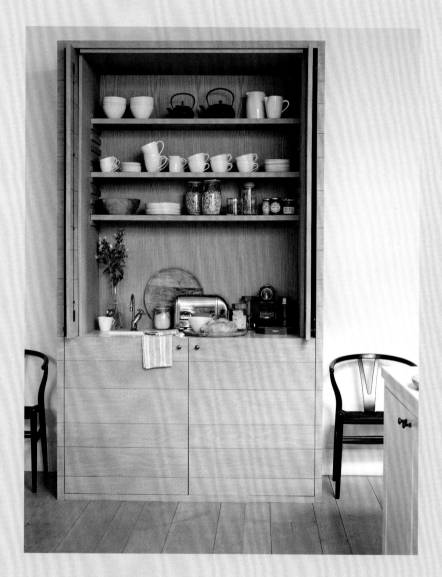

BREAKFAST ORDER

This custom-made breakfast unit is one of Chrissie's favourite features in the kitchen. In the morning, the doors slide back into the recess to reveal everything from a toaster, a coffee maker, cups and bowls to an integrated hot-water tap. When breakfast is over, the doors close and clean lines return. 'I love it because it has everything you need in this neat, hidden breakfast bar,' says Chrissie.

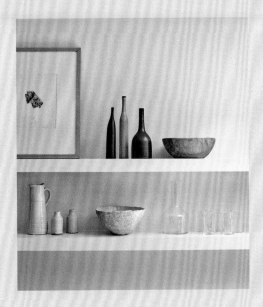

COLLECTIVITY

Small groupings of art, ceramics, textured bowls
and glassware create a pleasing composition on
open shelves. The pieces are unified by size, scale,
material and finish. Like any kind of family, such
combinations are more than a sum of their parts.

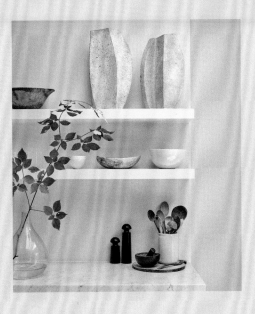

GREEN SHOOTS

A simple sprig of greenery, picked from the
garden, brings lovely, organic life to the kitchen.
Set against a neutral backdrop and in a plain and
transparent glass vase, the sprig has a powerful
and joyful impact.

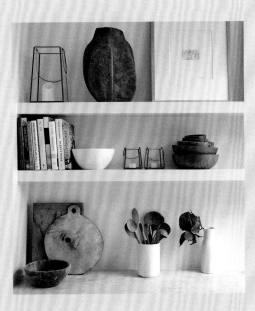

OLD & NEW

The kitchen shelves are layered with pieces that
are both old and new, decorative and functional.
Such a combination of elements, together with
the mix of natural materials and finishes, creates
texture and character.

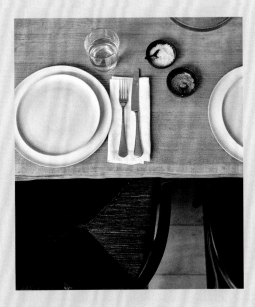

SIMPLE SETTINGS

A selection of crafted, tactile pieces complements
the handmade kitchen table perfectly. Soft,
sculptural shapes add to the composition, along
with the layering of plates, as well as simple white
napkins and weighty cutlery.

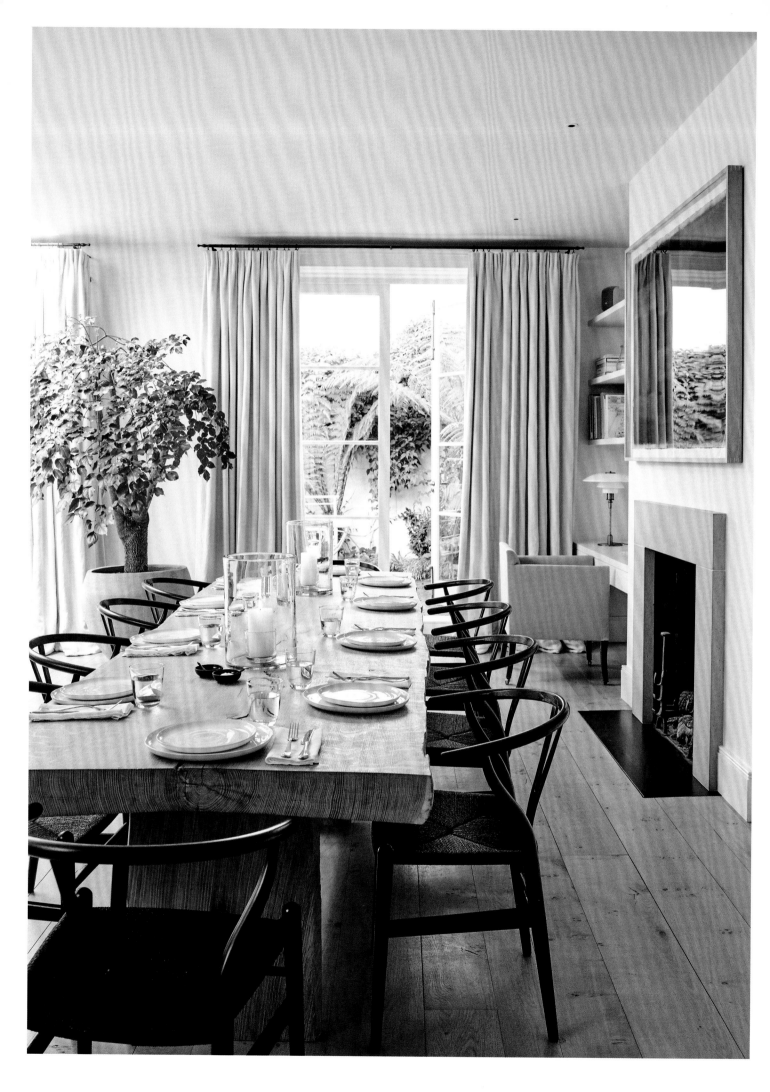

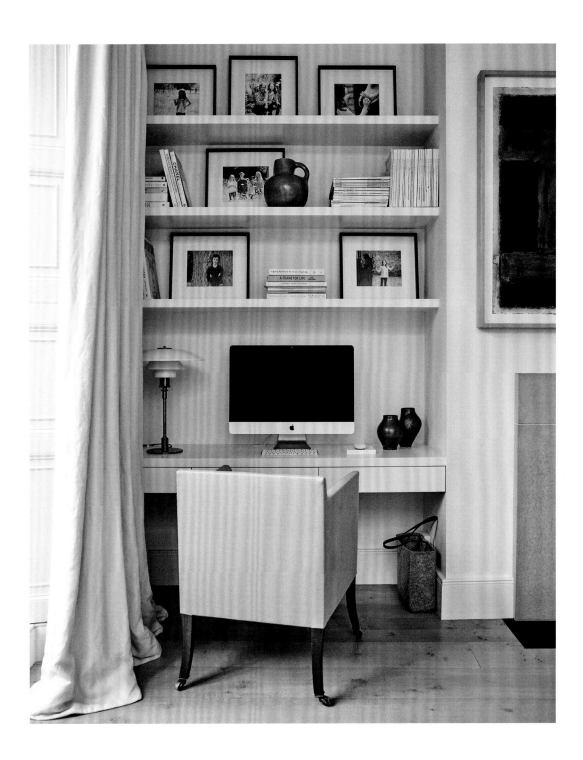

Opposite – In front of a new fireplace, the custom-made oak dining table seats ten comfortably. Adding weight to the neutral colour scheme are the black Wishbone chairs by Hans Wegner. The stoneware plates and glassware are from The White Company.

Above – In one corner of the kitchen, Chrissie wanted to have an integrated family work station with a built-in desk and shelving for storing books and displaying photographs. It's a great space for working at home or a place for revision for the children.

Left & opposite – The rear courtyard, which was redesigned and planted by Charlotte Harris, is a sheltered retreat. Accessed from the kitchen and dining area, this secret outdoor room is a delight in the city, offering a special setting for summer lunches and candlelit dinners. The white-painted walls of the courtyard accentuate the architectural shape of the palm fronds and the greenery of the creepers and other plants. The painted ironwork table and benches can be left out all year round and dressed, as required, with cushions and throws. Simple summer flowers in a glass vase are all that is needed to lift the tablescape.

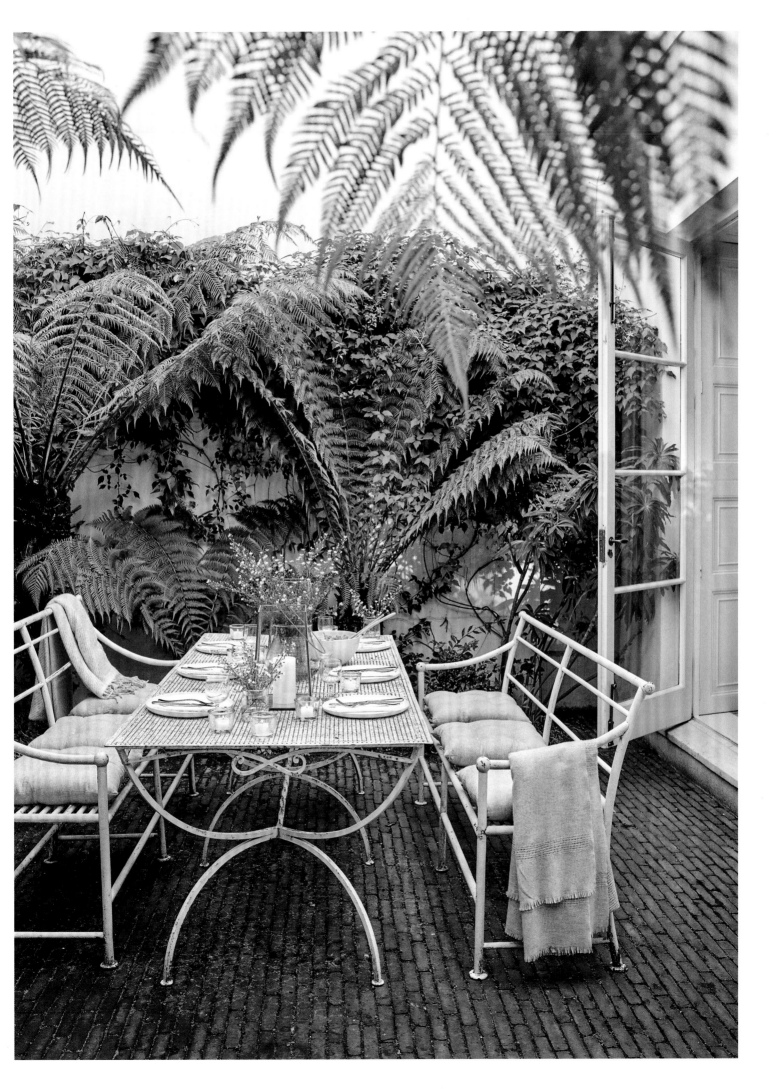

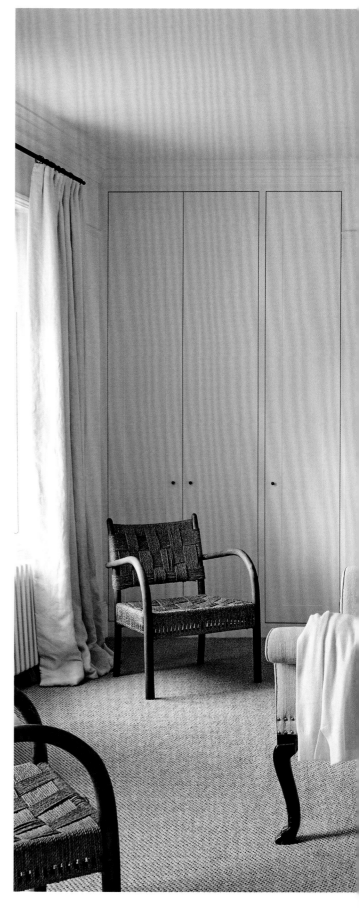

Above & right – The dressing room
alongside the master bedroom provides
storage and a dressing table. The white
painting is by Callum Innes. The bedroom
itself provides more wardrobes on either
side of the fireplace to allow the room to
remain calm and uncluttered. The natural
textures of the vintage wicker chairs and
chandelier stand out against the soft, white
backdrop. The charcoal-on-paper artwork
above the fireplace is by Lee Ufan.

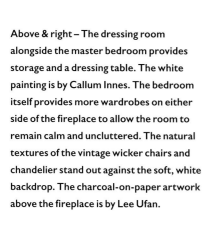

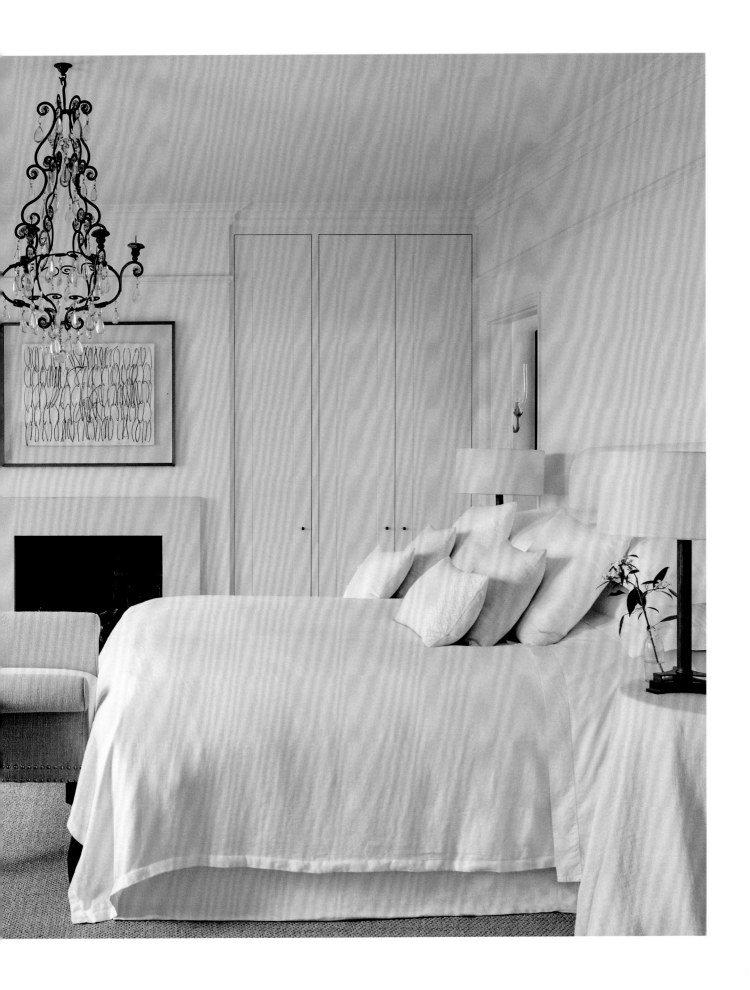

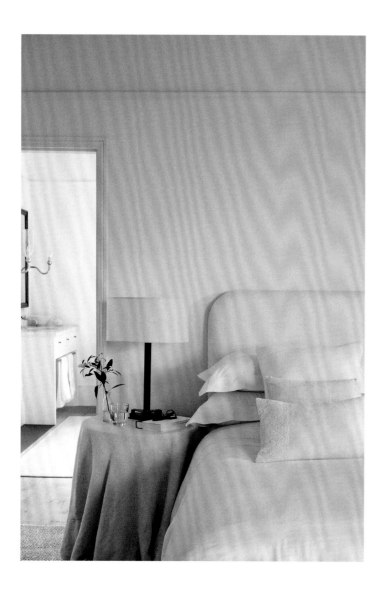

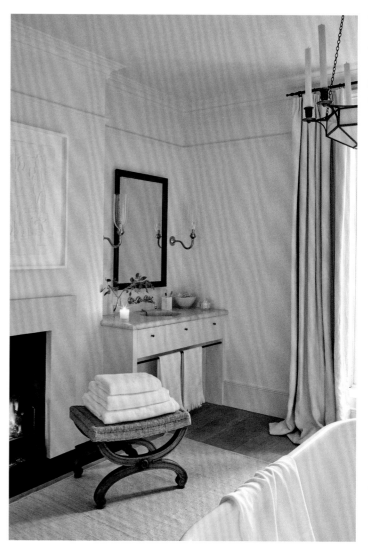

Above – A soft headboard, stacks of
pillows and comfortable bedding from
The White Company help to make the
master bedroom especially inviting.
The en suite bathroom is a much-loved
retreat for Chrissie and Nick.

Above & opposite – Oak floors,
marble surfaces and linen curtains make
the master bathroom feel wonderfully
natural. The bathtub, from Drummonds,
is opposite a relaxing open fire. French
doors open onto a small terrace.

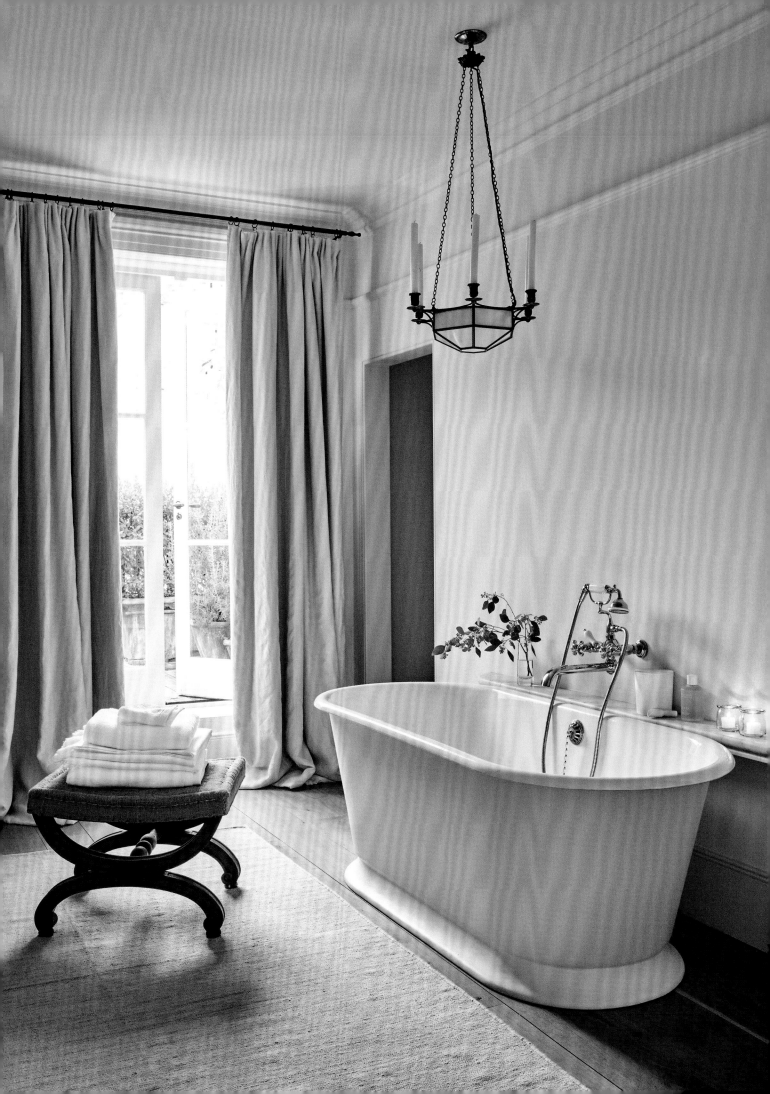

Styling details

— REST & RELAXATION —

TEXTURAL NOTES

Most of the bed linen in the master bedroom
is fresh and contemporary, with the notable
exception of the antique lace cushions made by
Charlotte Casadéjus. Their light touch of pattern
and texture creates a subtle contrast that brings
the composition alive.

SPARRING PARTNERS

A tealight, a sprig of eucalyptus and bath salts
and soak are simple touches that bring a spa-like
quality to the master bathroom. Decorative as
well as practical, they help to create a deeply
relaxing environment for winding down at the
end of the day.

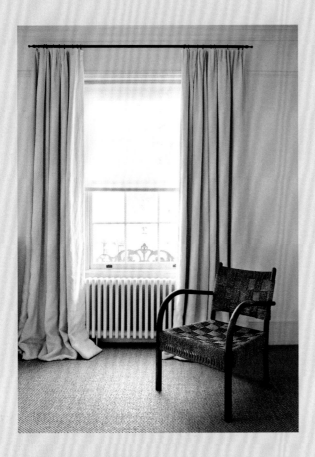

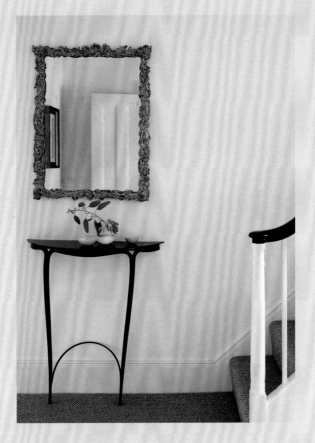

PICTURE WINDOWS

In the master bedroom, the window treatment, designed by Rose Uniacke, combines a fitted blind with linen curtains. 'I used as narrow a curtain rod as possible with a simple, hand-gathered heading,' says Rose. 'I chose linens, cottons and sheer layers to add depth and softness, but also an ethereal quality.'

CALM & COLLECTED

The landing and stairway connecting the bedrooms over two floors continues the calm aesthetic upwards. Within this relatively tight space, the combination of a 1940s wall-mounted mahogany console (designed by Carlo Enrico Rava), antique mirror and tiny decorative touches is enough to set the scene.

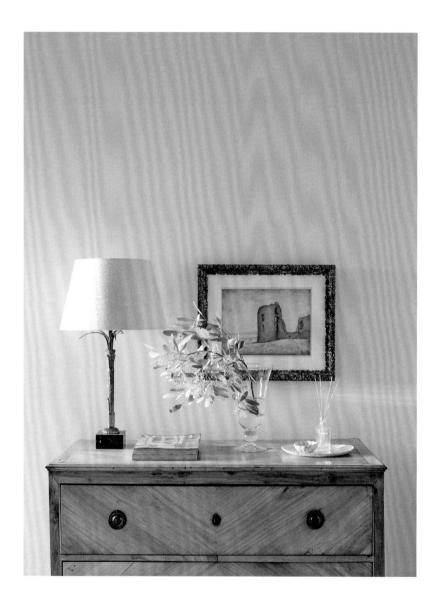

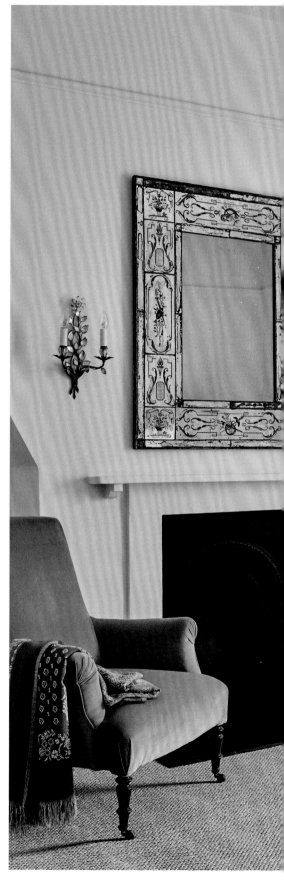

Above & opposite – The emphasis on clean
lines and creating a sense of calm continues
in the guest bedroom. As in the master
bedroom, the palette here is restrained
and there are plenty of fitted cupboards
and storage space to help keep things
orderly. With little to distract the eye,
the decorative details of the room shine
through, including the repeated but subtle
use of glass and crystal in the chandelier,
wall lights and mirror. The picture above the
antique chest of drawers is by L S Lowry.

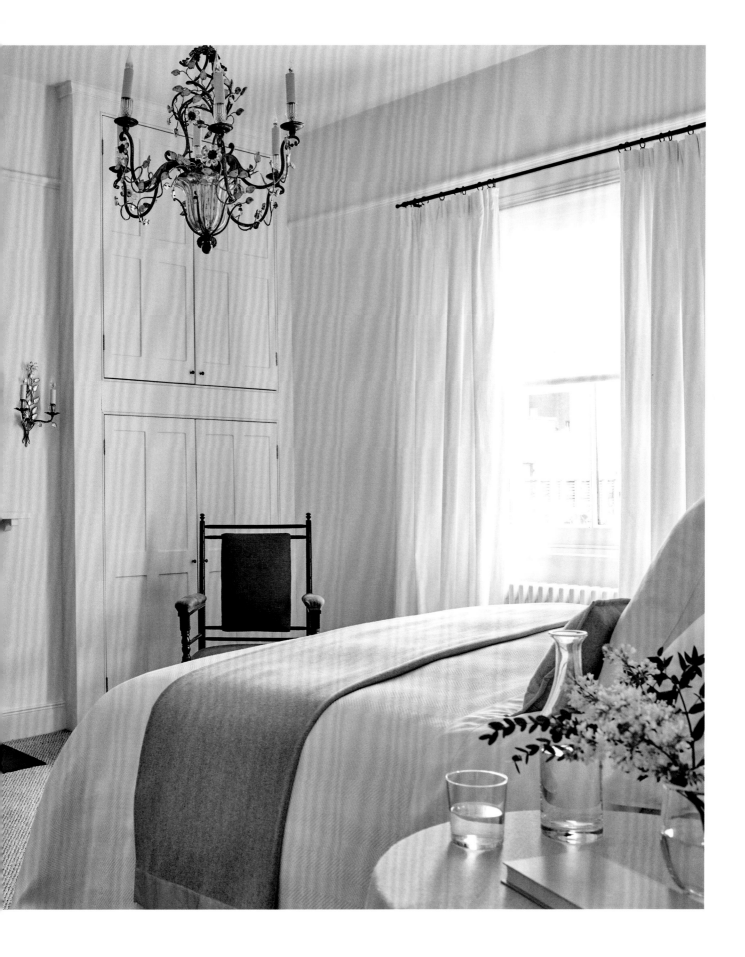

Above – The black and white palette is
carried through to the bedrooms, where
the original fireplaces have been restored.
The black and white photograph above the
mantelpiece in this room is a Fifties print
taken from South African *Vogue*.

Right – Complemented by striped linen
curtains and white blinds, the tall sash
windows are one of the glories of the house,
introducing light and framing glimpses of
the trees outside. The characterful wicker
shade for the ceiling light stands out against
the pale palette of paintwork, curtains and
layered bedding from The White Company.

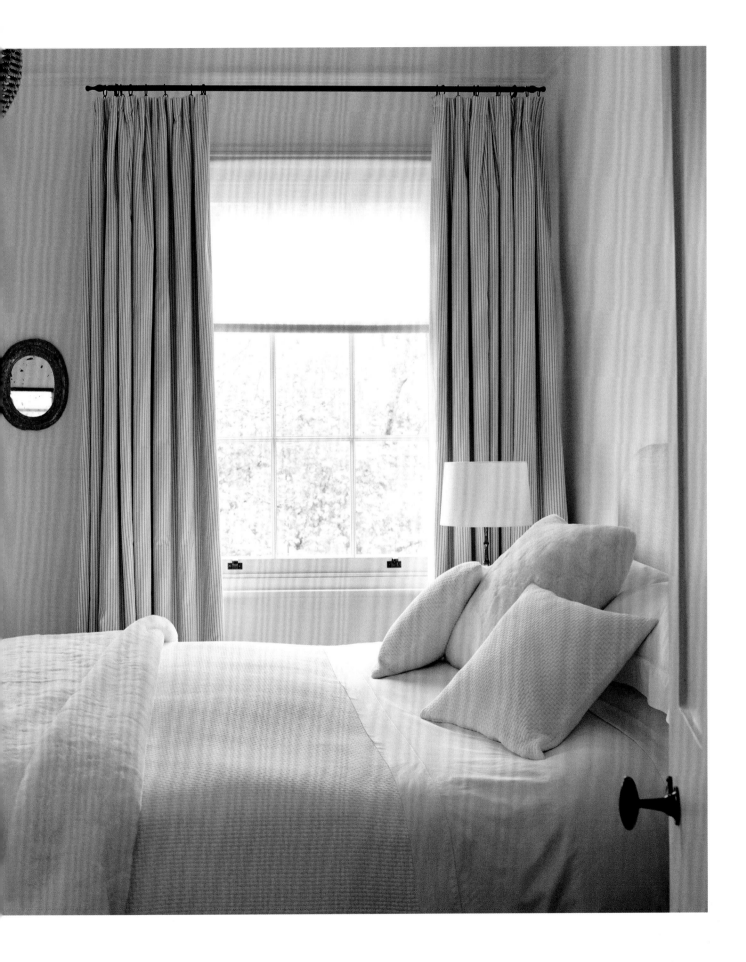

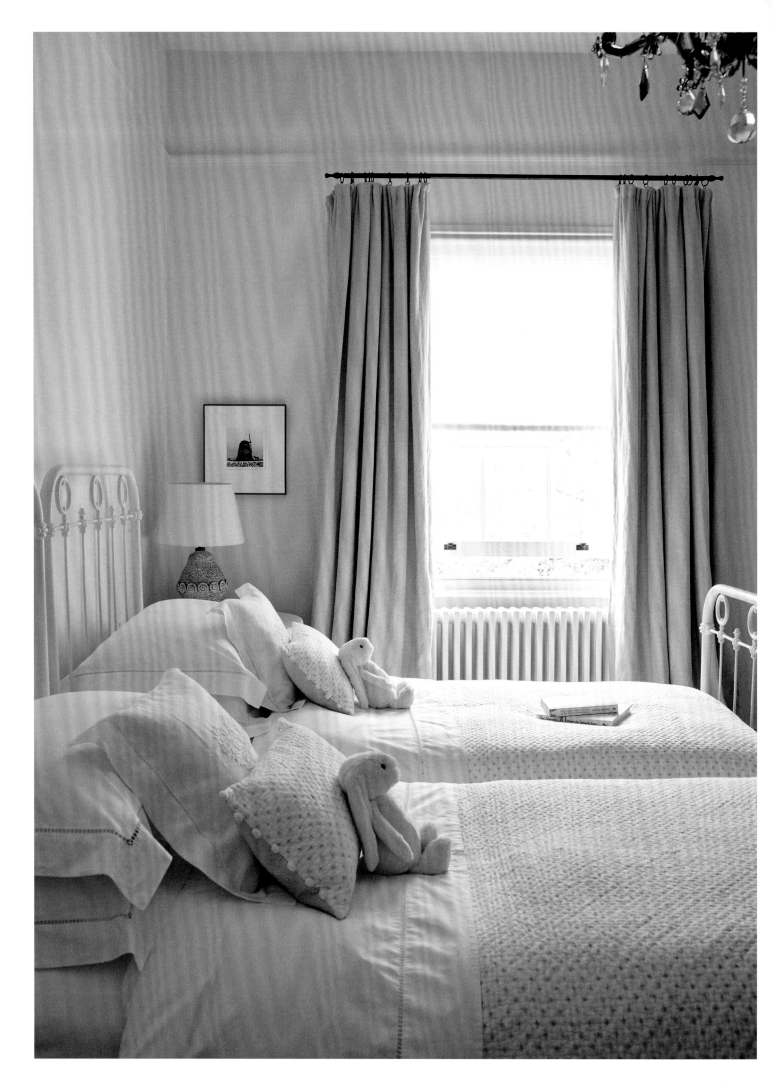

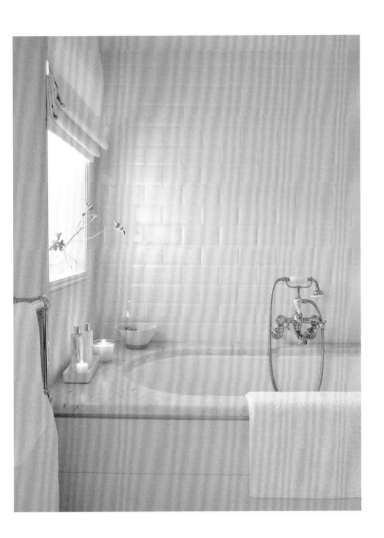

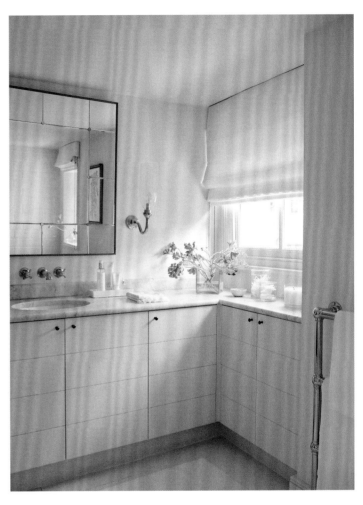

Opposite – Layers of texture add interest
to the children's bedrooms, located at the
top of the house. The soft bedding and linen
curtains sit within a soothing palette, with
decorative pillows and top blankets adding
textural contrast.

Above – The family bathroom, also on the
top floor, makes the most of the limited
space, with an L-shaped run of fitted
cabinets. White subway tiles around the
bath are highly practical but also work
beautifully with the pale marble of the tub.
The semi-reflective quality of the tiling
helps to push light through the space.

All the bedrooms were designed to be a place of restful
repose. 'In these hectic times of constant connectivity,
creating a calm space where we can retreat and sleep well
is more valuable than ever,' says Chrissie. 'At The White
Company we have always been passionate about the
elements that help us to get a good night's rest, including a
supremely comfortable bed; beautiful breathable linens that
feel wonderful against the skin, and blissfully comfortable
duvets and pillows that make climbing into bed a joy.'

Bathrooms, too, are a vital part of the winding-down
process. 'For me,' says Chrissie, 'my bathroom is the place
where I escape at the end of a hectic day, to have a good soak,
disconnect and really unwind.'

Styling details

— BED & BATH —

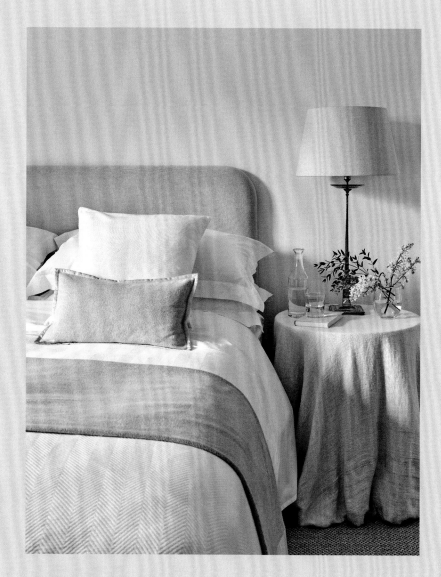

SOFT NOTES

In the guest bedroom, the bed linen, headboard and pillows, in a combination of white, neutrals and pale greys, offer inviting layers of texture. The pillows are arranged according to Chrissie's preferred pattern of two sleeping pillows on each side, with a square pillow plus a smaller cushion to the front. The addition of the throw on the bed and the linen cloth on the bedside table, together with a few stems of garden greenery, softens the composition.

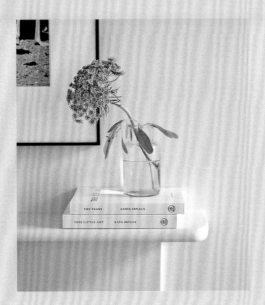

SEASONAL STEMS

The styling of a room should lightly shift and evolve according to the changing seasons. Just picking a simple stem from the garden and placing it in a glass vase is so quick and easy to do, yet it makes a huge difference to how a room looks and feels.

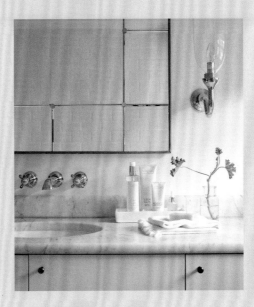

FORM & FUNCTION

In this bathroom, a white ceramic tray cradles bathroom essentials and small luxuries. Simple and practical, the vanity dish creates order and also helps to contain spills, protecting the surface of the marble countertop.

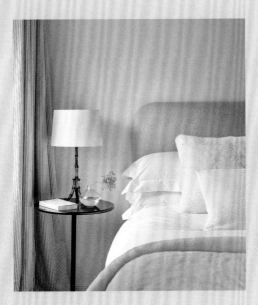

SMALL ASIDES

In this bedroom, the bed dominates, while the side tables and lights are small enough not to impose and so help to create a relaxing environment. The bedside light and the tulip table with its spindle stem have the appropriate delicacy for the setting.

WELCOME HOME

Thoughtful finishing touches, such as a special hand towel and a lovely bar of soap, go a long way towards making guests feel welcome. A fresh leaf introduces another pleasing note.

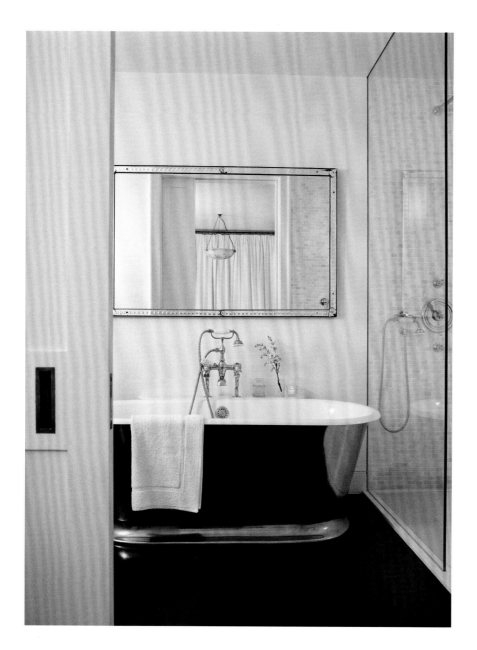

Left – In the partially self-contained apartment, the limited footprint available prompted many space-enhancing solutions. A large vintage mirror in the bathroom increases the sense of space, while a subtle glass screen avoids the need for a solid partition between the shower and the rest of the bathroom.

Opposite – The black and white theme continues throughout the apartment, including the hallway with its white walls and black-painted floorboards. The collection of alphabetical art, entitled *Graficus*, by Dutch graphic artist Harry van Kuyk, was sourced by Rose Uniacke. The black Wishbone chair is by Hans Wegner.

On the lower-ground floor of the house, Chrissie and Nick wanted to create a partially self-contained apartment for their older son Tom. The black and white palette continues here, but there are also a host of space-saving and space-enhancing measures to make the most of the limited space.

Daylight enters the basement only through skylights, therefore white walls and light-reflecting surfaces, such as glass and mirror, help lift the space to make the rooms feel more generous than they are. In addition to the bathroom and hall shown here, Chrissie and Rose Uniake were also able to create a small kitchen and living area.

'This self-contained space has been a great addition to the house, especially when a number of 20-year-olds descend on us late at night,' says Chrissie.

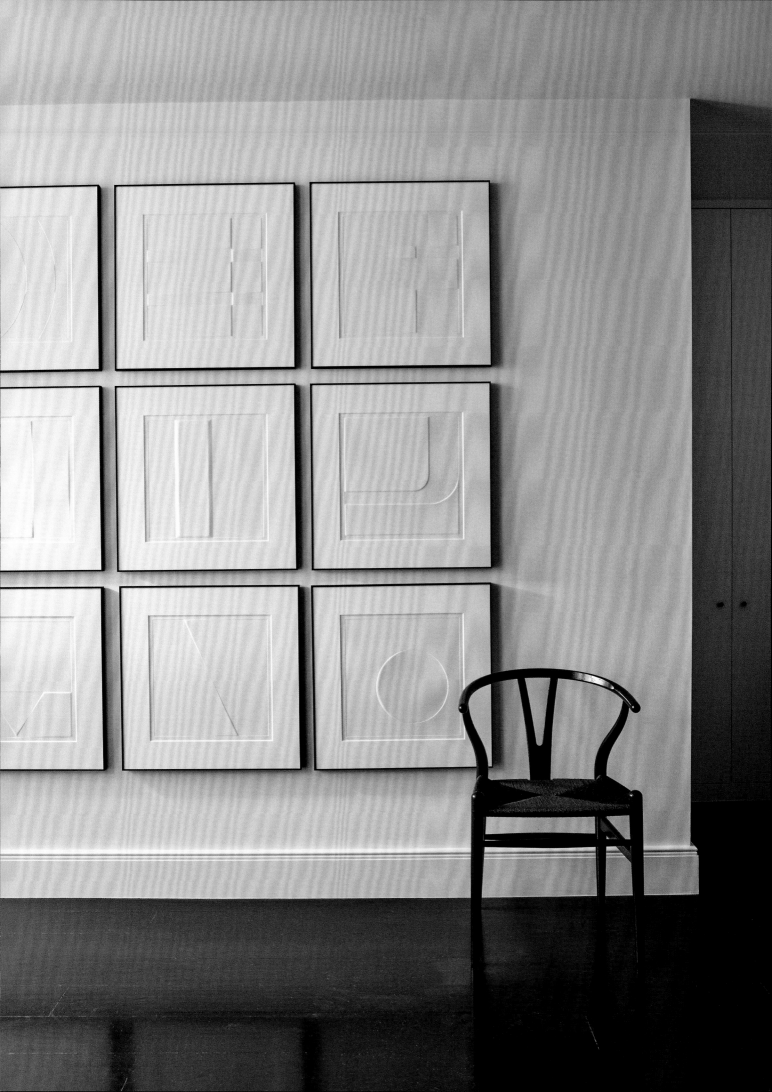

City Sanctuary

— SIMPLICITY BY DESIGN —

'It's my refuge,' says architect William Smalley of his apartment in London's Bloomsbury. 'I always assumed that I would live in a white home, and the fact that the rooms are panelled and white is really enough for me. I find colour too insistent – you might be in a dark red mood one day but not the next.'

William lives on the first and second floors of this Georgian townhouse, while the office of his architectural practice is housed in a former dairy and stables situated in a small mews just across the road. When he first moved in, he painted the stairwell powder blue, but soon regretted it and had to paint it again – in white. Instead of tying the two floors of the apartment together, the blue walls did just the opposite.

Above & opposite – The principal space in the apartment is large enough to provide not only a sizeable living room, but also somewhere to work and to play the piano. The large sash windows, which are kept simple by the use of wooden shutters rather than curtains or blinds, let in a wealth of natural light. The sofa and ottoman, upholstered in a soothing creamy white linen, are from B&B Italia, while the vintage armchair is a Hans Wegner design.

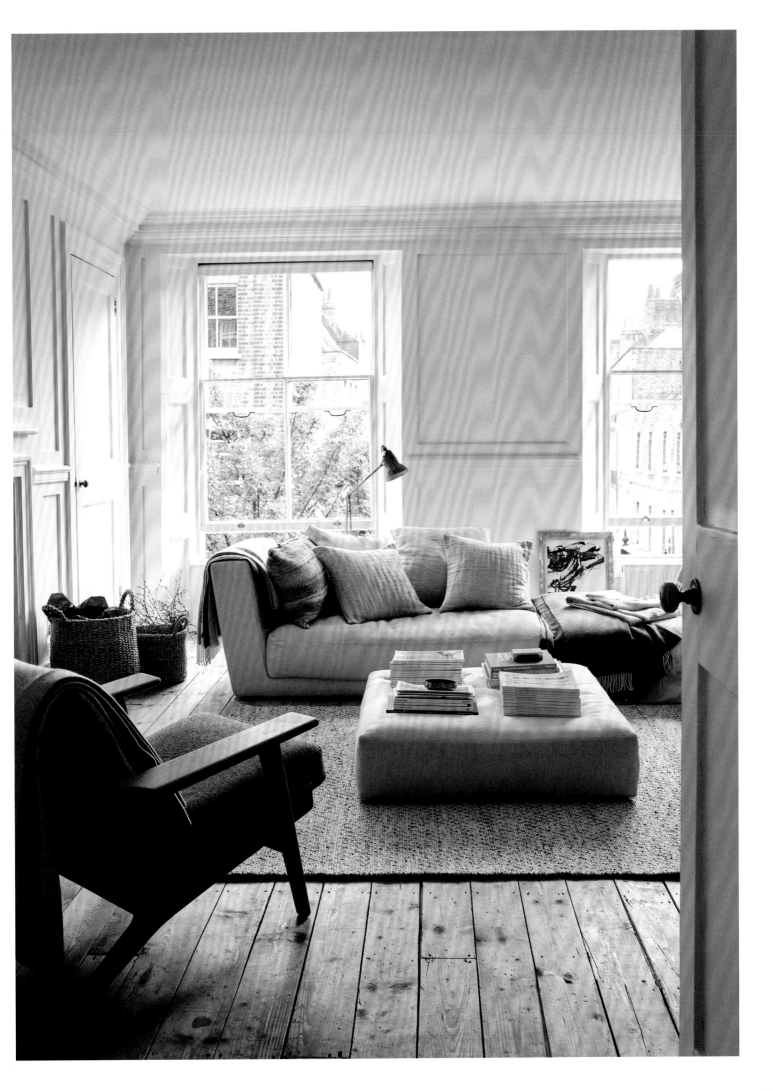

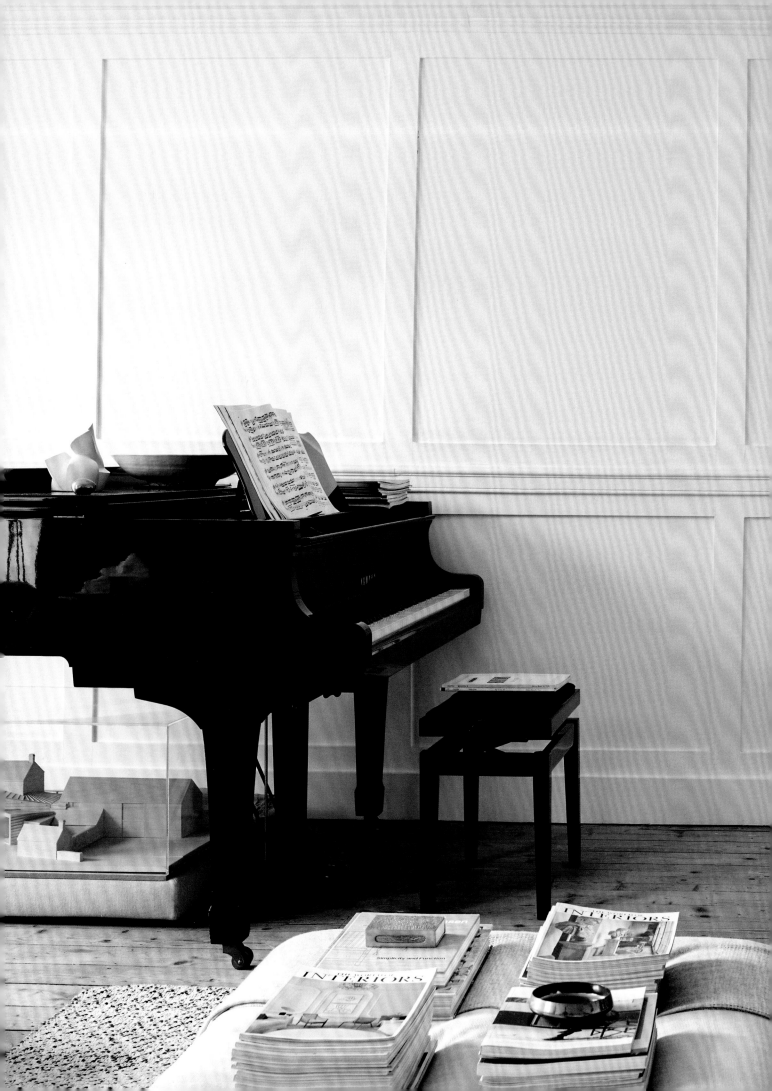

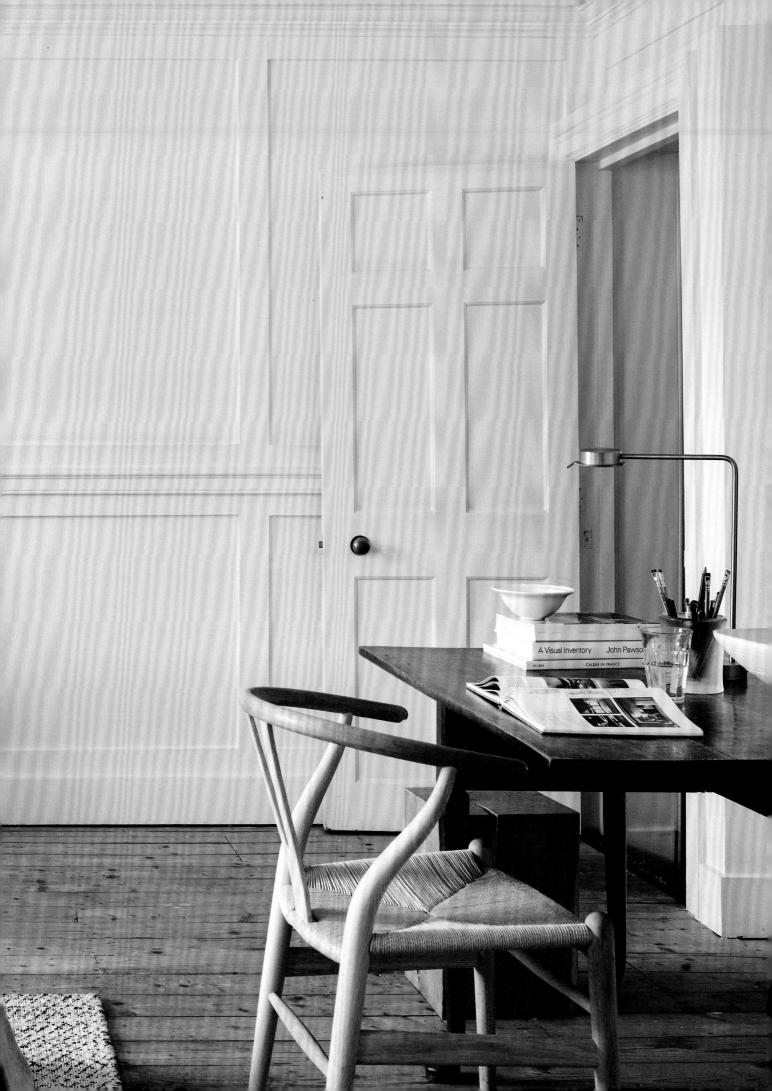

The panelled living room, painted white, is light and airy. Without curtains or blinds, the tall sash windows let in as much natural light as possible. William stripped back the existing pine floorboards to their original colour and restored the simple fireplace. Two large, walk-in cupboards provide plenty of concealed storage, which allows the room to remain uncluttered and harmonious.

Savouring the strong bones and striking proportions of the room, William took his time assembling the right furniture, beginning with just a chair and a rug, to keep the equilibrium of the space. The B&B Italia sofa and other pieces arrived over time. The architect's black grand piano forms a sculptural silhouette against the white walls but doesn't dominate.

'It's a 1973 Yamaha, so one year older than me, but such a timeless piece,' William says. 'One of the successes of the room is that the piano doesn't overwhelm the space and you still have a sense of balance. But things have developed slowly. Objects speak to one another, so you do need to try and make sure that it's a positive, harmonious conversation.'

Previous pages – Against the white, panelled walls, the black-lacquered Yamaha grand piano takes on a graphic quality in a chiefly black and white scheme. The small white sculpture on the piano is by F L Kenett.

Below – William's dog Dylan has a number of favourite spots in the apartment, but the sofa is his first choice.

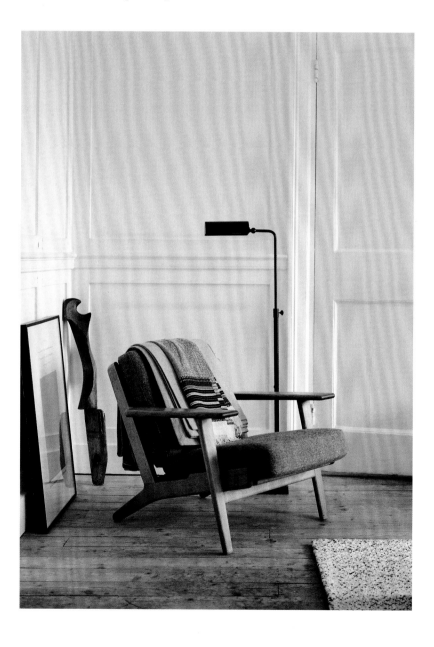

Left & opposite – Various parts of the living room suit different purposes, with the Wegner armchair and a floor lamp creating a reading corner, while a partially extended folding table serves as a desk against one wall. Pictures tend to be propped up on furniture or stood on the floor, rather than hanging from the wall and interfering with the elegant panelling.

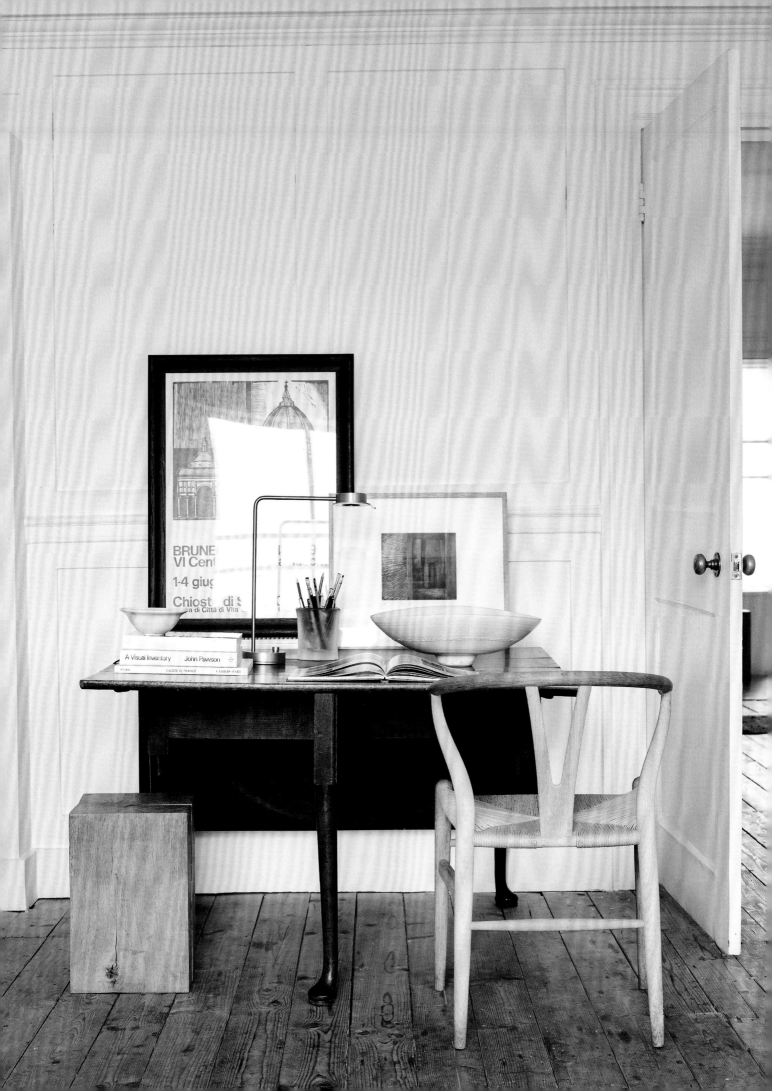

Above – William chose a light grey colour scheme rather than white for the kitchen. In this setting, the soft grey of the walls and units registers as a neutral tone, allowing the graphic pattern on the floor to sing out. The small space benefits from the natural light drawn in from the bare windows that look out onto the terrace.

Opposite – The oval shape of the Tulip table, designed by Eero Saarinen, helps to soften the feel of the dining room, with its high ceiling and grid-like panelled walls. At the same time, the colour of the table allows it to blend in with the room's decoration. The Wishbone dining chairs, with woven paper cord seats, are by Hans Wegner.

Styling details

— VALUABLE VIGNETTES —

CAMEO COMPOSITIONS

Any surface can become a frame or canvas for
a decorative composition, which is the idea
behind the term 'tablescape', invented by designer
David Hicks. Here, a small abstract sculpture
by F L Kenett sits alongside a Sigmar brass
egg by Carl Auböck on a wooden plinth.

OTTOMAN STYLE

The B&B Italia ottoman serves as a coffee
table, loaded with interiors and archicture
magazines, arranged in four symmetrical piles.
The addition of the throw and the foundation
of the rug create a set of complementary,
balanced textures.

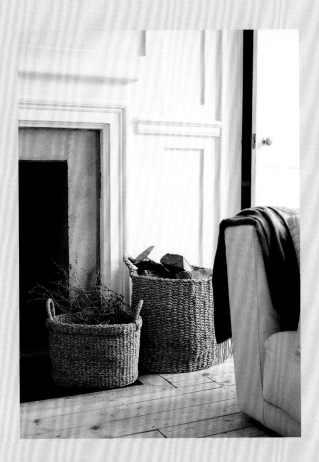

TEXTURAL TWINS

In an apartment defined by its harmonious, calm quality, textural contrasts sing out. The simple wicker baskets of wood and kindling by the open fireplace add an organic note, in keeping with the wooden floors.

STAIRWAY STYLE

The stairway offers another opportunity to create a memorable vignette. Here, a photographic print by Hélène Binet captures Edmund de Waal's 2007 installation *A Change in the Weather*, while the wicker basket below is used as storage for neat rolls of architectural plans.

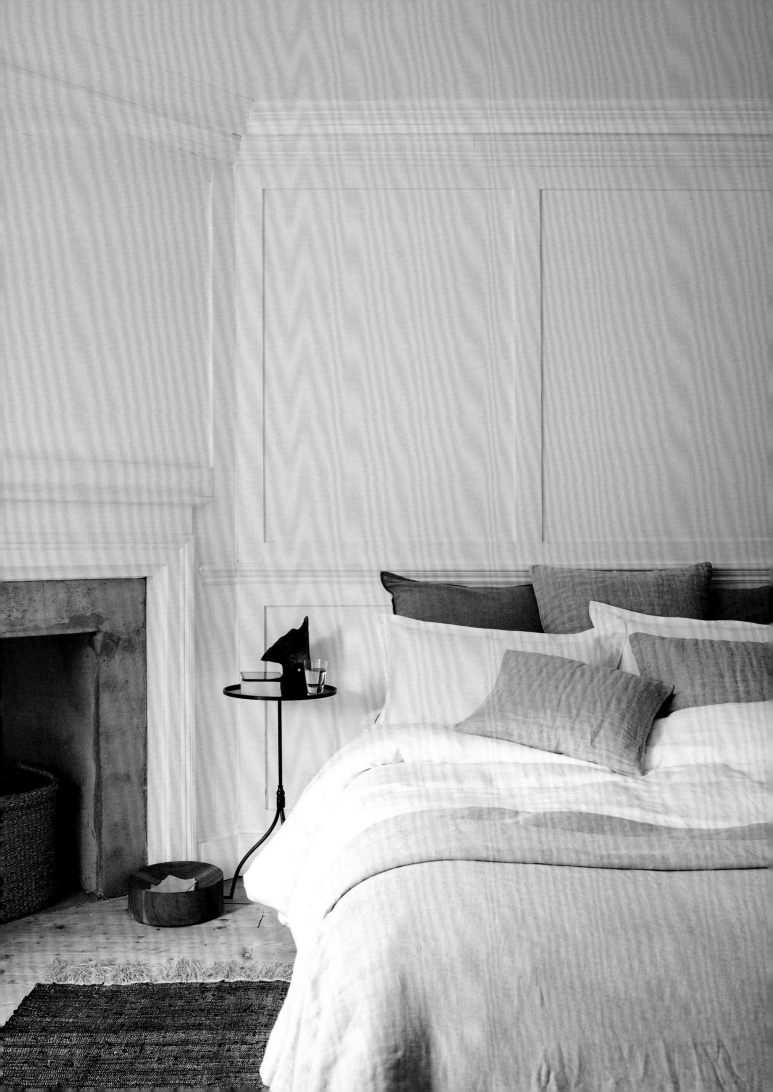

Opposite – In the master bedroom, a combination of grey and white introduces subtle contrast yet remains calm and composed. The layering of cushions and bed linen from The White Company, along with the rug and wooden floors, creates a spectrum of textural interest enhanced by the backdrop of white walls.

Right and below – As in a gallery space, curated objects in the bedroom stand out against a neutral canvas. The distinctive shape of the Hans Wegner Valet chair is accentuated alongside a circular mirror. This and the black Holkham side tables are from The White Company.

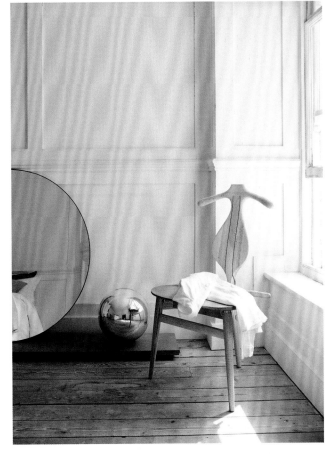

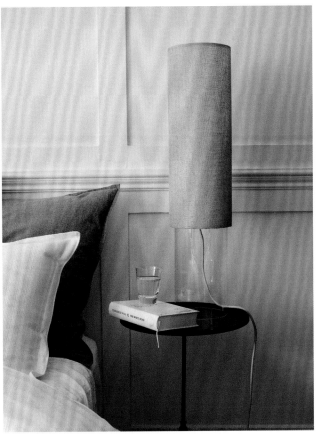

A key priority for William was to ensure that the different spaces in his home flowed smoothly and naturally from one to the other, helped by the unifying colour palette. This is true of the main living spaces and the bedroom, while in the kitchen the walls and units are painted in soothing Lamp Room Grey from Farrow & Ball.

'The kitchen steps out onto a south-facing terrace, so it can cope with being a touch darker. But typically, as an architect, I'm thinking about trying to make spaces flow and create this continuum, hence white or grey throughout. If I want to create a more intimate space, I might use hessian wallpaper or texture rather than a colour. It would be a misunderstanding to say that all my work is in white, but there is a feeling of repose and that often comes from using materials rather than colours.'

Courtyard Oasis

— THE DELIGHTS OF A REINVENTED DAIRY —

When interior designer Beth Dadswell and her partner Andrew Wilbourne, a graphic designer, first caught sight of a derelict dairy in Herne Hill, south London, it was the courtyard that really captured their imagination. A lattice of bare metal girders floated over this hidden space, creating a kind of pergola that was soon to become part of a welcoming outdoor living room.

'So many people have asked me why we didn't just build over the courtyard, but it was the atmosphere created by these plants tumbling over the girders that attracted us to the dairy in the first place,' says Beth. 'We really wanted to create a secret garden, and the appeal of the house is that you do feel as though you are living outdoors, seeing the greenery rambling up the rough, brick walls. It's like an urban oasis.'

Above – A soothing palette of colours has been used for this former dairy. Plaster walls are sealed with a clear varnish and complemented by a soft grey on the joinery, including the bookshelves and storage units.

Opposite – The main living area flows out into the glass-roofed courtyard garden via a wall of metal-framed glass, which increases the sense of space. A large skylight above this part of the house lets in even more sunlight.

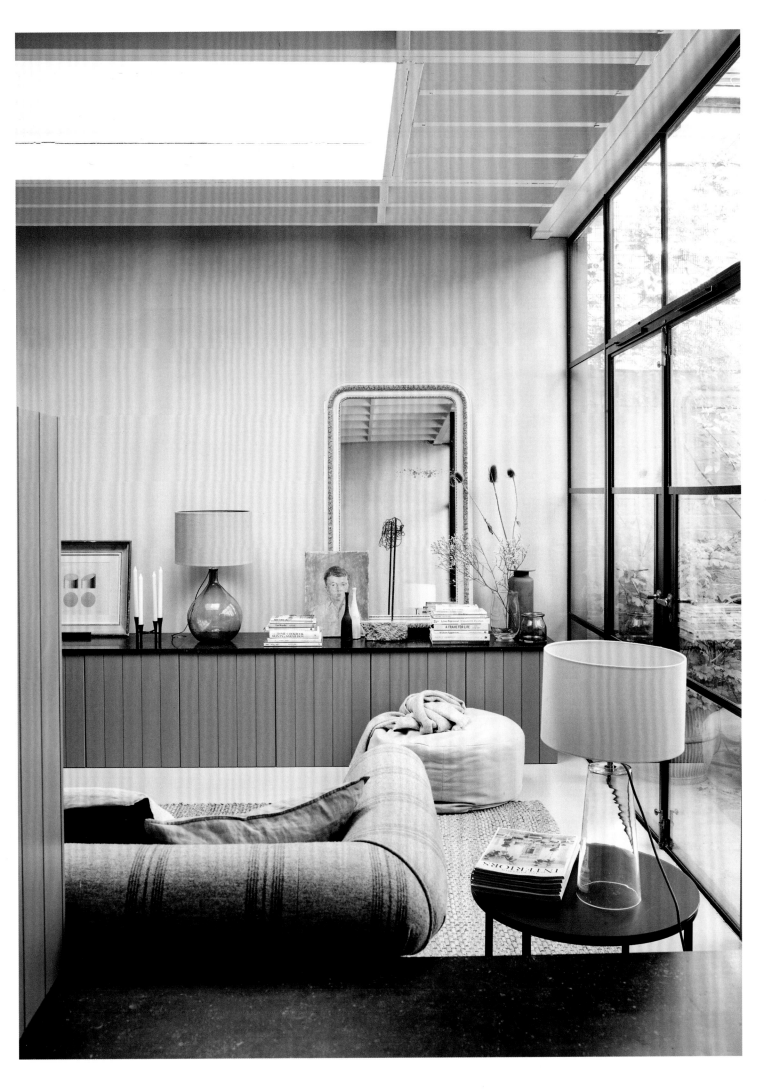

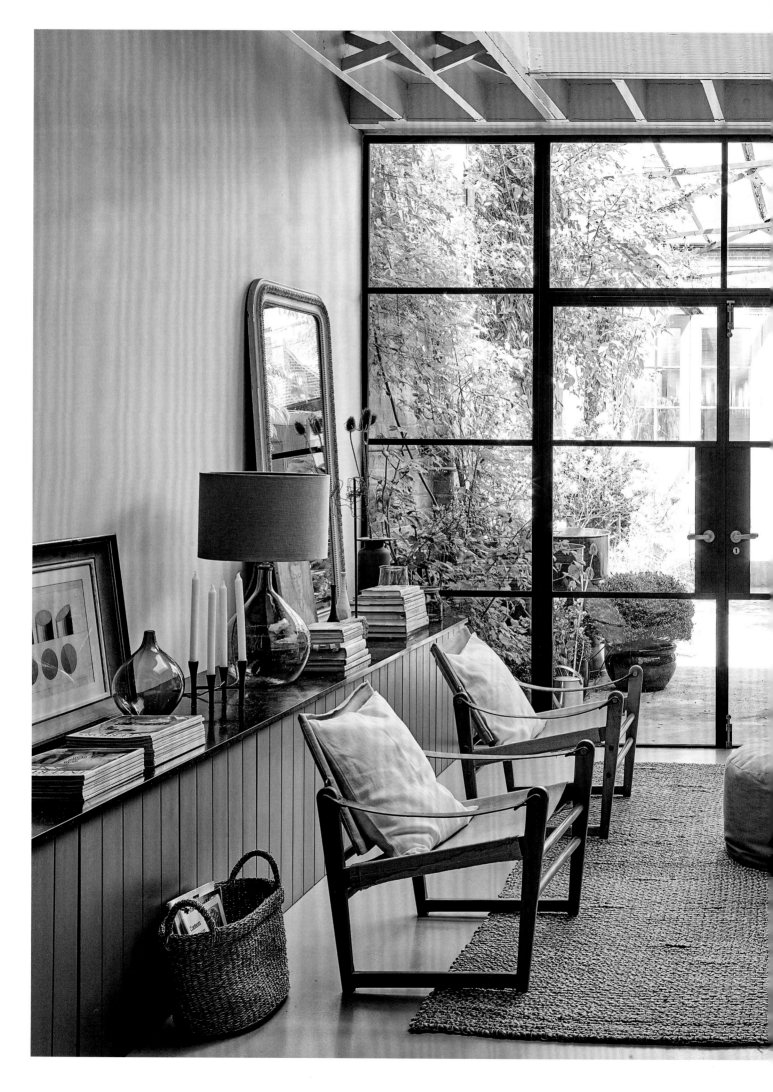

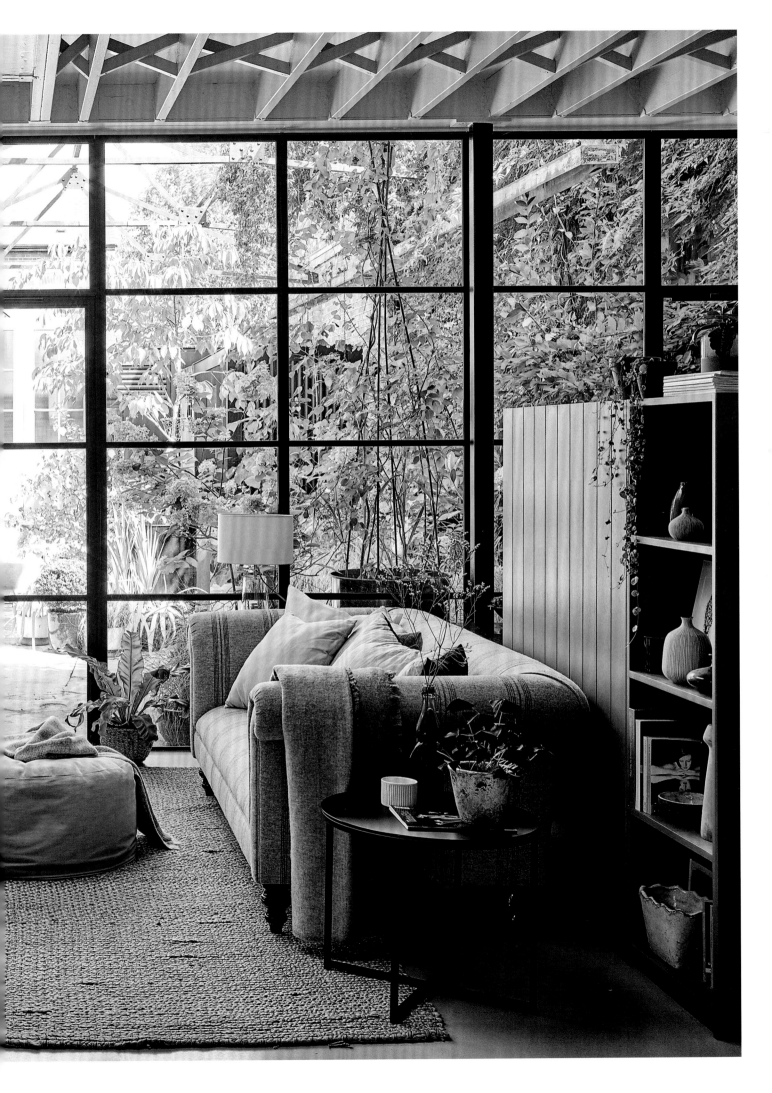

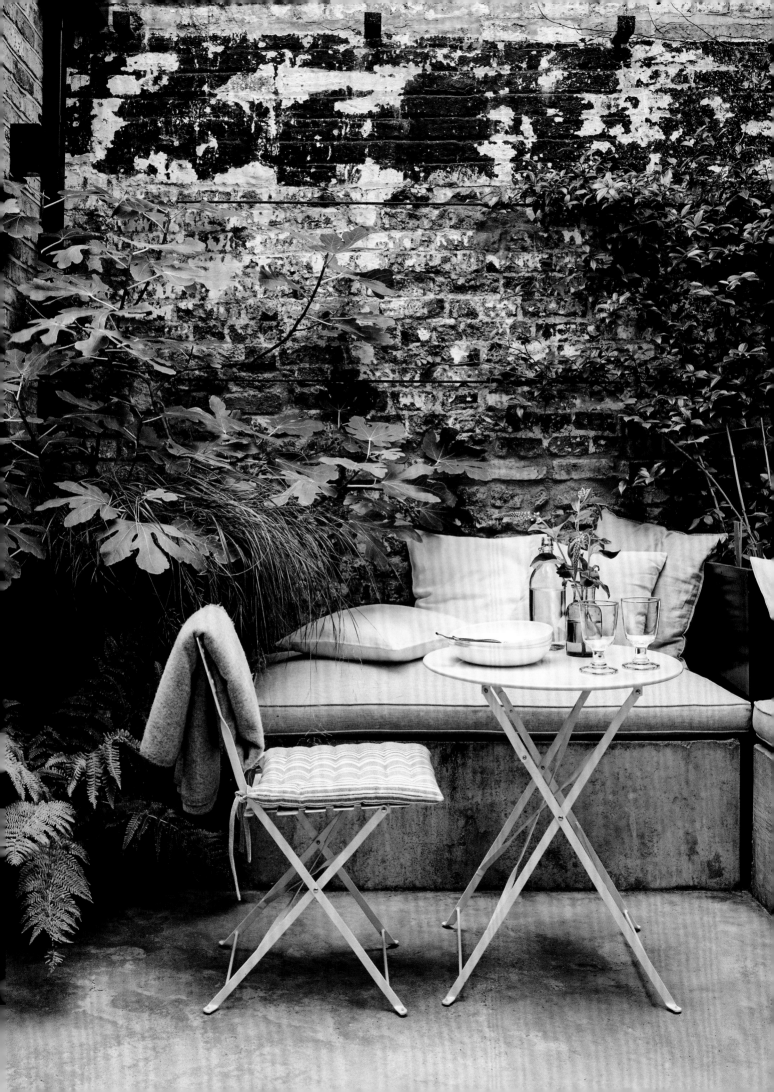

Previous pages – The main living area forms part of an open-plan space that leads out to the secret garden, creating a green backdrop to everyday living. The seating mixes vintage armchairs with a contemporary sink-in sofa from The White Company.

Opposite – This secondary courtyard offers a small, secluded but characterful outdoor room. Soothing greys and white link the space back to the house.

Right – Pearlescent white wall tiles form a partially reflective backdrop to the range in the kitchen and shine out against the matt plaster walls. The custom-made joinery of the units against the side wall continues into the living area in the form of matching grey storage cupboards, enhancing the sense of cohesion. The all-white pendant light, tablecloth and china make for unfussy dining.

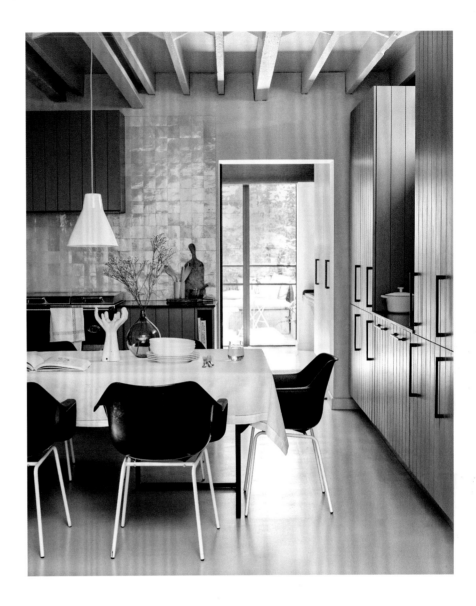

Beth and Andrew settled on the former dairy and ice-cream factory after renovating a series of flats and houses across the capital. Stumbling upon the site in Herne Hill, they saw an opportunity to do something fresh and different, making a home for themselves and their teenage son Louis that would be fully tailored to their own needs and desires. Creating a 'garden house', linking indoors and outdoors, played a key role in their conversion plans.

'Life is very frenetic, so living and working somewhere that feels calm and light is very important to me,' Beth explains. 'As I'm constantly working on the design of other people's houses, I decided that I wanted something that felt very pared-back and timeless, as well as a home that we wouldn't want to redecorate in just a few years' time.'

Working with architect Takero Shimazaki, Beth designed a layout that offered a fluid relationship between the ground-floor living spaces and a choice of outdoor rooms. The open-plan kitchen, dining and living room feed out into the main garden via a wall of metal-framed glass. Both the family den and a separate study to the rear look out upon a smaller, secondary courtyard. Upstairs, Beth and Andrew created two spacious bedrooms and bathrooms.

Styling details

— IN THE GARDEN —

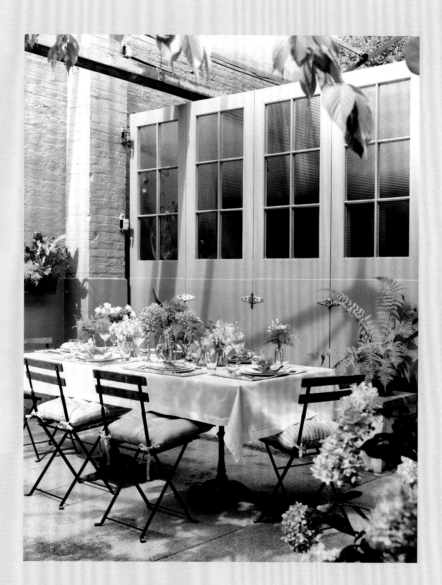

NATURAL TABLESCAPES

An abundance of green foliage and white flowers help to create a romantic dining area in the courtyard. The simple backdrop of white tablecloth and white walls allows the greenery to take centre stage. Partially glazed folding doors provide a screen between the courtyard and the parking bay beyond.

SCULPTURAL CHINA & GLASS

The china and glass on the garden dining table is
simple but with an engaging sculptural quality. The
white china frames the colours and textures of
the food, while the glass offers lightness, with the
vases allowing the greenery to shine through.

FOLDING FRIENDS

In a garden setting, simple, white, folding furniture
in the French style is both functional and elegant,
while seat cushions add comfort and texture.
For this modest, secondary courtyard, they are
the ideal choice.

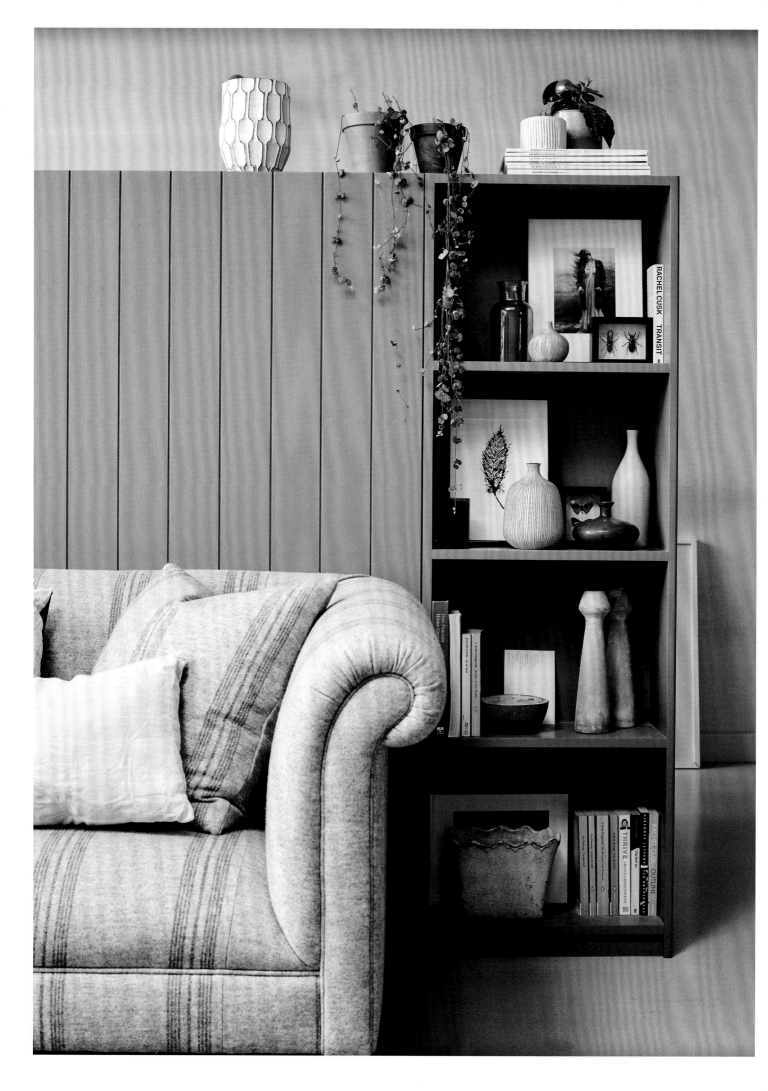

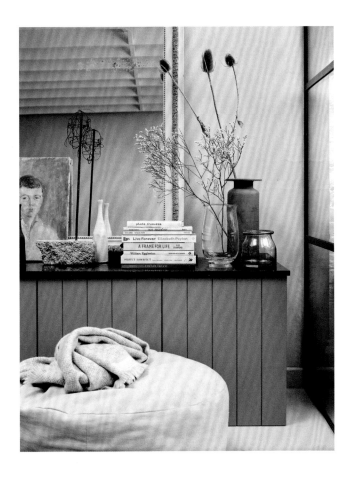

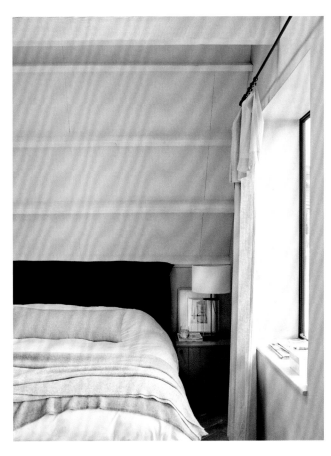

Opposite & above left – Beth designed all
the custom joinery, which includes the
bookshelves and low units, painted in Mole's
Breath by Farrow & Ball, in the sitting room.
The grey tones form a pleasing backdrop
for collections of white ceramics, books,
magazines and small works of art.

Above right – The two bedrooms are
situated on the upper level of the former
dairy, overlooking the courtyard gardens
on either side of the house. Beth and
Andrew restored the original 'barn-style'
roof and painted it white, and introduced
herringbone parquet floors.

Beth opted for a soothing colour palette throughout. The
walls are in bare plaster, which has been lightly sanded and
then sealed with a clear matt varnish. The coffered wooden
ceilings are picked out in a soft Dulux eggshell paint called
Wiltshire White, while the floors – which run through to the
courtyard on the same plane – are coated in a thin layer of
cement with a grey-white tone. The custom-made joinery
for the kitchen units, storage cupboards and stairs has been
painted in Mole's Breath by Farrow & Ball.

'The idea was that the kitchen units would morph into
the book and storage cupboards in the living room,' says
Beth. 'The joinery in the snug, office and bedrooms all has
the same design and colour. The combination of the plaster
walls and paint colours, with the soft sheen of the joinery,
gives a real sense of warmth to the house. We just love
the mood and atmosphere, as well as looking out onto the
courtyard all year round. It feels as though we are on holiday
all the time.'

Townhouse Living

— A GEORGIAN REVIVAL —

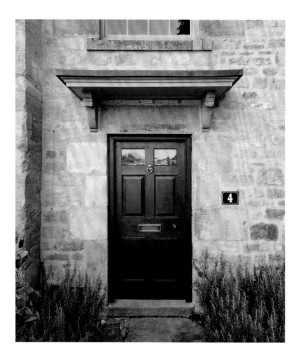

Historic houses grow and change over time. This is certainly true of Harry and Rebecca Whittaker's home in the centre of Bradford on Avon, Wiltshire, not far from Bath. Their Georgian house had originally been built as a weavers' workshop, with looms on the top floor and living space below. It was later split into two houses but reunited in the Seventies. By the time Harry, an architect, and Rebecca, a relationship counsellor, bought the house, it was semi-derelict and in great need of love and revival.

As a conservation specialist with his own practice, Bath Conservation Architects, Harry was well placed to bring the house back to life. Building a new and sympathetic three-storey extension to one side – which holds the main entrance and bathrooms above – not only created additional space, but also helped to stabilize the original stone building. A ramshackle extension in the garden courtyard to the back was rebuilt, creating a welcoming kitchen and dining area.

Above – The front door, which now sits in the new extension built to one side of the house, leads to a wide hallway with flagstone floors. Designed by Harry and constructed with locally sourced stone, the extension fits in perfectly with the rest of the building and its surroundings.

Opposite – The display wall in the living room is a new but sympathetic addition. Although Harry and Rebecca designed it as a bookcase, they found that parts of their collection of white statuary and metal and glass salvage fitted neatly into the niches, which act like picture frames.

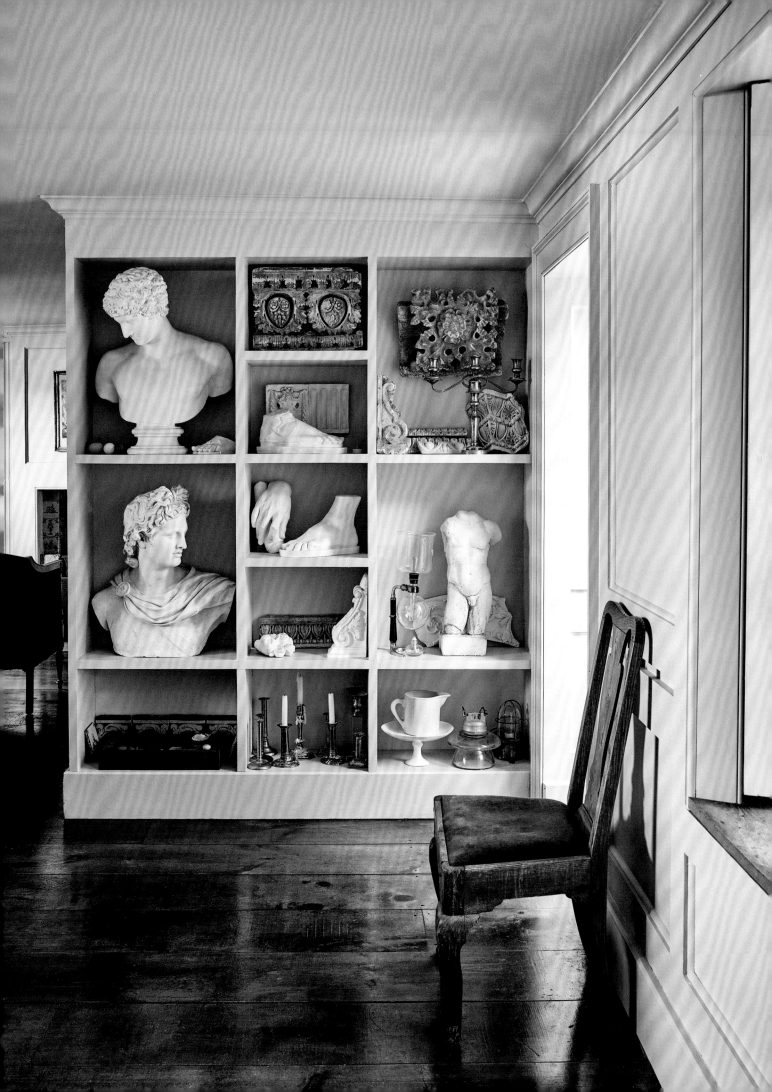

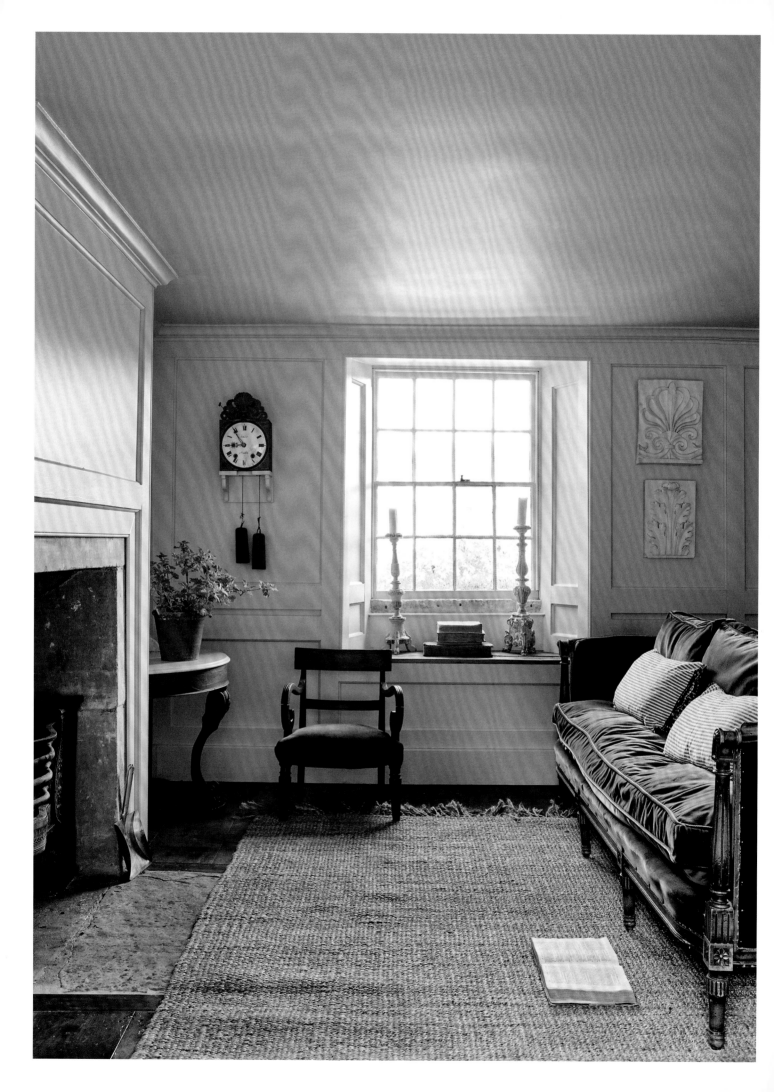

Over the years, many of the original Georgian features had been lost, so Harry, aiming for cohesion as well as character, reintroduced focal point fireplaces and other appropriate period detailing.

'The house was semi-derelict when we bought it, so every wall had to be dry-lined with insulation and, rather than plastering, we decided to panel most of the walls in the old part of the house,' says Harry. 'We used an off-white for all the panelling – a grey white – and the same colour for the ceiling. So everything is this one colour, apart from the wooden floorboards, which are quite dark.'

In the main living space there are fitted cupboards and also a new display wall, made to Harry and Rebecca's design, for pieces of statuary and other personal treasures. 'We built the shelves thinking they would be bookcases, but all of these white pieces that we had slotted in perfectly. So it was really serendipity rather than a purposeful plan.'

The new kitchen at the rear of the house flows out into the courtyard garden through a wall of Crittall windows, with the natural light supplemented by a long skylight close to where the extension meets the main body of the house. Here, Harry and Rebecca opted for a palette that was close to black and white, with the custom-made kitchen units painted a dark blue grey, which stand out against the light and neutral backdrop. Harry and Rebecca scoured eBay and other sources for scraps of marble, which they used to make the stone floors, piecing them together like a jigsaw puzzle.

'We found a whole batch of Carrara marble in London but none of it quite matches,' says Harry. 'Then we found the sink on eBay – it's made from a single block of marble.'

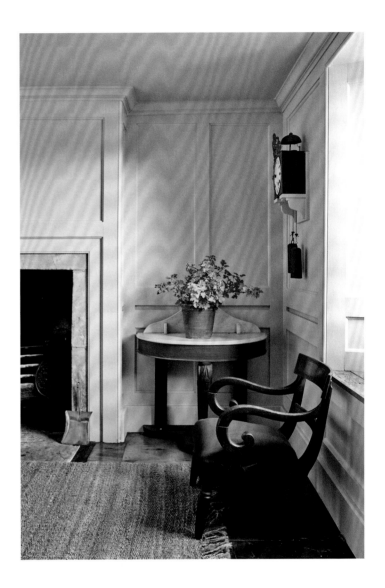

Opposite & above – The sitting room has a natural period quality, even though the space had to be stripped back and reinvented in its current form. New panelling covers the walls, while Harry introduced a fresh fireplace with a cast-iron grate, which adds to the period feel. The vintage sofa was bought on eBay.

Styling details

— THE ART OF DISPLAY —

PICTURE PERFECT

In the sitting room, the wall panelling offers a space to display personal treasures, such as these architectural mouldings that have been collected over the years. The straight lines of the panel recess act like a frame, so that the display becomes reminiscent of a painting or wall sculpture, while the soft grey of the paintwork helps the white mouldings to stand out all the more.

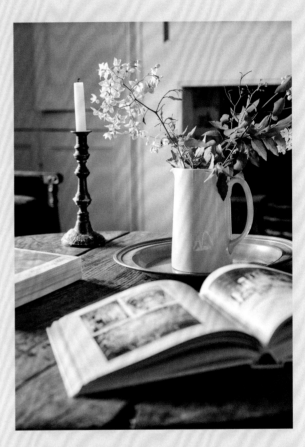

SURFACE NOTES

Graced with wooden shutters rather than curtains
or blinds, this living room window frames a modest
cameo of a loosely affiliated pair of candlesticks and
a small stack of books. The subtle mismatch of the
candlesticks is a part of the display's charm.

LIGHT TOUCHES

Harry and Rebecca make good use of their
collection of antique and vintage candlesticks.
Soothing and seductive, candlelight is a simple and
straightforward way of introducing atmosphere
and warmth to a room.

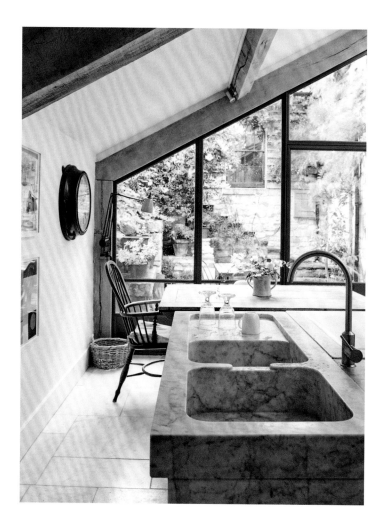

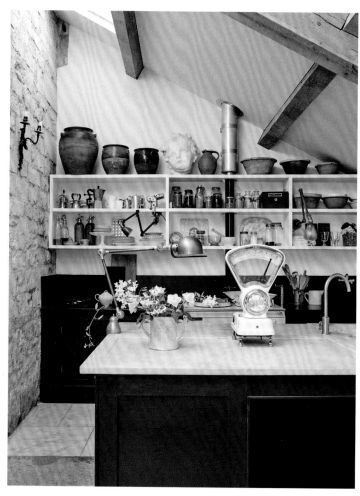

Above – The kitchen and dining area is a freshly invented space that connects to the courtyard garden at the rear of the house. Light flooding in through the wall of glass and the long skylight enhances the different materials used in the space.

Above & opposite – The dark frames of the Crittall windows and the kitchen clock reinforce the contrasting palette of grey and white used for the custom-made units and island. The floor was created from a collage of different-sized pieces of marble, while Harry made the trestle dining table from an old ping-pong table. The chairs are by Charles & Ray Eames.

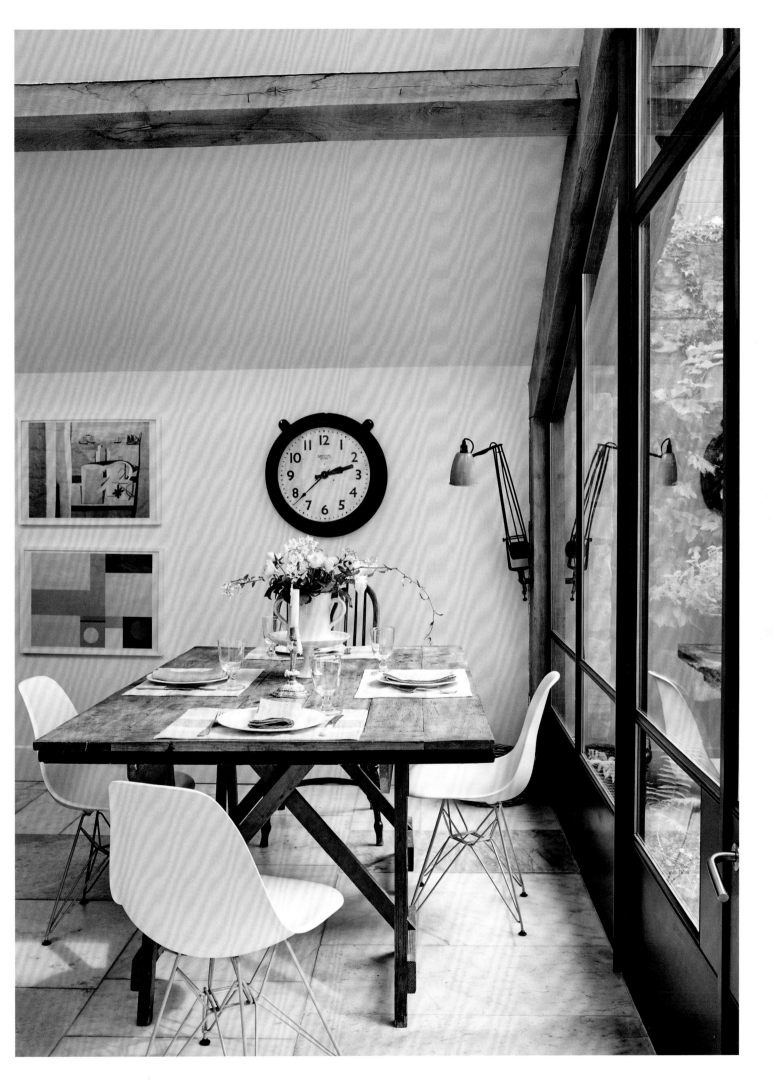

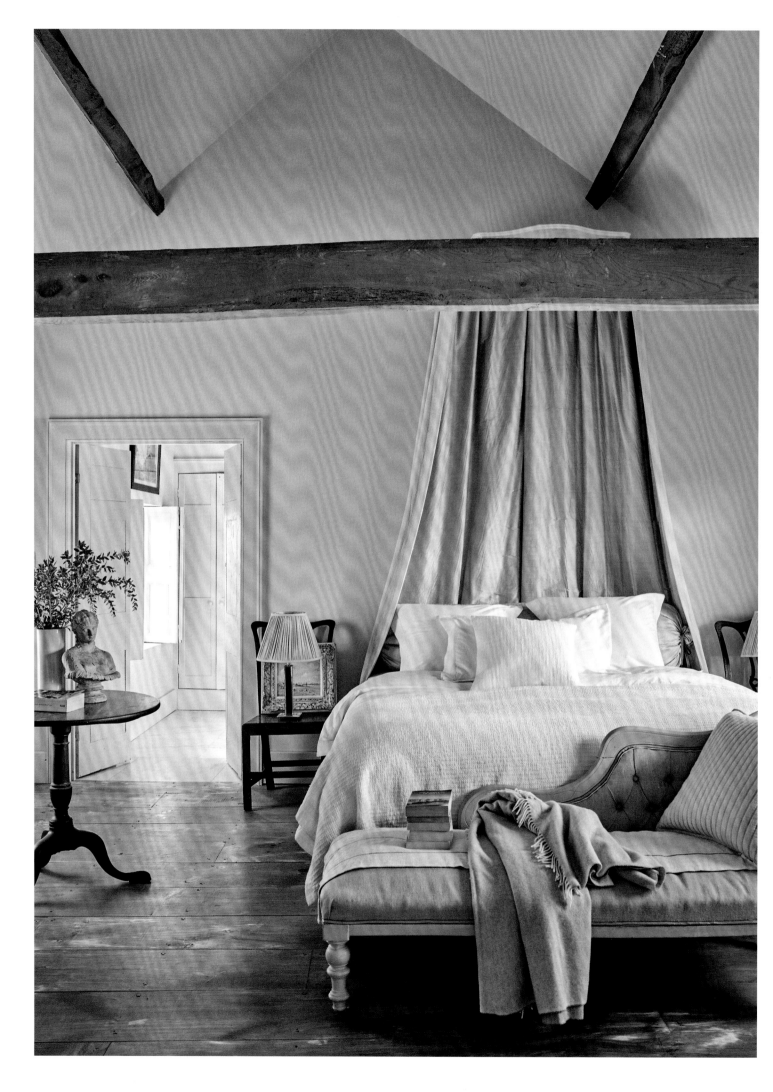

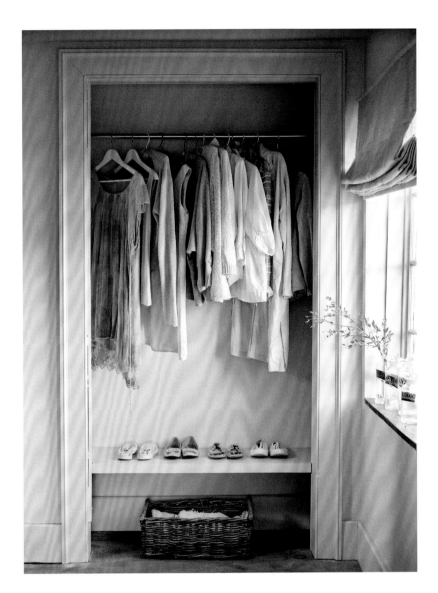

Opposite – Spacious and inviting, the white-painted master bedroom at the top of the house opens up to the eaves. The chaise longue at the foot of the bed lends a relaxed feel to the room. The linens used for the furniture, bed and canopy are in a complementary range of tones and soften the space still further.

Right – A simple recessed closet without its doors is an attractive and accessible way of containing an edited selection of everyday clothes and shoes.

A palette of whites and off-whites, combined with natural textures, has been used for the bedrooms and bathrooms. In the attic, Harry combined two former rooms to create a large and spacious master bedroom, with an adjoining bathroom.

Like the kitchen, the bathrooms also feature salvaged pieces of stone and marble. In the master en suite, for instance, the vanity was made with a combination of concrete legs, slabs of marble for the top and an impressive, antique French pestle, also in marble, converted into a sink. All these different elements are held together by the use of soft tones, with occasional sparks of colour.

'Being an architect, I have always loved white interiors,' says Harry. 'When I think of white, I remember Turner's paintings, with all these swirling pale colours and then just a touch of heat at the centre to draw your attention.'

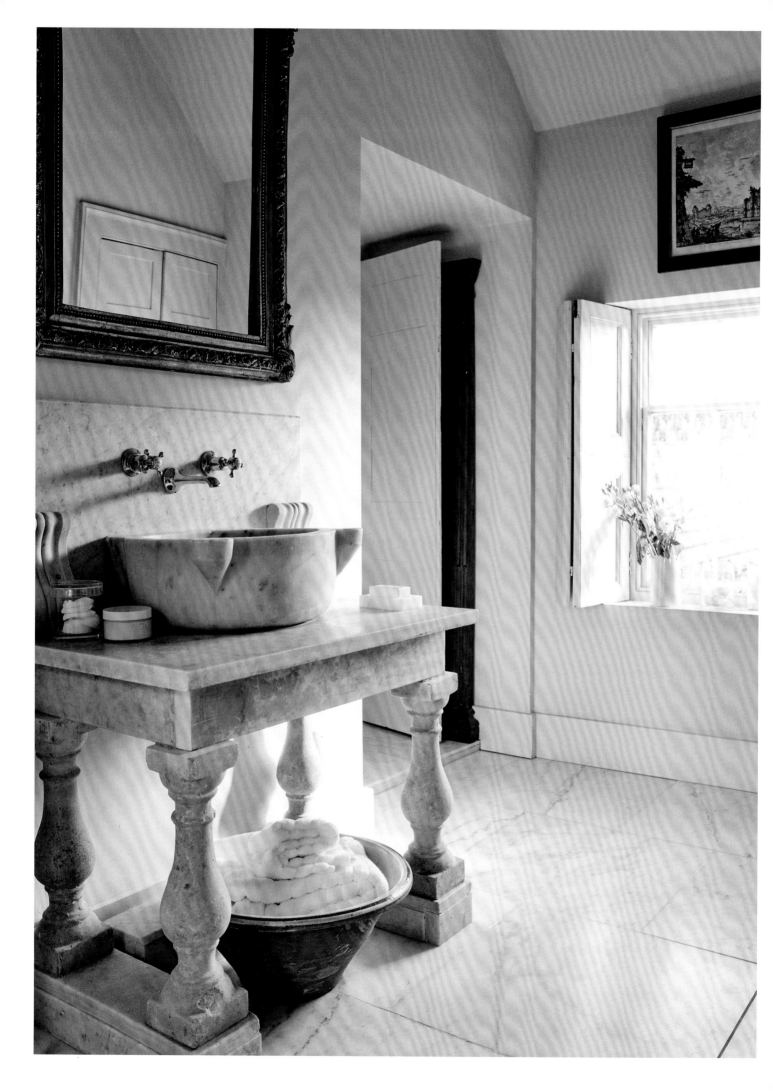

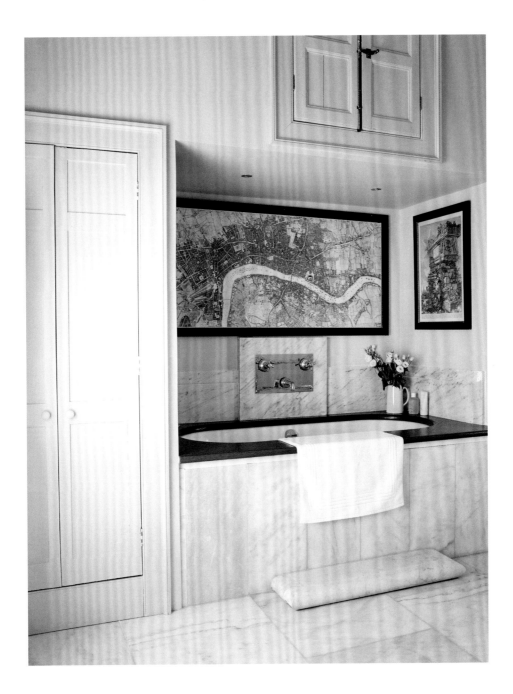

Opposite – The bathrooms, including the en suite master, sit within the new extension. Here, Harry used a combination of stone and salvaged elements to create the vanity unit. Shutters at the window maintain the clean lines of the space.

Above – A black-and-white 18th-century map of London forms a graphic echo of the veined marble, all within a similar colour range. Practical, integrated storage around the bathtub declutters the space, so that the room remains a relaxing retreat.

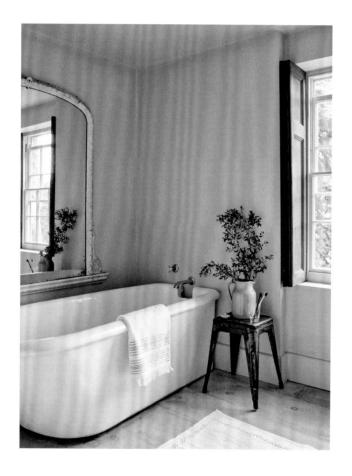

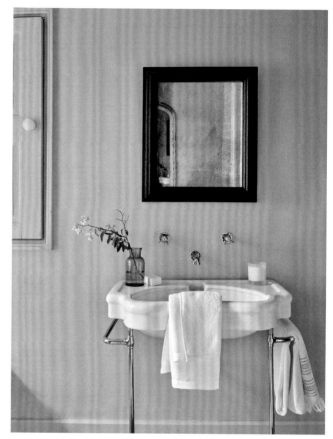

Above & above right – Antique mirrors in the guest bathroom circulate the light as well as increasing the sense of space. Taps and spouts are fixed directly into the wall, hiding the pipework and allowing the proportions of the room and the lines of the white bathtub and sink to be fully appreciated.

Opposite – The French influence at work in the decoration of the guest bedroom gives a romantic feel, enhanced by the upholstered bed and its elegant fabric canopy. The subtle stripes and ticking on the bed linen by The White Company introduce pattern and interest, while sitting well within the overall colour scheme.

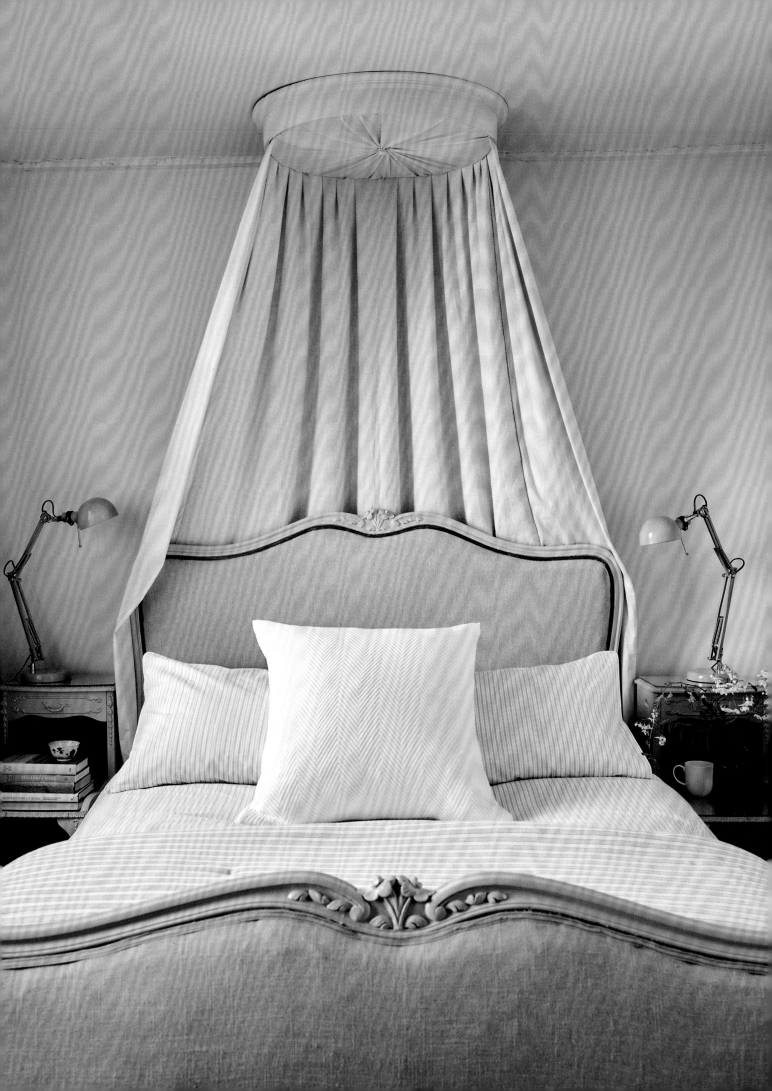

Styling details

— BEDROOMS & BATHROOMS —

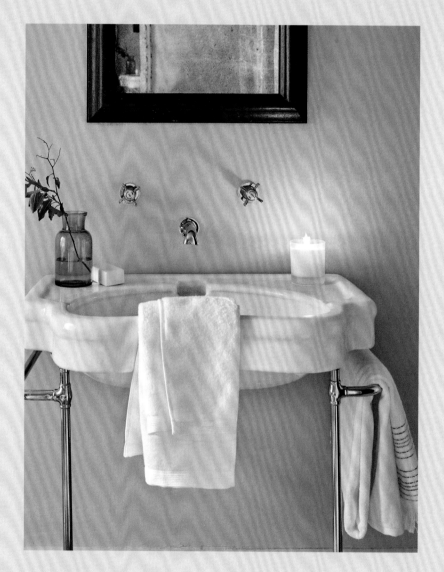

SOFT NOTES

The calming character of a beautiful bathroom is so often reinforced by the use of white ceramic surfaces and clean lines. Soft white bath and hand towels are essential and an inviting ingredient. Here, the ensemble is softened further by a simple flickering candle, with the light circulated around the room by strategically positioned vintage mirrors.

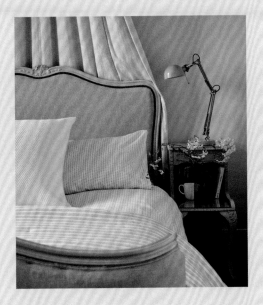

FABRIC & TRIM

In this French-style setting, natural and neutral tones dominate, yet some darker notes, as in the black trim around the headboard, create contrast and character. The ticking sheets and pillowcases, along with the linen canopy, create layers of inviting fabric. There are subtle differences in tone and pattern, but the overall impression is of harmony.

LIGHT & DARK

Although the house as a whole is layered with whites and off-whites, there are subtle contrasts offered by occasional darker surfaces, such as painted joinery, dark floorboards and pieces of furniture. These elements create a harmonious and consistent theme that runs throughout the home, adding to its appeal.

SIDE BY SIDE

A vintage Tolix steel stool serves as a side table in the guest bathroom. The rugged texture of this mid-century classic, originally designed by Xavier Pauchard, offers a foil for the smooth white finish of the bathtub. A pitcher of garden sprigs introduces a refreshing natural note.

SEATING PLANS

The addition of a simple chair – such as this vintage metal Tolix piece – or even a small sofa helps to transform a bathroom from a merely functional space into a spa-like retreat, from a place for getting ready for the day ahead to a haven of quiet relaxation at its end.

II

COUNTRY

Family Matters

— A CALM AND CHARACTERFUL COUNTRY RETREAT —

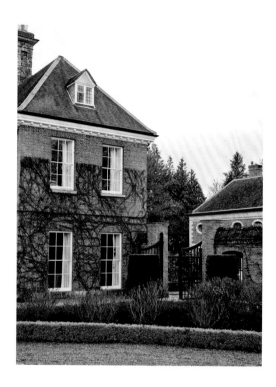

Both Chrissie Rucker and her husband Nick describe themselves as country people at heart. The two of them grew up in the countryside and seized the chance to move to rural Buckinghamshire when their children were small. Their house provides not just a true family home, but also generous-sized gardens and stables, which allow Chrissie and her daughters to pursue a long-standing passion for riding.

'We both fell in love with the house the moment we walked through the door, although it was quite colourful and dark in places,' says Chrissie. 'The hall was yellow, the drawing room was turquoise with gold leaf and the guest bedroom was dark red. We moved in and lived with everything for a year to allow us time to discover what worked well and what we wanted to change to suit our family. It's been a gradual process, but using lots of chalky whites and the softest greys has made the house feel lighter, airy and peaceful.'

Above – The house sits within large gardens bordered by trees and paddocks for the family's horses. There are stables to one side of the house, which is largely 17th century with some older parts to it as well as later additions.

Opposite – In the great hall, this button-backed, banquette-style sofa was designed by Ann Boyd, who helped Chrissie decorate the home when they moved in ten years ago.

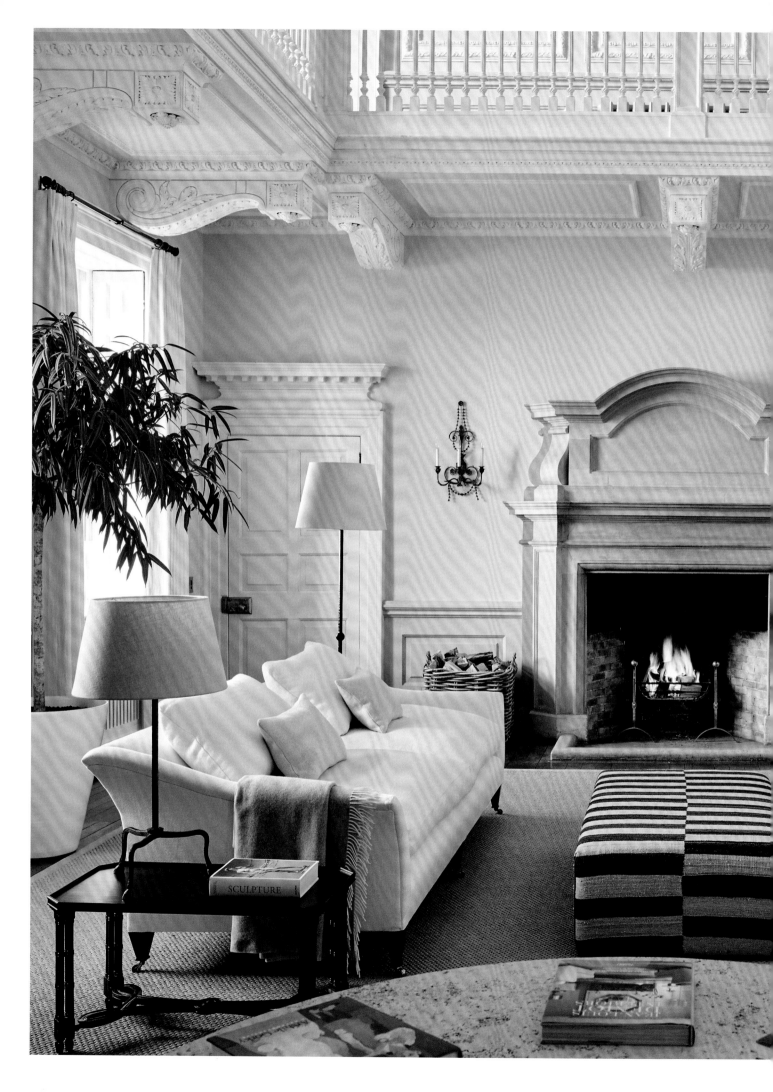

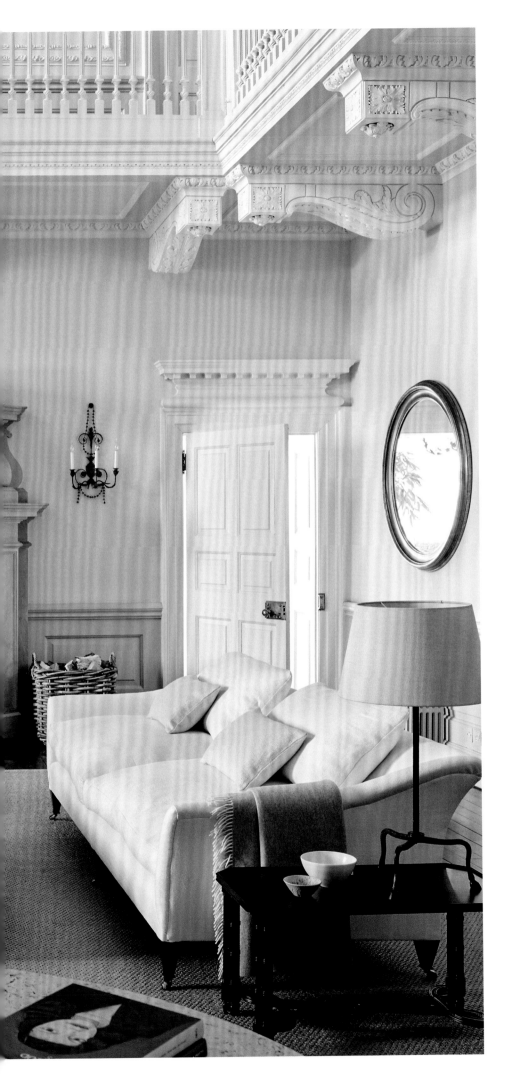

Left – The great hall has a special sense of character drawn partly from its original 17th- and 18th-century architectural detailing, including the dramatic stone fireplace and mezzanine gallery, as well as the panelling below the dado rails and the striking doors and doorways. The subtle variation of paint colours on the walls and panelling includes Slate I and II from the Paint & Paper Library, plus All White by Farrow & Ball for the doorways.

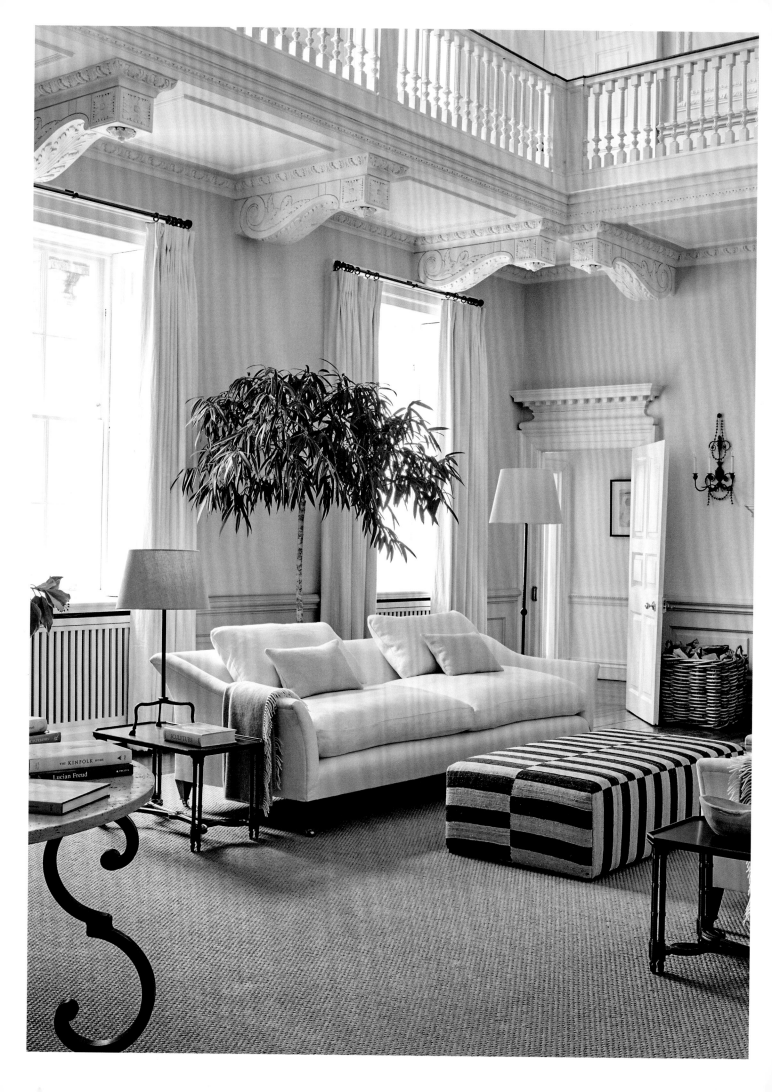

Opposite – In the great hall, seagrass matting provides a natural complement to the white walls and decorative details, as well as grounding the deep, comfortable sofas. The pair of low, ebonized side tables next to the sofas pick up on the subtle black and white theme in the room.

Below – In addition to the seagrass matting and wicker baskets by the fire, other natural notes within the space include, a potted fig tree and a carved wooden bowl on a side table. Throws draped over the arms of the sofas can be used to help protect the white linen, as well as adding a soft, textural element.

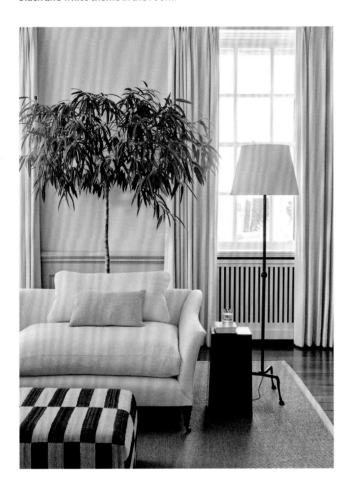

The oldest parts of the house date back to the 16th century, after which it was remodelled and extended twice during the 17th and 18th centuries. Among the most enticing characteristics of the house are the large windows throughout, which bring in plenty of natural light and frame the open views of the gardens.

At the centre of the house is the great hall with its mezzanine gallery. This spacious room, with its dramatic stone fireplace, original plasterwork and mouldings, is the heart of the house but also a place for entertaining. A palette of subtly different white paint choices brings out the character of the original detailing while creating gentle contrasts in tone.

'When we first moved here, the hall felt so empty and soulless. The challenge with a generous room like this is to make it feel comfortable and welcoming,' Chrissie says. 'So we chose very wide, deep sofas that help fill the space and sit on either side of the fireplace, with an ottoman between them. I love having a soft ottoman in the middle of a room because they become another great place to perch and chat when we have friends over.'

The matching twin sofas were designed by Rose Uniacke, who helped Chrissie with a recent update of some of the rooms in the house. 'It's essential that the scale is right in any space and, in the case of a sofa, going for something larger than you first think usually works better,' says Rose. 'In this room, anything smaller would have felt inadequate and marooned. Traditionally upholstered, the sofas are also extremely cosy and welcoming, and have a simple, refined outline.'

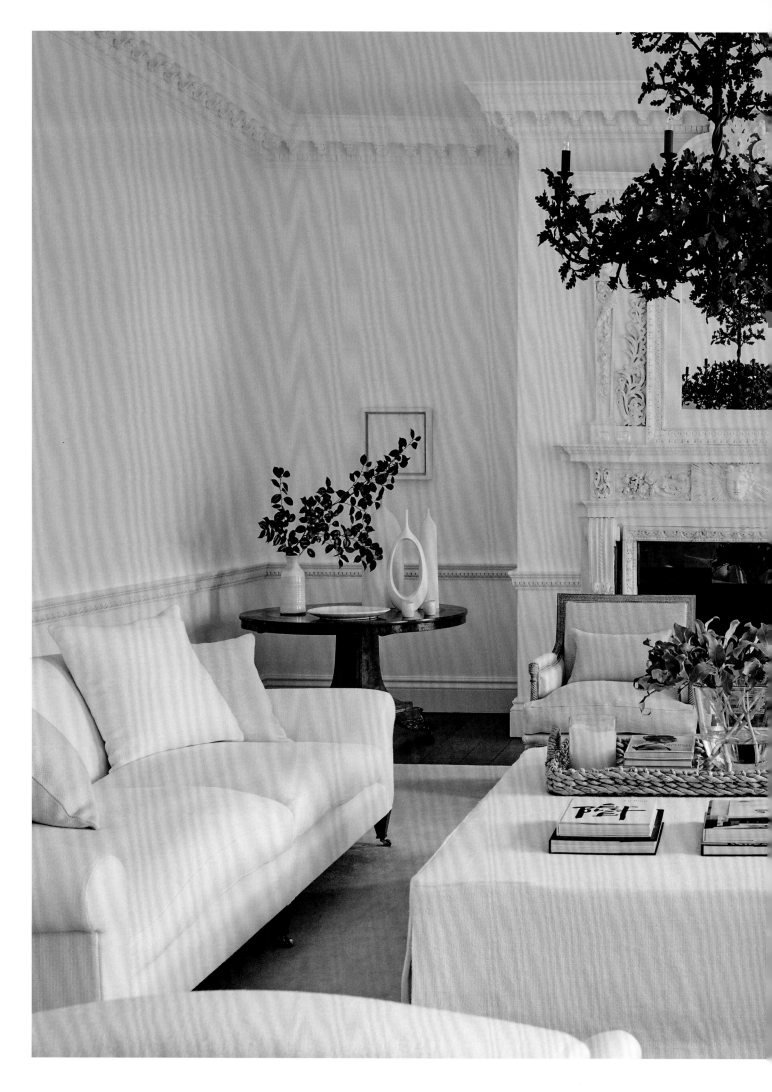

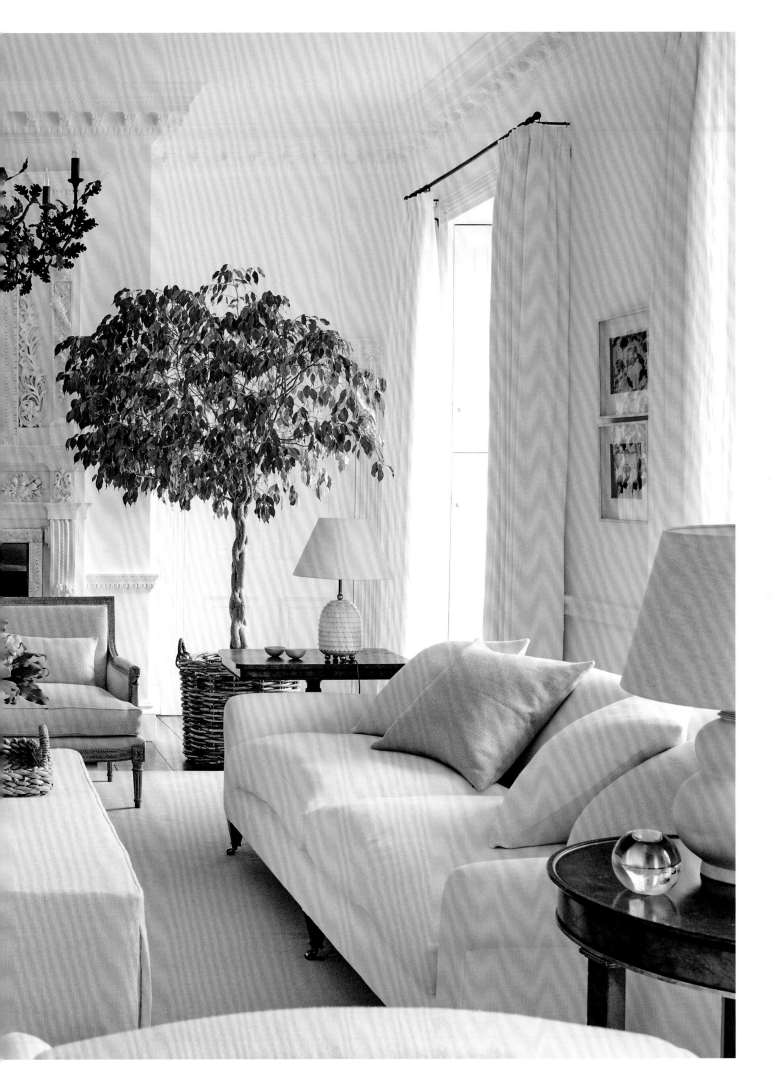

Previous pages – A custom-made bronze chandelier from Rose Uniacke forms a dramatic centrepiece in the drawing room. The sofas and ottoman, also by Rose, complete the seating arrangement. The fireplace is an original feature, picked out in white, with a theatrical quality to its ornate plasterwork.

Right & below – The linen curtains are a soft presence at the tall windows, which look across the more formal part of the gardens. The single, large painting is by Deborah Tarr, and the two smaller pictures are by Susan Foord.

Opposite – The round table is a George IV period piece dating from around 1830, which was sourced by Rose Uniacke. 'I love the way that the warmth of the oak punctuates the purity of the white-on-white colour scheme,' says Rose. 'It's important in classical houses to have some antique pieces, even if the feeling of the space is fairly contemporary.'

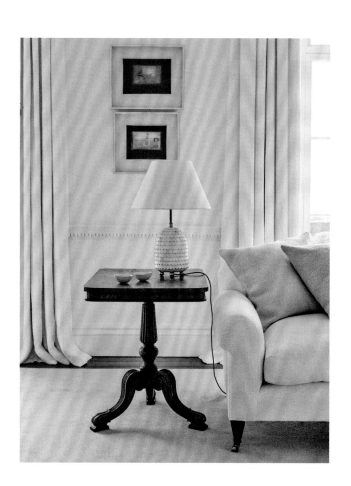

Comfort was also a priority in the drawing room. Deep-seated sofas are complemented by comfortable White Company armchairs and another central ottoman, serving as a coffee table with books and a wicker tray.

Here, as elsewhere in the house, there are gentle shifts in texture, with a clear link between the crafted bronze leaves of the custom-made chandelier, the carved foliage around the ornate fireplace and the fig tree in a wicker planter that graces one corner of the room.

'I often try and find ways to bring the outside in,' says Chrissie. 'So as well as big trees, I like to use lovely big branches from the garden in vases. A new addition to the drawing room are these lovely antique pieces that Rose found for us. I love the round table by the fireplace, which feels so right in the country. Antique furniture in these darker tones went out of fashion for a while but, to me, it now feels so wonderful having these pieces in the mix. They create this sense of warmth and contrast, yet the room feels contemporary because the rest of the room is still white at heart.'

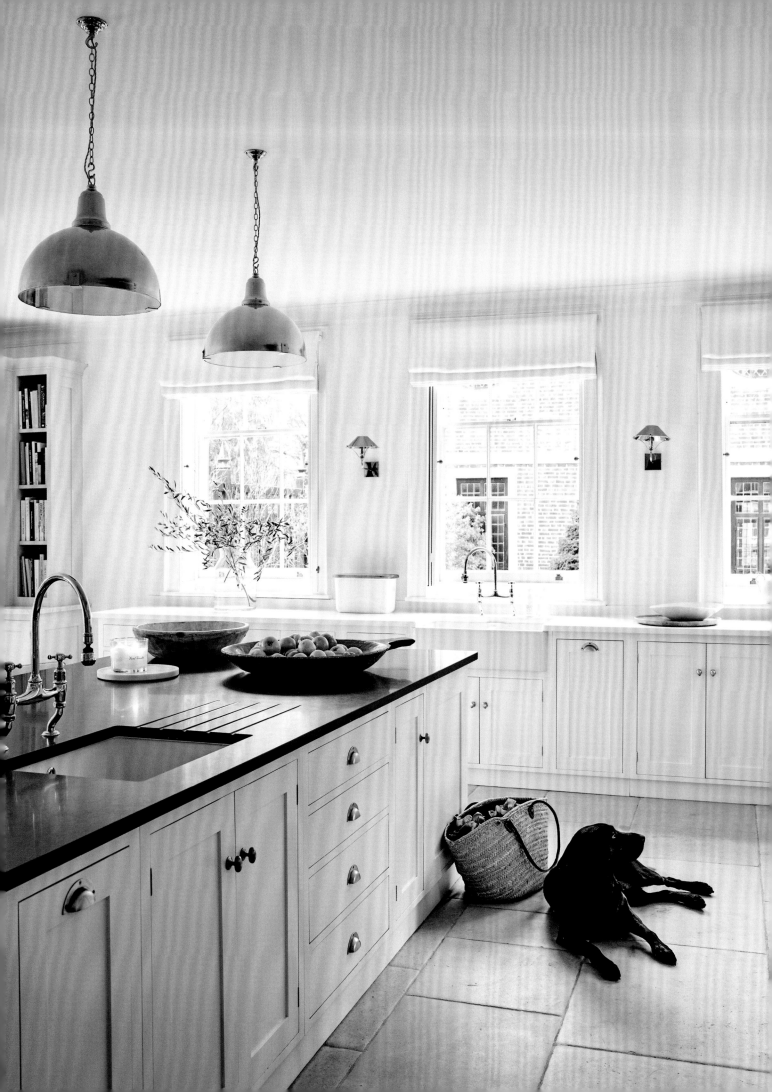

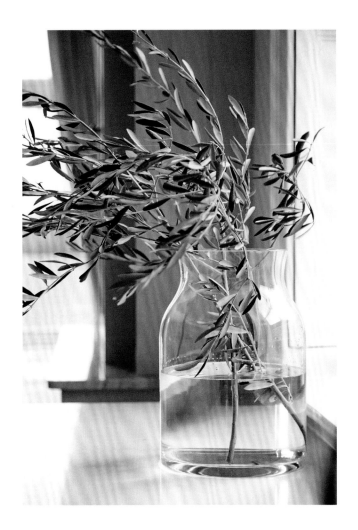

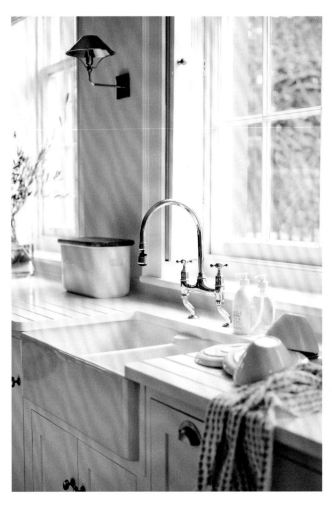

Opposite – Coco the labrador reclines next to
the large, granite-topped kitchen island, which
doubles as a serving station and additional
breakfast bar. The custom-made kitchen island
and the units, which have a Shaker influence,
were designed by Ann Boyd and made by
Edmondson Interiors in Sussex.

Above – Simple branches from the garden bring life
to the space and echo the greenery in the courtyard
beyond the windows. The kitchen garden, close to
the house, provides seasonal fruit and vegetables.

The kitchen is a focal point for the whole family. Chrissie
remodelled this part of the house shortly after she and Nick
bought it, transforming a number of smaller rooms into one
large and inviting hub.

Along with plenty of fitted storage cupboards, a separate
larder helps keep the room uncluttered; it's one of a number
of 'engine room' spaces, which include a dedicated laundry
on the top floor of the house.

'The kitchen is undoubtedly the part of the house that
gets the most use,' says Chrissie. 'It's often full of children
and their friends, visitors and the dogs, so it had to be
a hard-working space. It's also quite a draughty house,
so having the Aga – in white – is fantastic to keep the room
feeling warm and cosy, especially in the winter.'

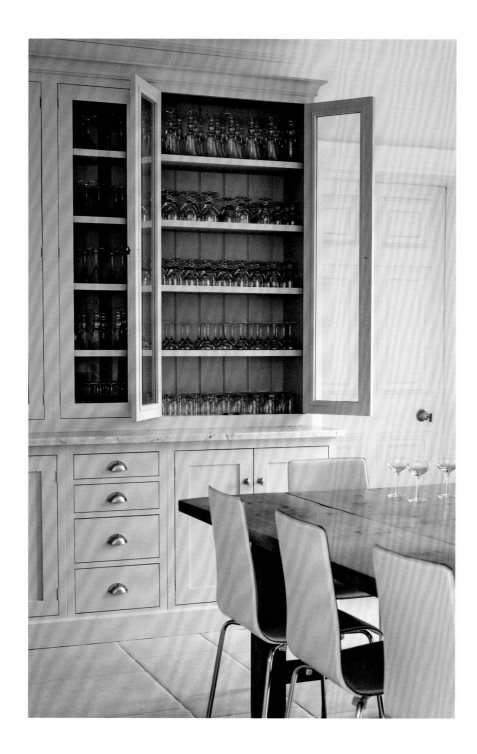

Above – This custom-made dresser to one side of the kitchen has been amply stocked with glasses of all kinds. It forms part of the generous amount of storage in the kitchen, which often sees impromptu meals for family friends with lots of children.

Opposite – The L-shaped kitchen is ideal for family breakfasts and can seat up to 12 comfortably. The island can also be used as an extra 'table', with stools pulled up to the countertop. French windows bring in plenty of natural light and connect with the garden.

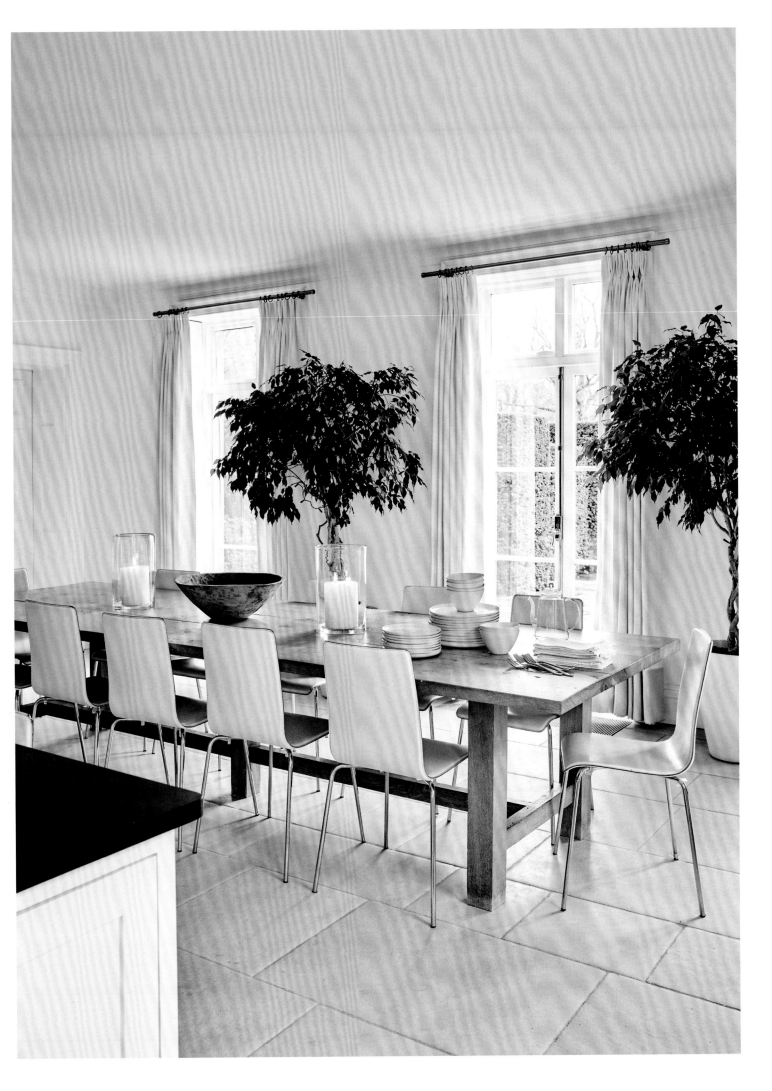

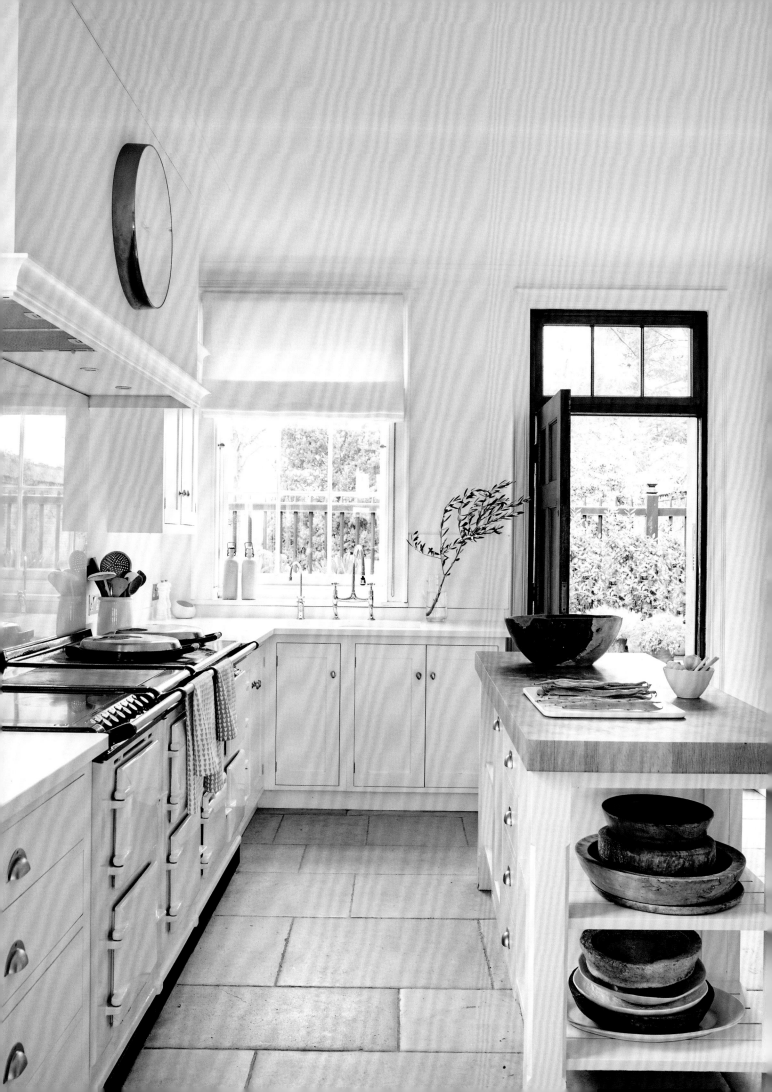

Opposite – This is the hard-working part of
the kitchen where family meals are prepared.
The arrangement is ergonomic, with the Aga
range, prep island and sink by the window,
all within easy reach of one another.

Above – Inspired by the old-fashioned butcher's
block, the wood-topped island is an invaluable
work surface but also stores kitchen essentials,
from sharp knives and a bin to salad ingredients.
Hard-wearing flagstones give the room
a sturdy base.

The kitchen was designed as a series of interconnected
zones. Most of the food preparation and cooking takes place
in the area by the back door, where the Aga range, sink and
wooden-topped prep island are situated. Beyond this is a
larger island with a granite top, which doubles as a serving
station and breakfast bar, with extra storage space tucked
underneath. There is room enough for a large wooden
dining table with a substantial fitted dresser alongside,
holding a collection of glassware and china. Tucked away
in one corner is a coffee station. A combination of natural
tones and a cohesive aesthetic style, with a Shaker influence,
helps to tie the whole space together.

'Most of our family meals happen in here,' Chrissie says.
'We try to get everyone sitting down together and have
proper family time. But with four children, it can often
be chaotic. We have become quite good at feeding the five
thousand in this kitchen.'

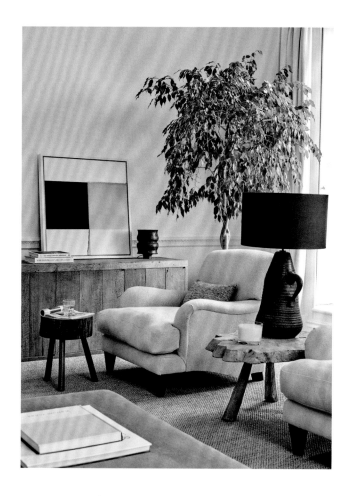

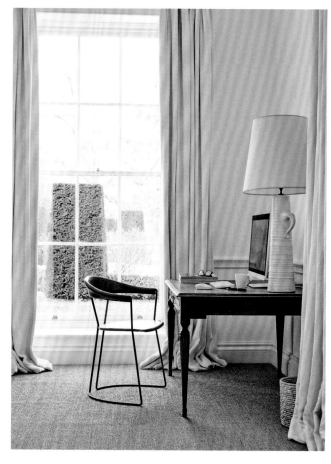

Above – The ceramic stoneware lamps with handles are Fifties pieces made by Mobach in Holland and sourced by Rose Uniacke, while the abstract painting is by Scottish artist Callum Innes. The Louis XVI French writing table has been paired with a leather chair designed by Rose, from her RU Editions collection.

Opposite – Comfortable armchairs from The White Company – with one occupied here by Pepper – anchor the seating in Chrissie's study. The space also serves as a reading room and a quiet retreat, which the children sometimes use for studying. The painting between the windows is by American artist Sol LeWitt.

Chrissie's new favourite space is her own study. Previously the children's playroom, but now outgrown, this recently redesigned room is now a calm working retreat. From her desk in the corner, she has a view of the garden framed by the tall windows.

'I love it,' says Chrissie. 'Nick and I used to share a home office, but now I can lock myself away in here and quietly deal with my emails and post. I often need to catch up at the weekend and generally work from home two days a week, so it's lovely to have this special new space.

'It is a very calm room with linen curtains, seagrass on the floor and a lovely combination of white and earthy tones from the flooring, the wooden furniture and the fig tree in the corner. I wanted it to feel relaxed and comfortable, so we used big armchairs from The White Company and the Fifties stoneware lamps from Rose.'

Chrissie's trademark ottoman reappears here, too, creating a flexible, tactile surface that doubles as a stool or a place for books and magazines. Rather than a solid, hard piece of furniture at the centre of the room, it offers another layer of soft texture.

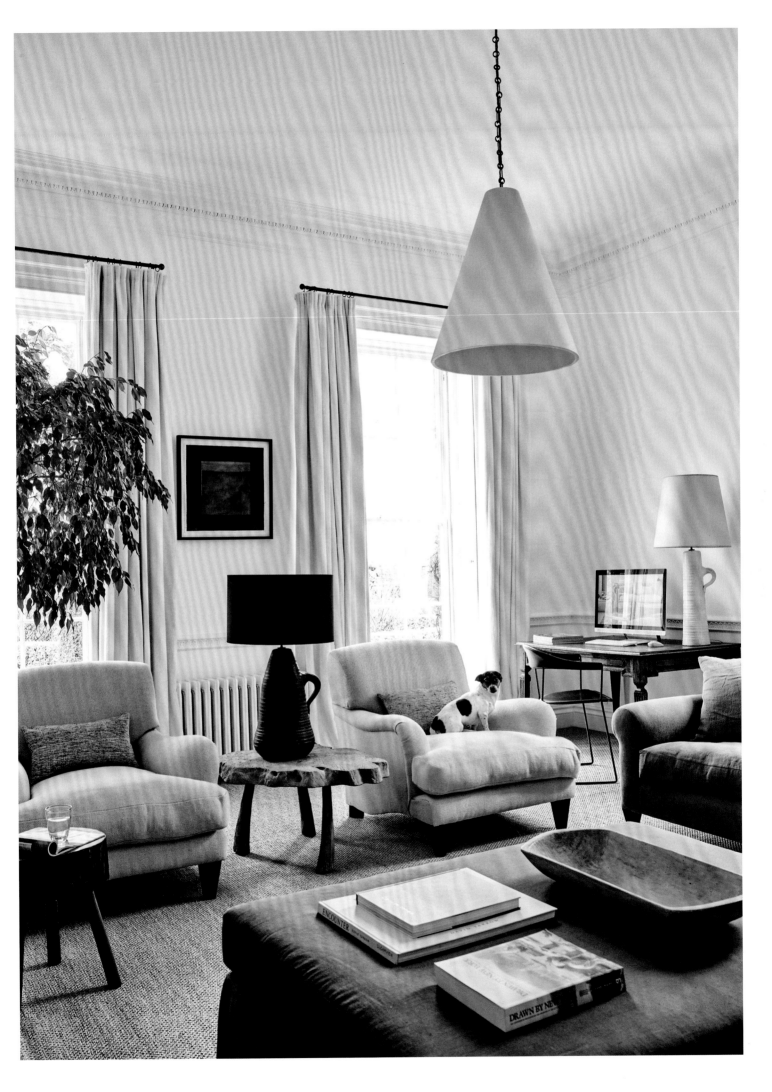

Left & opposite – A bed and an upholstered, buttoned headboard from The White Company anchor the master bedroom. Mirrored coasters on the bedside tables help to protect the surfaces, while a luxurious faux fur throw at the end of the bed softens the arrangement of linens and pillows.

Importantly, the house has evolved over many years now, to include 'new' spaces like Chrissie's study. She has continued to collect favoured pieces of furniture and art, which have also found a place in rooms such as the master bedroom. Here, Chrissie recently added an antique chest of drawers between the windows and a small number of other period pieces.

'What's so wonderful about this room is the calm neutral canvas of whites, some rustic textures and the white-on-white painting,' says Chrissie. 'So you have all these layers of whites and neutrals but then a few lovely darker pieces that help to lift the space and stop it becoming too bland.'

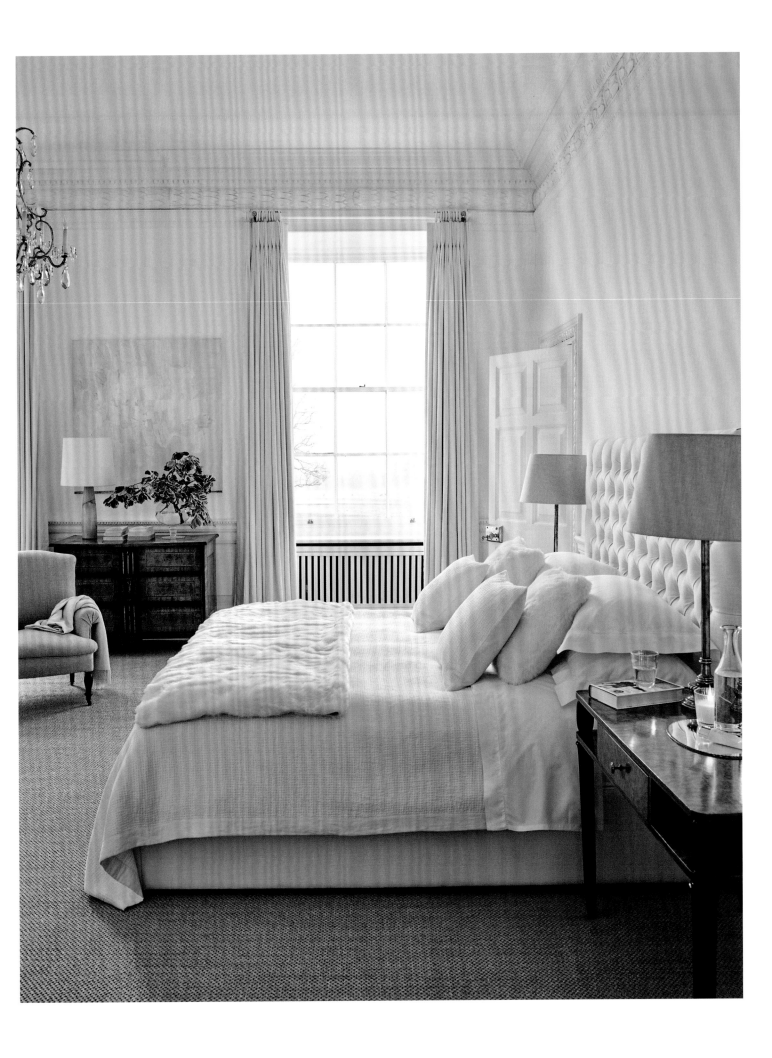

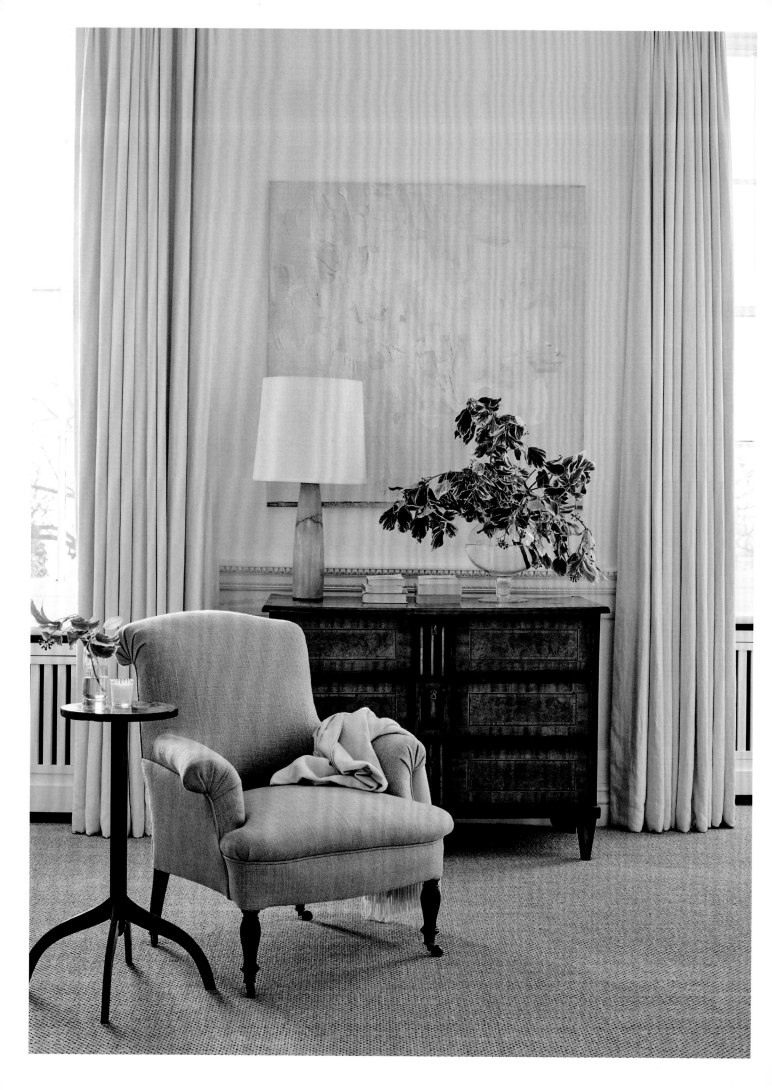

Opposite – An abstract, textural painting by Deborah Tarr floats above an antique chest of drawers between the windows in the master bedroom. Seagrass on the floors and linen at the two windows provide additional tone and texture, while keeping the palette natural and simple.

Right – A number of antique pieces in dark finishes contrast with the layers of white within the master bedroom. 'A white scheme is timeless, always relevant and provides a neutral setting for a mix of contemporary and antique pieces,' says Rose Uniacke, who helped Chrissie with a recent update of the house.

The master bedroom is a very restful, tranquil space. Sunlight from the tall windows helps to bring out the character of the original detailing, such as the cornicing and door surrounds, as well as the panelling below the dado rails. The mismatching bedside tables challenge the symmetry of the space and add the kind of character that takes the room beyond the rigorous perfection of a hotel bedroom.

The large painting by Deborah Tarr, from Cadogan Contemporary, is a particular favourite with its combination of textures and tones in a similar colour spectrum. It is one of a number of abstract pieces that Chrissie and Nick have collected that explore similar themes and variations on particular palettes. 'I love the fact that the painting is unframed, as well,' says Chrissie. 'It's so quiet and feels perfect for a bedroom.'

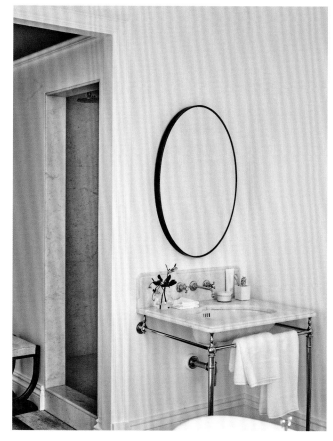

Above – The small table by the bathtub in the master bathroom is a walnut and oak candle stand, dating from the early 19th century. The marble sink is custom-made, while the oval mirror is from The White Company.

Opposite – Set in the middle of the bathroom, with its reclaimed oak floor, is the freestanding bathtub from Drummonds, with Volevatch taps. The sculptural child's chair by the window is English, from the 1820s.

Next door, the master bathroom has just been reinvented. The stone floors had begun to crack and other problems had surfaced, so Chrissie asked Rose to remodel the room. A marble shower enclosure sits discreetly to one side, but the glory of the bathroom is the sheer sense of space and light, with the sculptural bathtub taking centre stage sitting beneath a French Art Nouveau ceiling light from the Twenties.

'I love the balance in this room,' says Rose. 'The bath has been placed in the centre, lined up with the window, so that the view can be enjoyed. It feels incredibly luxurious to have a bath with a view, I think, and to that extent the room needed little more than the right bath with a few pieces of simple furniture. It feels clean and minimal, but with a touch of age. In a scheme as simple as this, whichis stripped back to the bare essentials, everything is exposed to scrutiny and everything has to be right. So the nickel tap stand, for instance, with its exposed pipework, is both functional and beautiful. The dark, oak furniture roots the room nicely.'

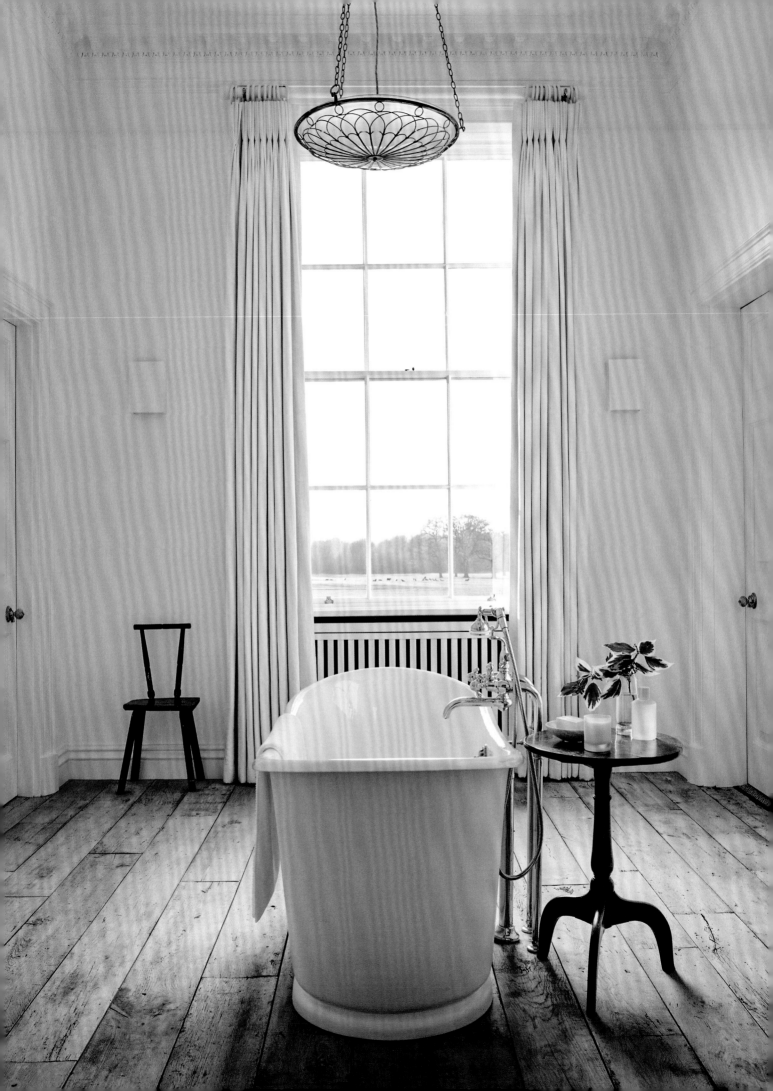

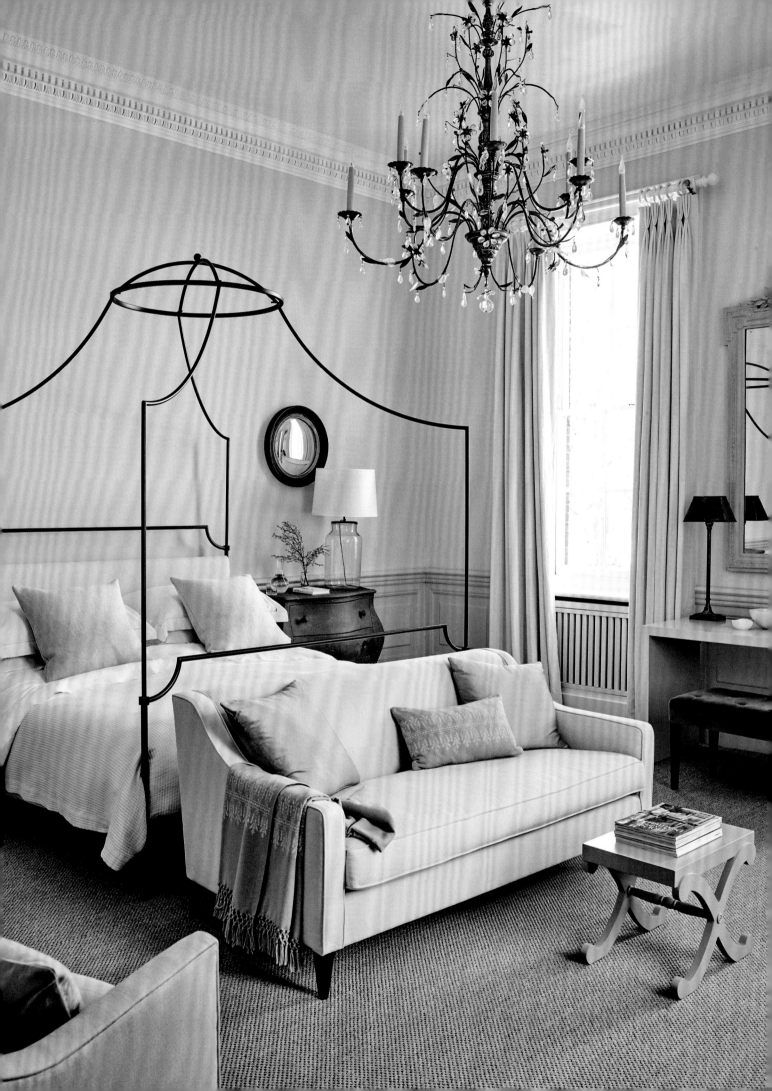

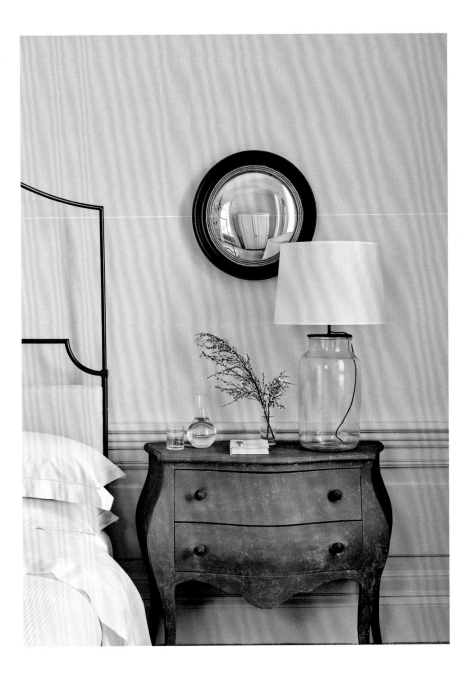

Opposite & right – A soft grey and white colour scheme continues through this guest bedroom, where a combination of a small but comfortable sofa and armchair creates a relaxing and inviting retreat. The small chests of drawers that serve as side tables are contemporary pieces in the French style with distressed paintwork, while the lamp bases were made with vintage glass ginger jars. The campaign bed and chandelier are from Ann Boyd.

For Chrissie, it was particularly important in this country house setting to create guest bedrooms and bathrooms that are inviting and welcoming. These are thoughtful and considerate spaces, designed with a sense of empathy and attention to detail. Yet, at the same time, they also serve as places to test out ideas and different combinations of textures and tones.

In this guest bedroom, the tall campaign bed and the introduction of a chandelier help to reduce the overall sense of height in the room and make it feel more intimate and relaxed. The dressing table and mirror also suggest a level of thought and understanding about what visiting family and friends might need from such a space. The small sofa at the end of the bed is a setting for quiet reflection. The palette here and in the other guest bedroom is white, neutrals and soft greys, with the darker shades featured in some of the furniture and the decorative accents such as throws and blankets.

Styling details

— FOR YOUR GUESTS —

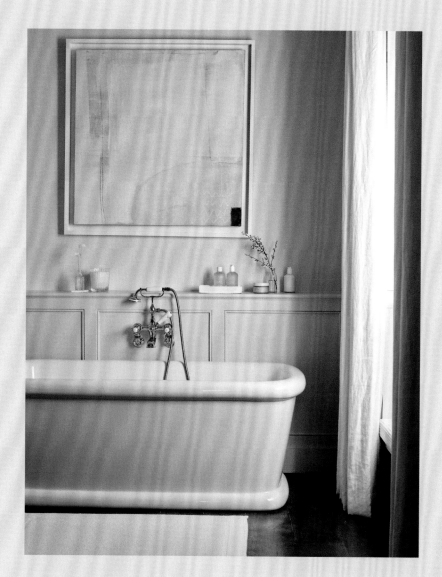

FINISHING TOUCHES

The guest bathrooms and bedrooms are restful and relaxing places where a degree of empathy is all important when it comes to the little, thoughtful details that make time spent here feel special. Layers of white and natural tones combine with soft textures, including a freshly laundered bathmat and a selection of towels, and lovely scented bath and body treats. The painting over the Albion Bath Company tub is by Kate Hunt.

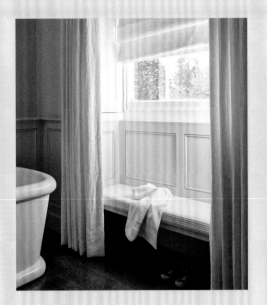

SOFT & GENTLE

One of the delights of this country bathroom is the layering of gentle textures. Soft, clean towels and slippers complement the linens of the blinds, curtains and cushion on the window seat.

NATURAL NECESSITIES

Thoughtful gestures speak volumes in a guest bedroom. A carafe of water, a few books and a simple sprig of greenery from the garden all help to create a feeling of welcome.

SENSORY PERCEPTION

In this guest bathroom, many of the finishing touches are sensory, including the fresh greenery, a scented candle and diffuser, as well as lovely spa-like bath and body treats.

FRESH & FRAGRANT

A crisp, white bathrobe is a key element on the checklist for the perfect guest bathroom. 'When friends come to stay, I want them to feel like they have escaped for a restful break,' says Chrissie.

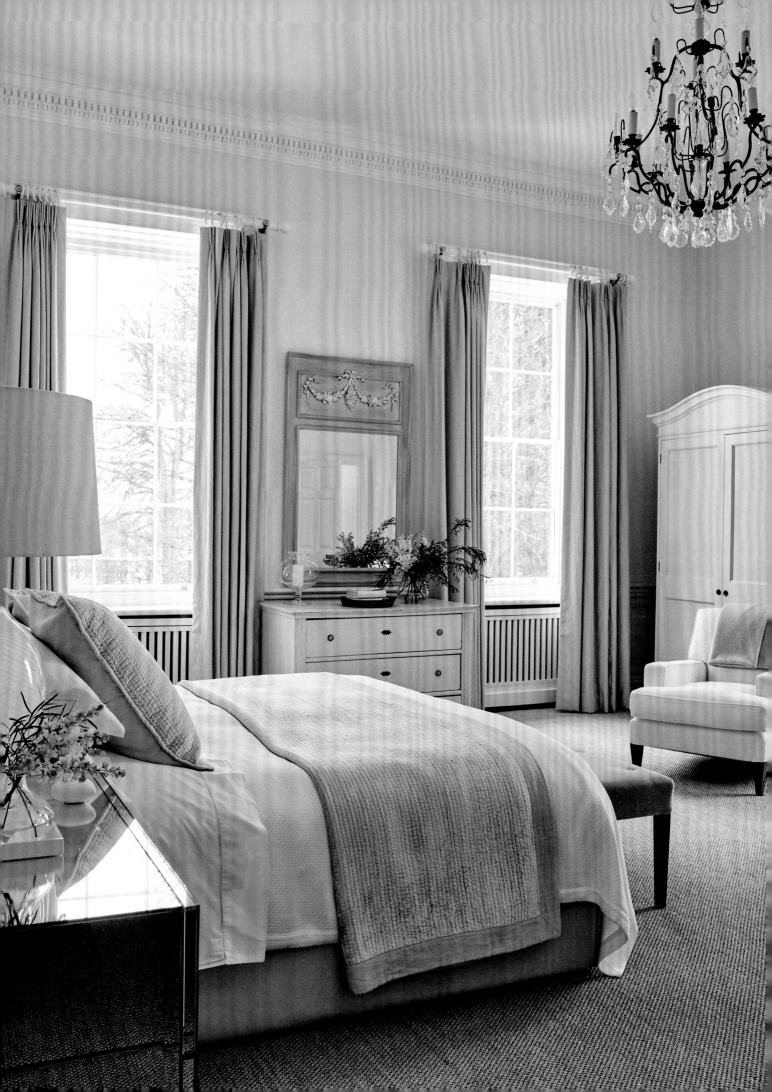

Opposite – The gentle pale grey and white theme continues in this guest bedroom, with its painted furniture and textural layers. The reflective surfaces of the crystal chandelier, French mirror and mirrored-glass side table and glass lamp bases help to circulate the light. The wardrobe was designed by Ann Boyd.

Above – On the bedside table, a scented candle from The White Company sits alongside a recycled glass candle holder, which has been cleaned and repurposed to create a matching vase for seasonal foliage.

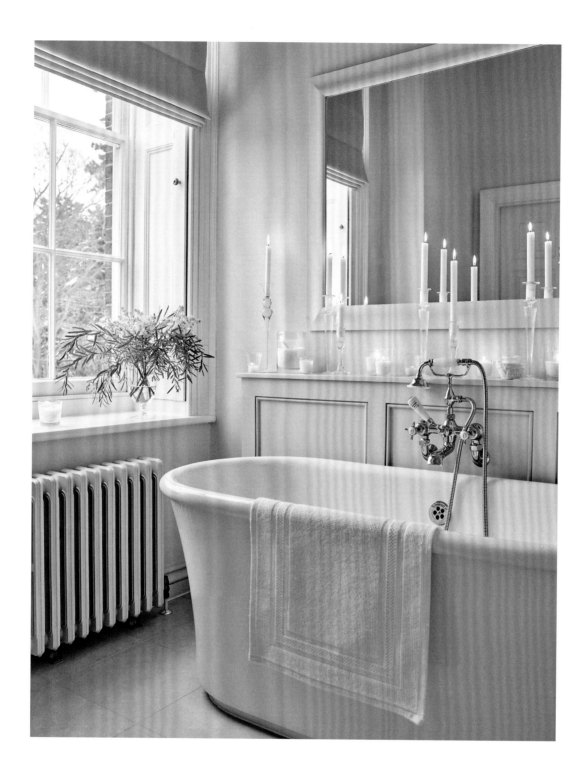

Above – Scented candles, tealights
and candlesticks, reflected in the
mirror, impart an escapist atmosphere,
transforming this bathroom into
a restful home spa. The deep-sided tub
is from the Albion Bath Company.

Opposite – The use of mirrors in this
relatively small bathroom helps to
create a greater impression of space,
circulating the light from the window, as
well as the candlelight. Placing the oval
mirror opposite the window also gives
a pleasing reflection of the trees outside.

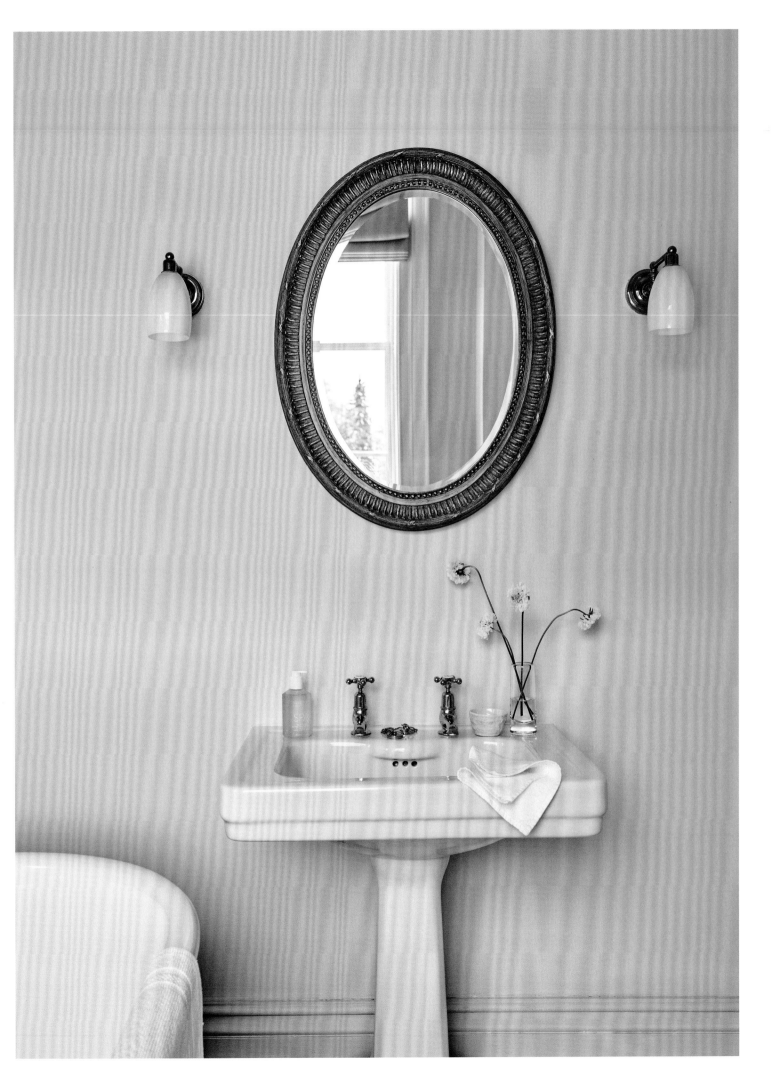

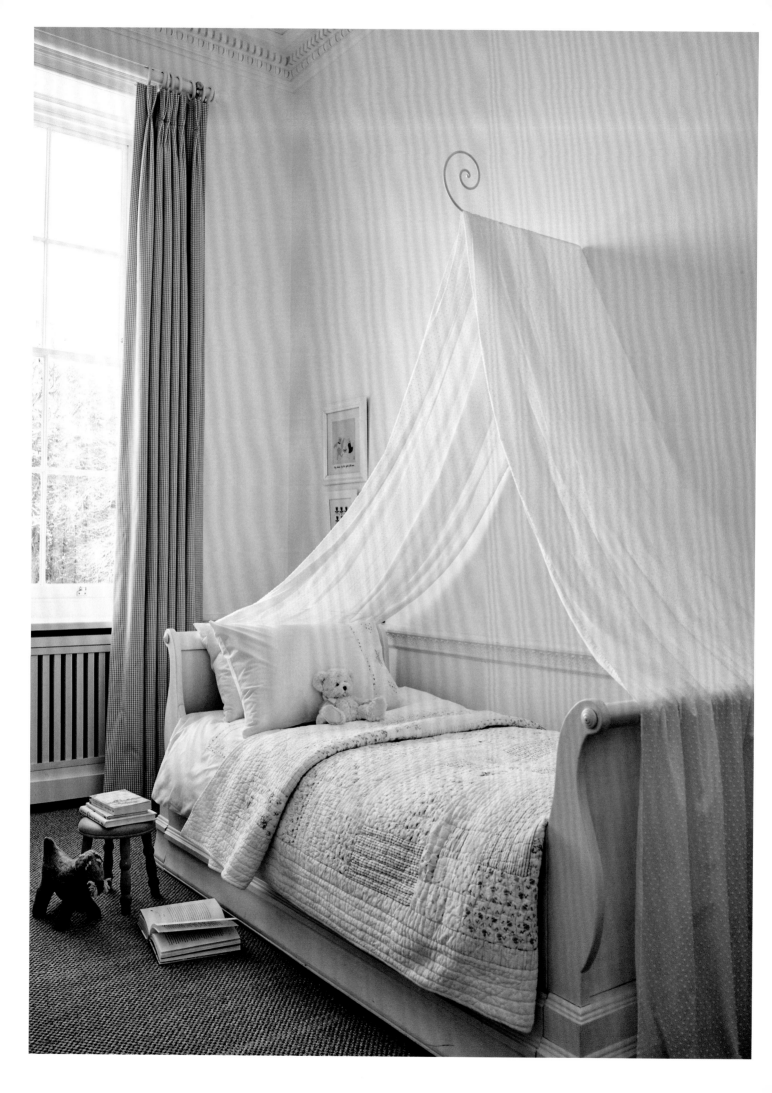

Opposite & above – This bedroom was
designed for Chrissie's daughter India.
The vintage bedding is by The White
Company, while the three pictures are
by Willemien Stevens.

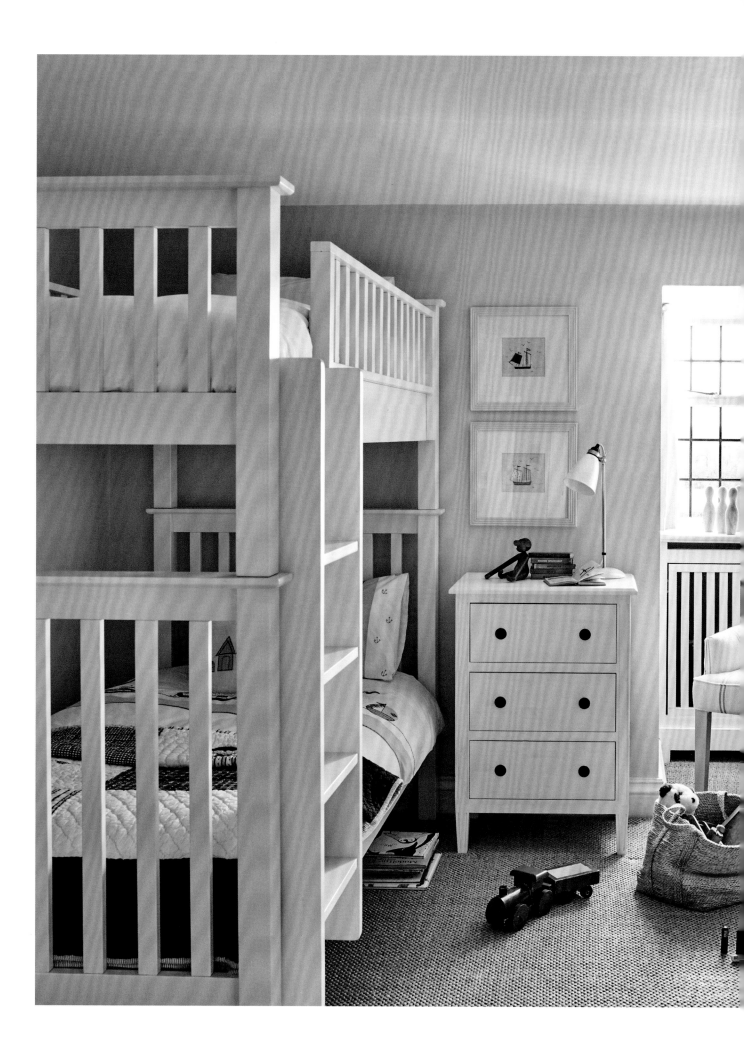

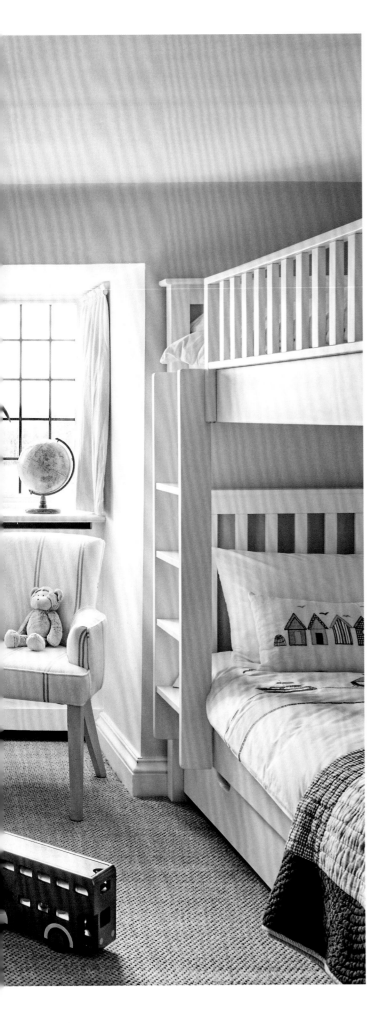

The children's bedrooms offered the chance to create joyful, playful spaces, while also responding to the needs of the family. When her daughter India was younger, Chrissie created a feminine, romantic haven for her. The room has a vintage French sleigh bed with a simple, diaphanous canopy floating above it. Pink highlights in the bed linen and the pink curtains are in tune with the look and feel of the room.

The other children's rooms are on the top floor of the house. The ceilings here are lower and the windows smaller but the bedrooms have an appealing scale and a cosy feel. Chrissie created a bunk room for her son Tom when he was smaller – a place where friends could come to stay and enjoy the escapism of being at the top of the house.

The Rest

— AN INVITING RURAL RETREAT —

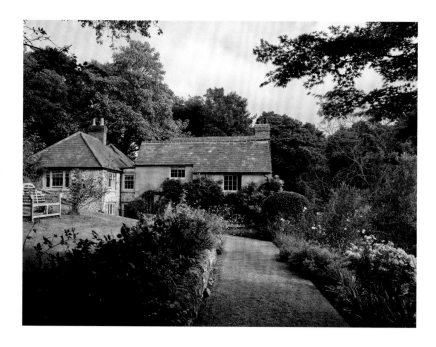

This Sussex farmhouse, where Mark Winstanley, Chief Creative Officer of The White Company, his wife Sally and their two children have their home, was once known as 'The Rest'. It seems more than appropriate for such an idyllic setting on the edge of the South Downs and not far from Charleston, the country seat of the Bloomsbury Set. Surrounded by mature trees and terraced gardens, the house offers a view across to the rounded flint tower of the neighbouring church.

Parts of the flint and brick house, which served time as a tavern for many years, date back to the 17th century. The previous owners extended the house to the rear but in a sympathetic style.

'It started life as a cottage but grew over time and now has that farmhouse quality that we love,' says Mark. 'With the interiors we wanted to play with the materials, the natural palette and more rustic textures that have this sense of character and longevity. There's nothing terribly delicate or too precious, which suits the house.'

Above – The Rest sits within lovingly restored and maintained terraced gardens on a gentle hillside overlooking the local church. The newer part of the house, extended by the previous owners, is to the left, nestling up against the trees, and is in complete sympathy with the original building.

Opposite – A generous floral display on the concrete garden table makes a welcoming gesture in the entrance hall, drawing the eye further into the house, towards the curving staircase. The collage of reclaimed French hexagonal floor tiles gives way to lime-washed wooden floorboards.

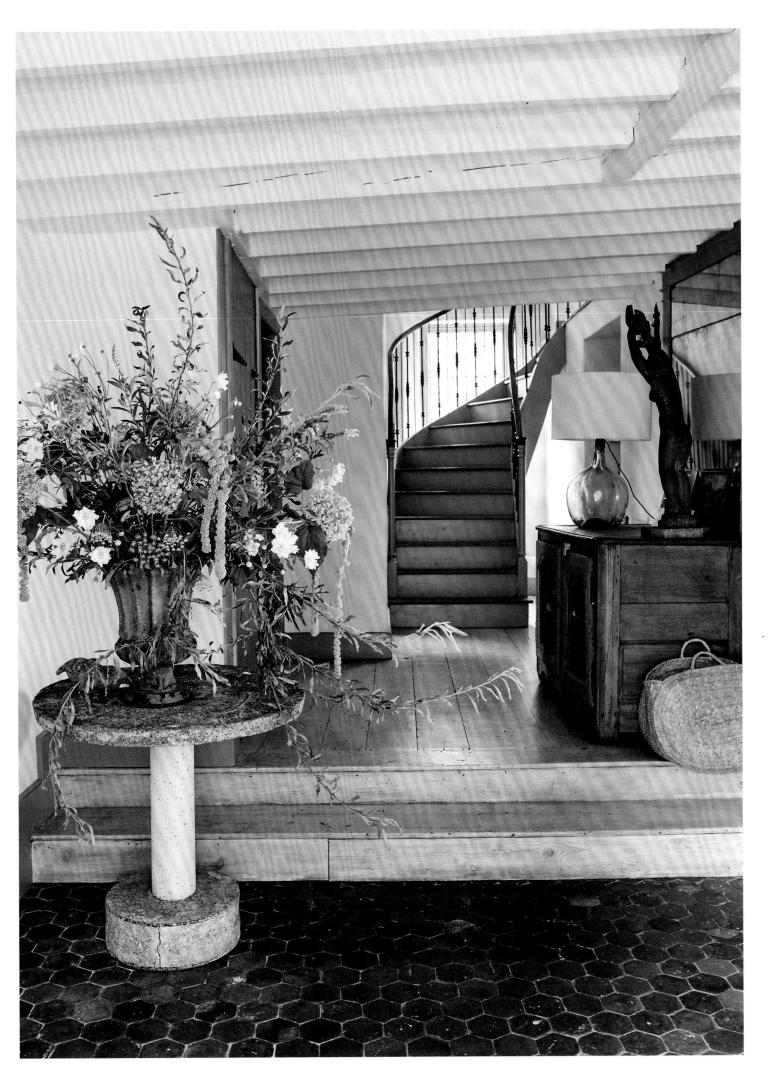

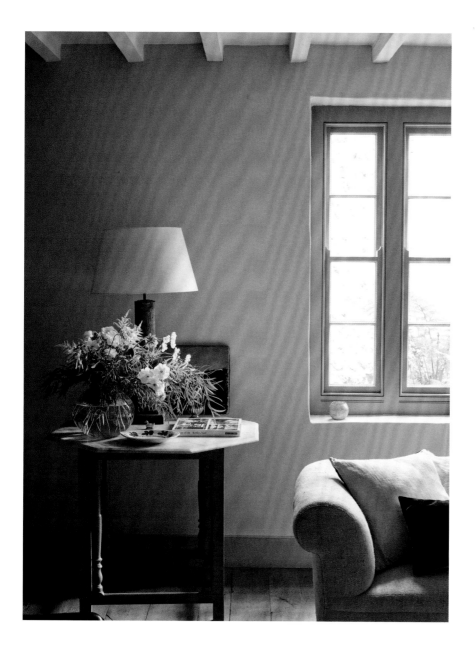

Left – Multiple side tables in the sitting room are opportunities for decorative displays and table lamps, which provide subtle, warm lighting at night. The windows, framing glimpses of the garden, are left deliberately bare, so that they let in as much natural light as possible.

Opposite – The lime-plastered walls in the sitting room are a soft shade of white, like the ceiling, with the exception of the principal wooden crossbeams. This creates a subtle backdrop for layers of texture, from the linen-covered sofas and cushions to the wool rugs.

The entrance hall (see previous page) is not only welcoming but also helps to set the tone for the house as a whole. Lime-plastered walls painted white form the foundation, along with lime-washed wooden floors, while the curving staircase adds a sculptural element, picked out in grey and black for contrast. Mark has assembled a mix of old and new pieces, with a focus on texture, such as the wooden chest, which serves as a console, and the weathered concrete garden table. On the floor inside the front door, reclaimed French hexagonal tiles add a splash of colour, as well as being practical in such a rural setting.

'Something that is very important to us is how the house flows together overall,' Mark says. 'We want rooms and spaces to connect together naturally without jarring, so the hall is the beginning. It is nice to have a surprise now and again but even the surprises should feel right. White is certainly the foundation and the plaster walls do help soften the colour and give it warmth.'

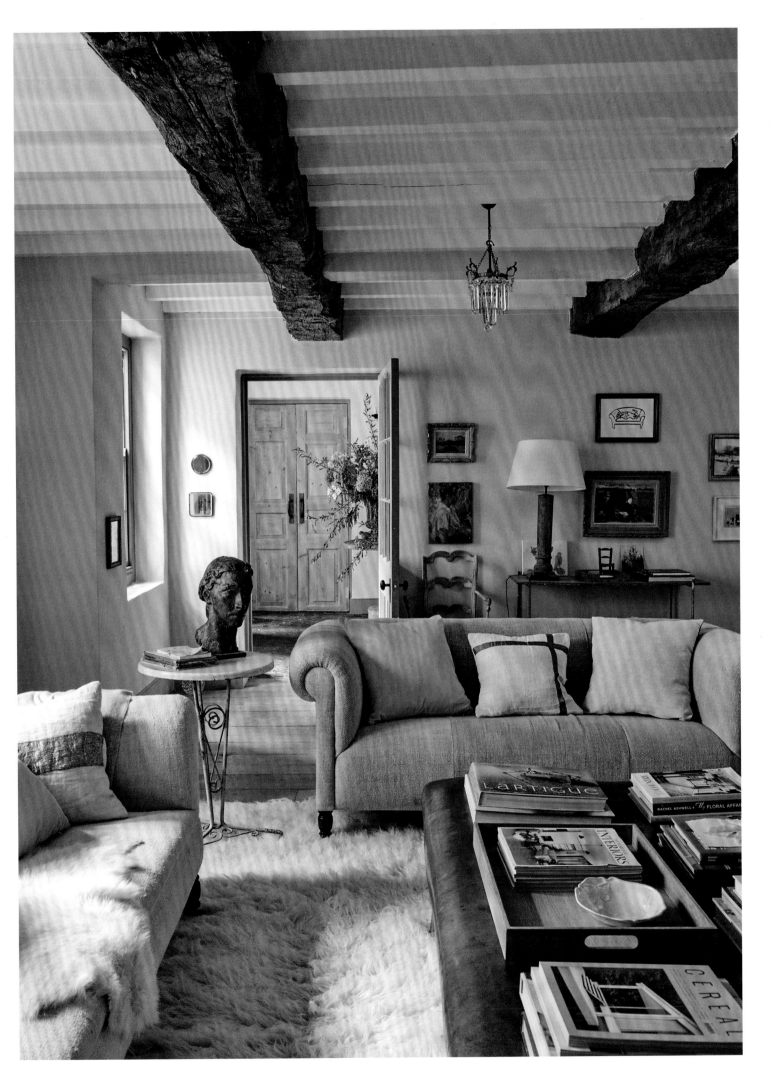

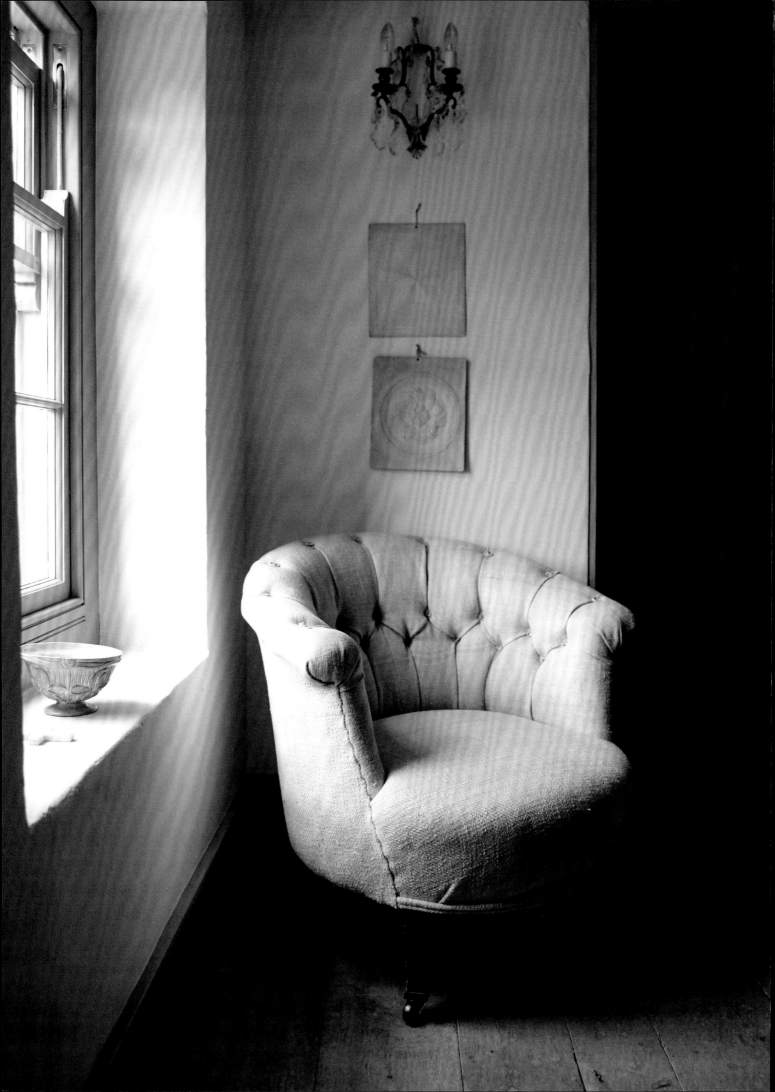

Opposite – Mark and Sally love vintage
fabrics and textiles, such as linens, ticking
and old grain sacks with their raw charm.
This armchair on the landing has been
covered in off-white linen, which lends
textural interest and accentuates the
sculptural shape of the chair.

Right – Art is another family passion, with
Mark and Sally often opting for collections
and collages of small pieces rather than
large canvases. Here, in the sitting room,
the picture on the wall behind the console
features a number of portraits, landscapes
and a favourite Hugo Guinness linocut.

Overleaf – The long refectory table closest
to the kitchen range is one of a pair that
serves as an island for much of the time. For
larger gatherings, it is brought back into use
for dining, positioned alongside its twin.

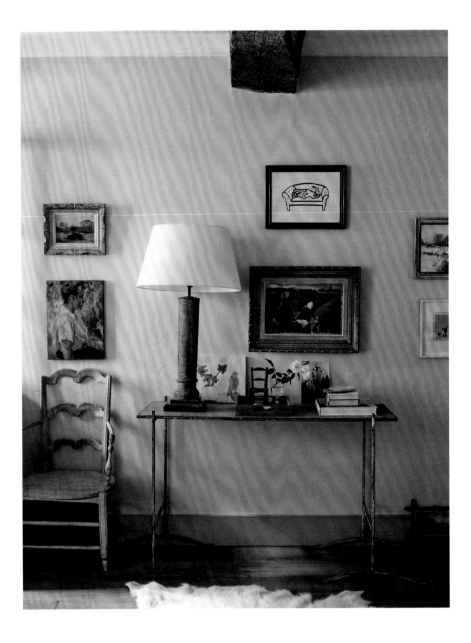

The layers of texture in the main sitting room are provided by natural materials
– wood, linen and the sheepskin rug – which are all in shades of white, helping to
tie the eclectic elements of this room together. Purposefully, there are no curtains
at the windows, enhancing the sense of light, but also framing a characterful flint
garden wall.

'It's not all about pure white here, but more about living with white and neutrals
as a backdrop and then adding these layers of texture and textiles,' says Mark.
'But I also like the idea of having rooms that are all about sitting down and being
comfortable so that you just read, talk, listen to music. That has always been an
overarching thing for us – making spaces that feel comfortable and lived in rather
than precious.'

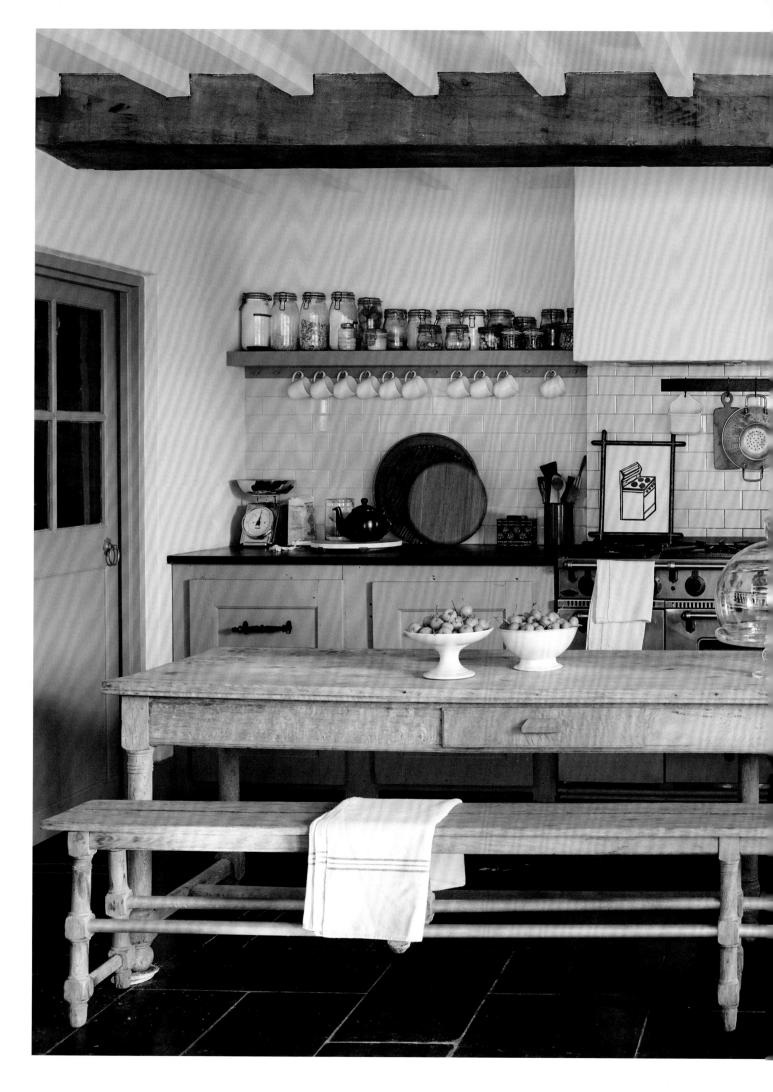

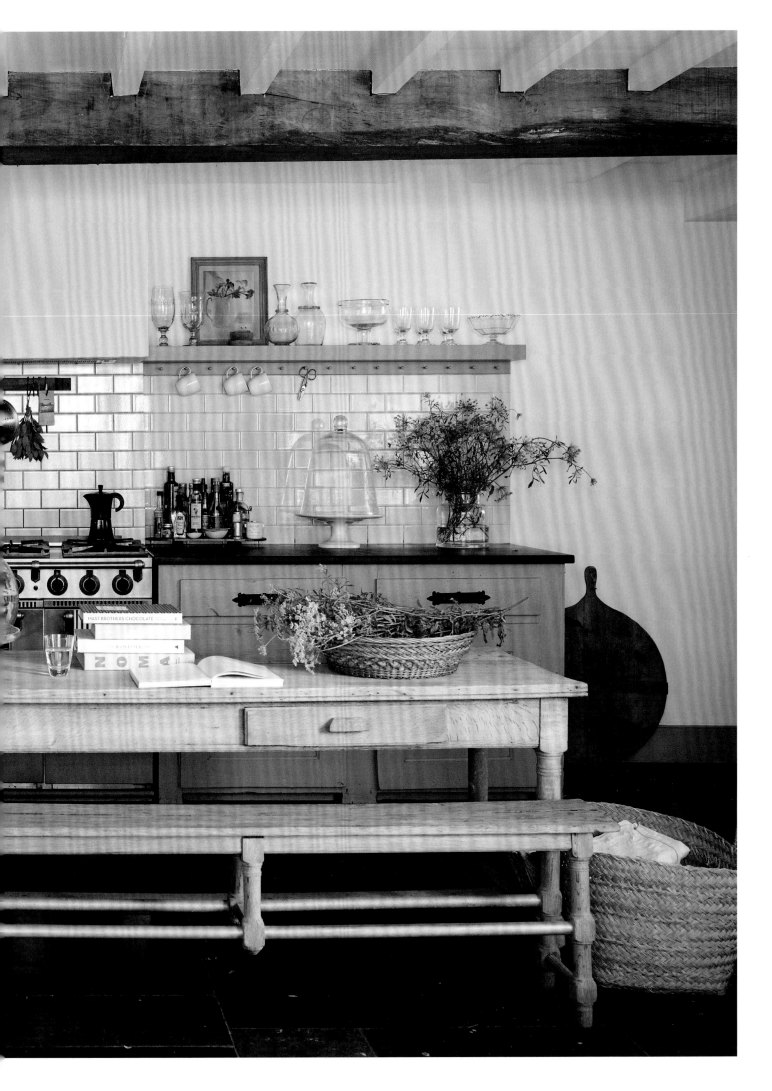

Styling details

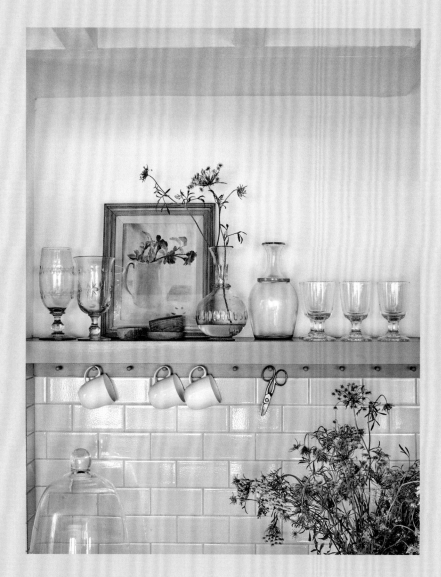

ART OF GLASS

The chunky wooden shelf above the white subway tiles hosts part of Mark's growing collection of glassware, both old and new. Two of the vases hold flowers from the garden, which stand out beautifully against a simple palette of whites and greys. Just as delightful is the small painting by Tessa Newcomb, propped up against the wall. Its subject matter – a small vase holding a simple gathering of flowers – is particularly appropriate in this setting, with themes connecting, overlapping and echoing each other.

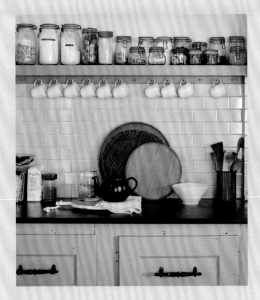

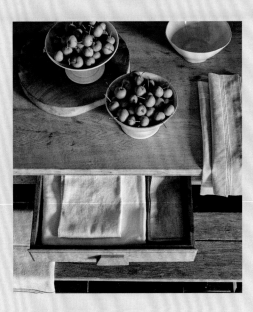

STILL LIFE

The rows of glass storage jars, both big and small, hold kitchen staples such as seeds and pulses. As well as being practical, the jars act as miniature frames for textures and tones.

LAYERED LINENS

The recessed drawers of this old refectory table make practical storage for napkins and table linen. The combination of the linen fabric set against the raw wood of the table creates the perfect textural treat.

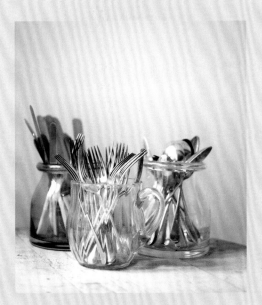

PRÊT À MANGER

A triptych of glass jars, filled with knives, forks and spoons, makes useful storage in the kitchen, yet also forms an engaging composition. Easy to bring over to the dining table, the jars are pleasing and practical to use.

ECHOES BY DESIGN

The horizontal lines and layers of the shelves, surfaces and tiles create a sense of order, but there are some playful thematic echoes at work, including the Hugo Guinness print of a stove to one side of the real range.

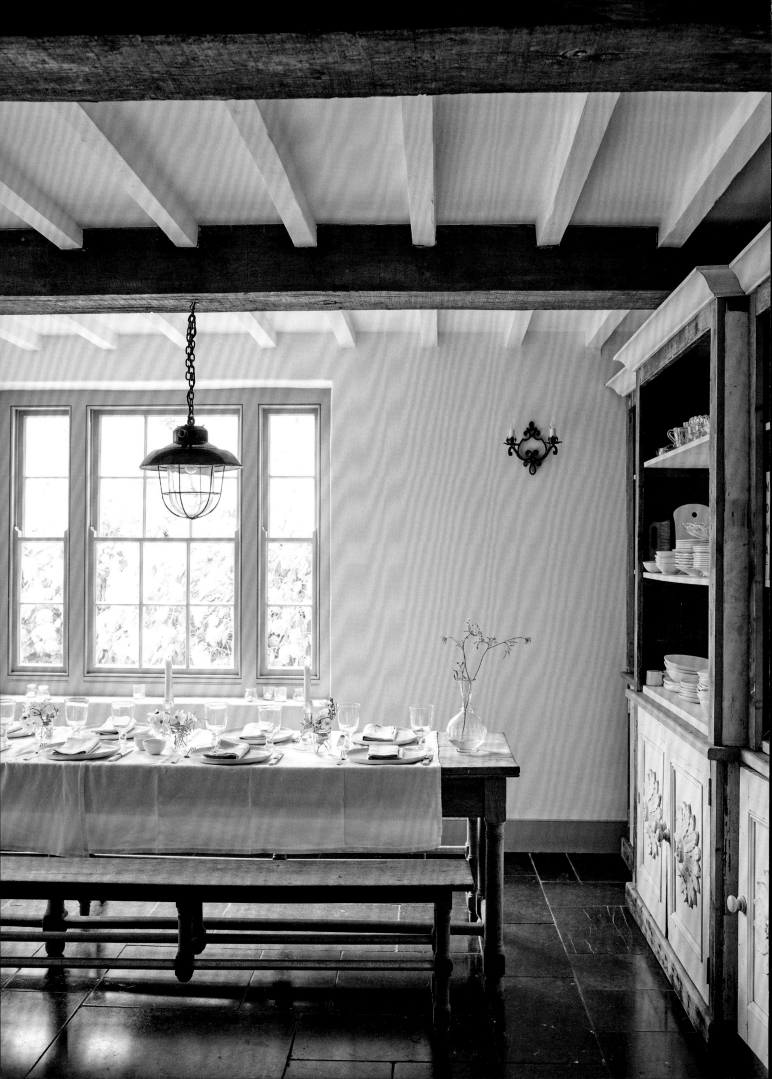

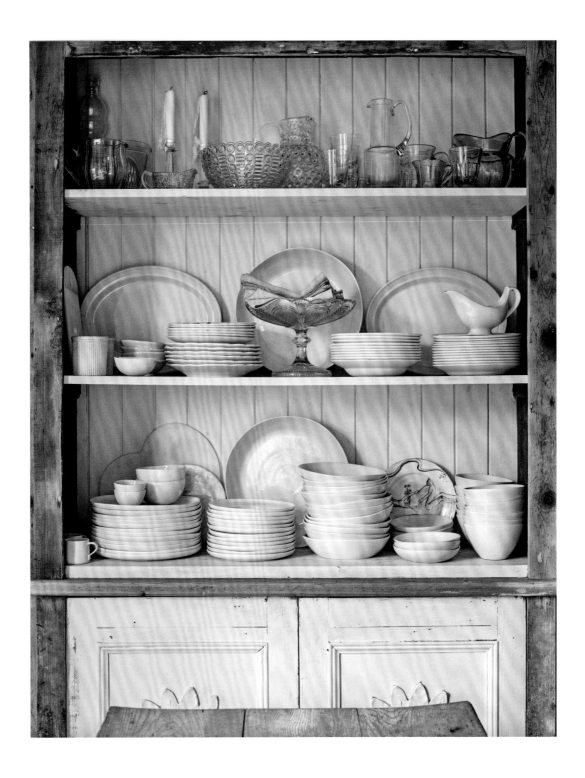

Opposite – The welcoming kitchen is large enough to double up as both a cooking and a dining space. Two former refectory tables, which were once housed in a convent, fit into the space easily, with one usually serving as an improvised island, while the other, positioned by the window, is the family dining table.

Above – To one side of the kitchen/dining room, the white-painted fitted dressers, with their surrounds left natural, are of great practical use, as well as an attractive opportunity for display. The shelves and cupboards are loaded with white china, cookbooks and a small portion of Mark's extensive collection of glassware.

Styling details

— IN THE KITCHEN —

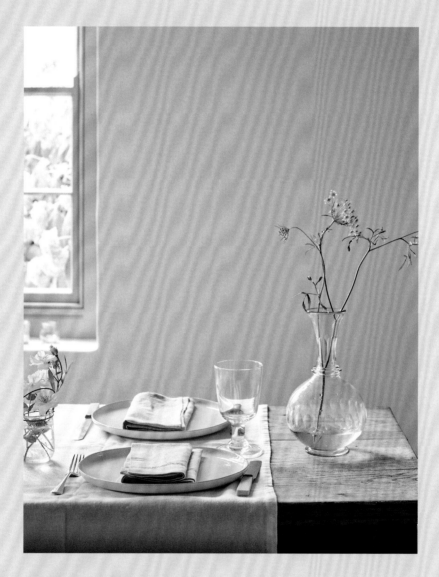

GARDEN TABLE

Positioned next to the window that overlooks the garden, the long, vintage refectory table makes the perfect setting for summer lunches and evening meals. The windows offers a framed view of the greenery outside and, in this setting, simple table displays of plants from the garden seem highly appropriate, with sculpted stems and small cupped blooms emerging from shapely glass vases. Using simple white table linen and stoneware plates, from The White Company, ensures that the greenery takes centre stage.

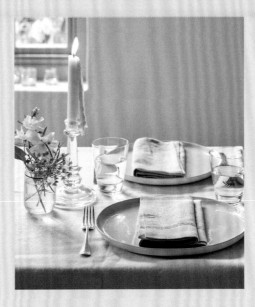

COMPLEMENTARY DISHES

This neat pairing of two ceramic dishes creates a pleasing composition as a result of their different sizes and irregular handmade qualities. The bone-handled spoons add another textural element.

LIGHT TOUCHES

One of the easiest and most elegant ways of bringing a dining table to life is with candlelight, which provides instant warmth. The soft, flickering light is a treat for the senses.

MULTIPLICATION & DIVISION

Layering of textures creates depth but also softness. Piled on a vintage glass bowl on the dresser shelf, the folded linen napkins in neutral tones are in easy reach of the dining table.

STACKS & TONES

Conveniently stacked in piles on the dresser, the stoneware plates and bowls make an attractive display. On the table, the plain white crockery allows the food to take centre stage.

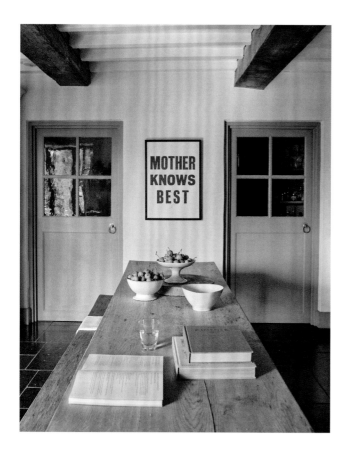

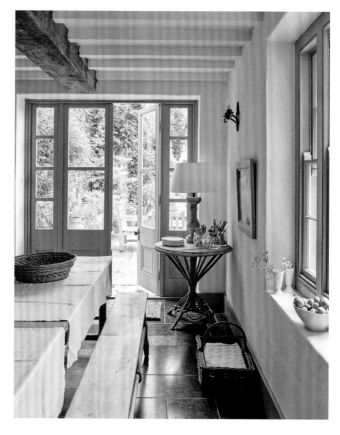

Above – The kitchen and dining area remain
relatively uncluttered and peaceful, thanks to
not only the fitted dressers and cupboards,
but also the two 'engine room' spaces – one
a utility room, the other a pantry.

Above & opposite – French doors in one corner
of the kitchen open onto a sheltered terrace and
the garden beyond. This sense of connection is
all-important in the warmer months, when there is
constant traffic between inside and out. The glass
doors add valuable natural light, while above the
vintage Belfast sink are reclaimed mirrored panels
that reflect sunlight all around.

The spacious kitchen, which leads out into the garden, is very much the heart of the home. This is in the new part of the farmhouse, but the reclaimed black slate floors and the unpainted wooden beams lend the space a rustic feel. The overall colour scheme here is black and white, with black slate also used for the kitchen worktops, and the subway tiles, walls and ceiling all in white. The grey of the units produces a softening effect, as does the greenery.

The two refectory tables are the 'anchors' of the room and, being a pair, create a sense of balance and order.

'We love the size of the tables and that we can have one for prep and one for meals,' says Mark, 'but the joy of it is that we can also put them together for larger gatherings so there's a lot of flexibility. And, as a family, we like the fact that they are quite narrow, which means that meals are still quite intimate when you sit opposite one another.'

The benches are just the right length and complement the tables perfectly. 'They are wooden but have these steel scaffolding tube supports running through them, which I have never seen before,' Mark explains.

The Godin range, a French semi-professional stove, is at the centre of the working part of the kitchen, arranged against one wall, while a large Belfast sink stands next to the French doors. Its backdrop of patterned blue and white tiles, peeling paint and reclaimed mirrors gives a simple rustic edge, in keeping with the origins of the house.

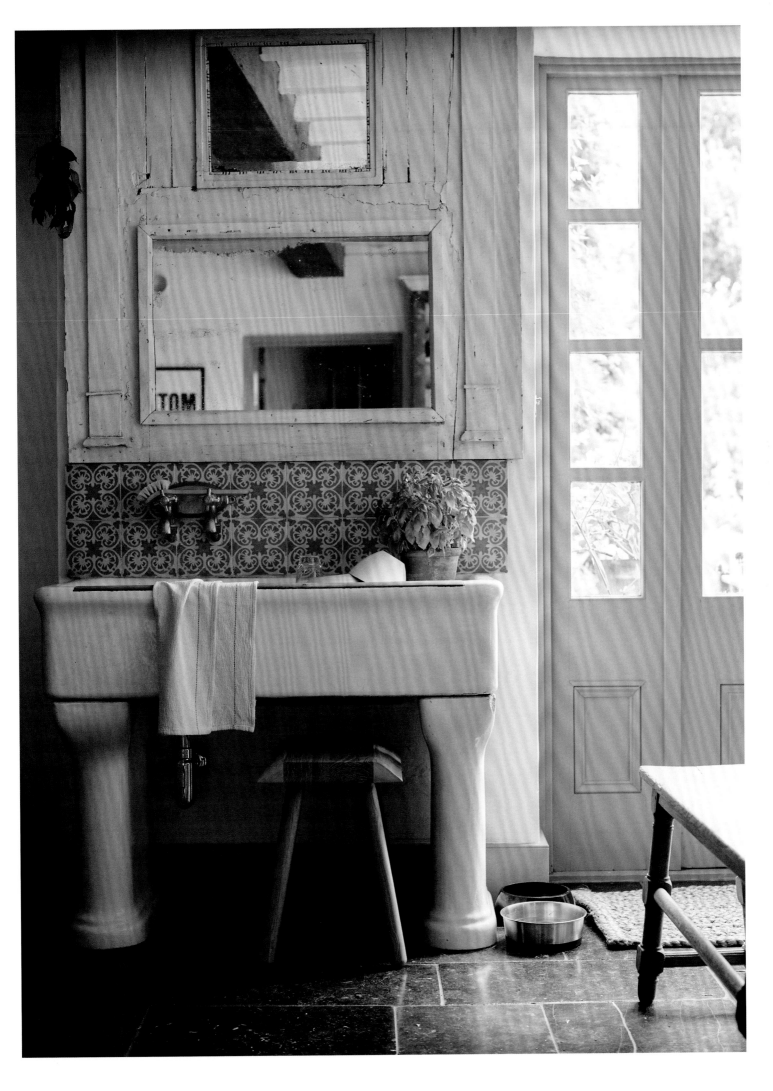

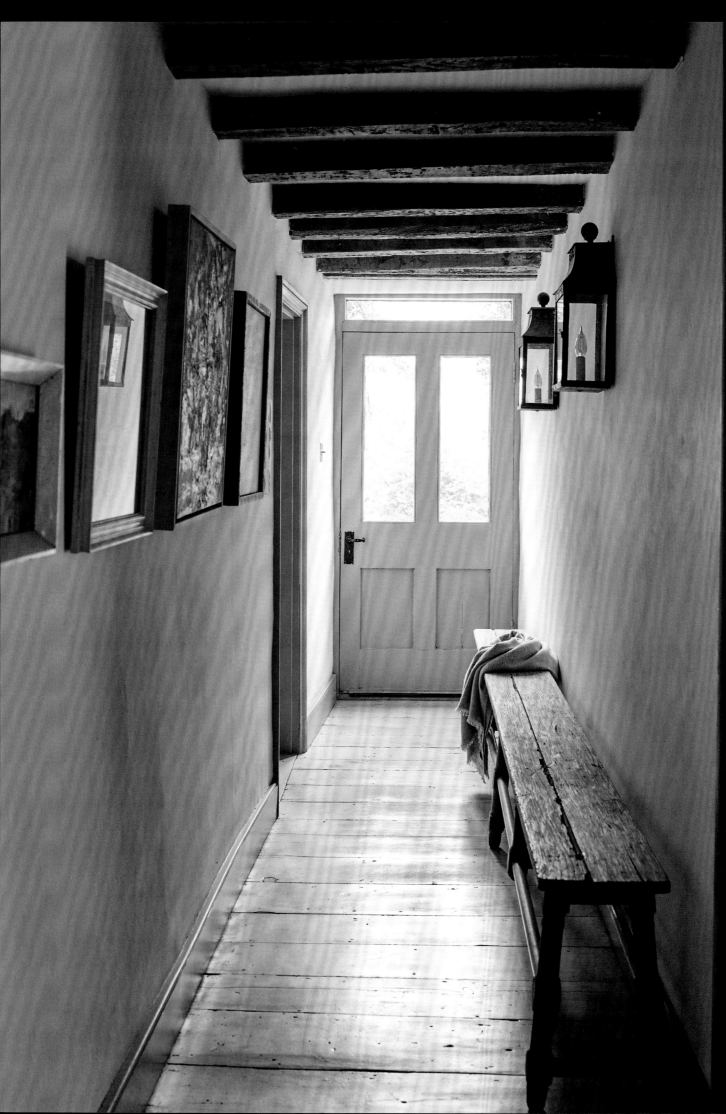

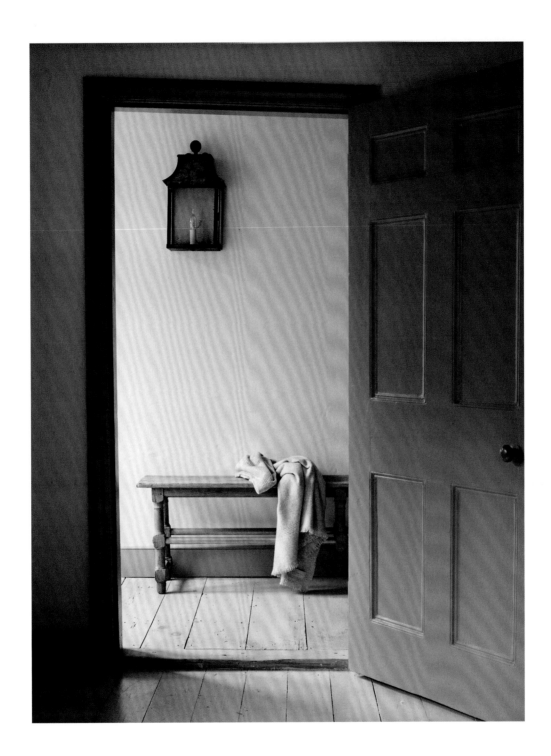

Opposite – The hallway leading to the back
door doubles up as a display space for art, with
the sequence of frames neatly aligned at the
base. As well as having aesthetic value and
complementing the crossbeams above, the
vintage wooden bench is a practical addition
for putting on and removing muddy boots.

Above – The shifts in colour and texture in
the hallway are subtle but important, creating
pleasing contrasts between the old wooden
floors, the bench and the lime-plastered walls.
The doorways and woodwork are painted
a gentle grey, so that they stand out against
the white walls and floorboards.

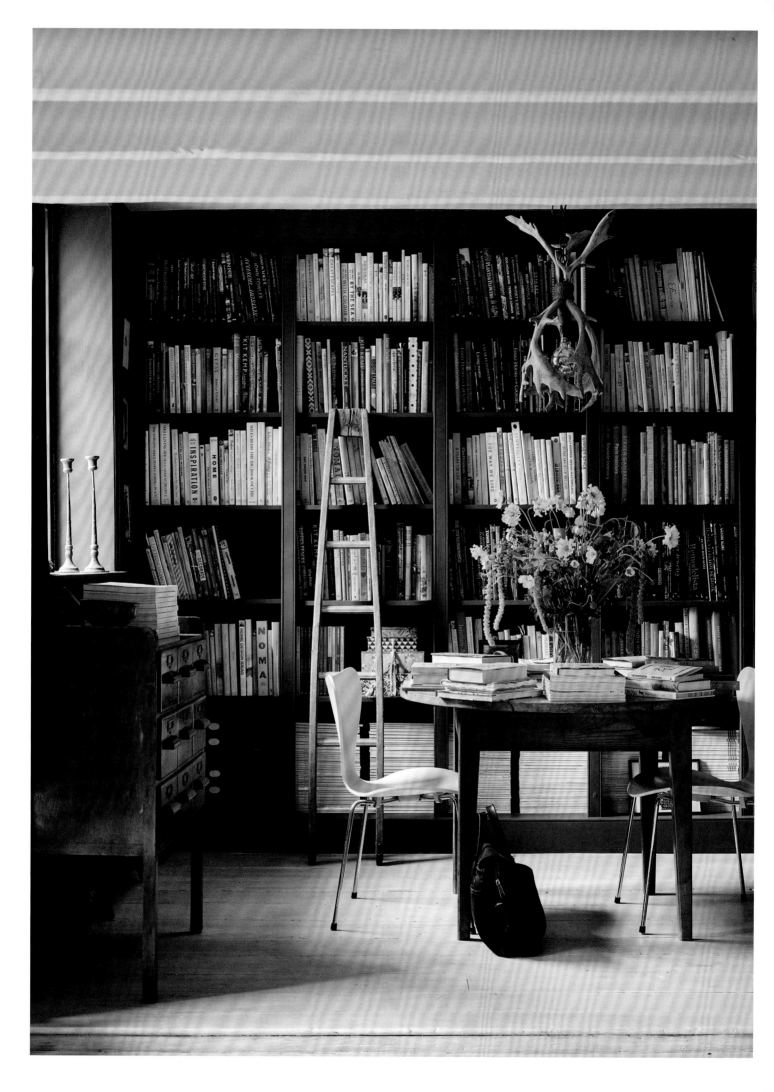

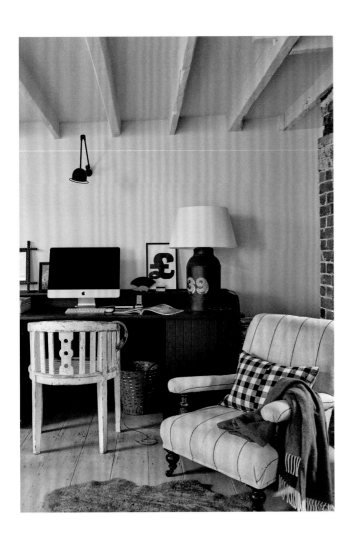

Opposite & above – The combined study
and library offers a quiet retreat for working
and reading. Mark's collection of books has
been colour-coded on the fitted shelves,
while the black and white colour scheme
seen in other parts of the house has been
adopted for the work station to one side.

Above right – The winding staircase
connects the main hallway to the master
bedroom and other rooms in the new part
of the house. An architectural feature in its
own right, this salvaged piece forms a focal
point at the heart of The Rest.

At one end of the study, floor-to-ceiling bookshelves,
picked out in Nearly Black by Farrow & Ball, frame Mark's
extensive library of design, architecture and interiors
books and magazines. The study is spacious enough to
house not only a reading table with a couple of chairs, but
also a separate work station and comfortable seating, too,
for whenever peace and quiet is called for.

'For me, books do make a home, as you can see from
both the library and the sitting room. It's your own personal
collection of all the things you have read and all the things
that inspire you,' says Mark.

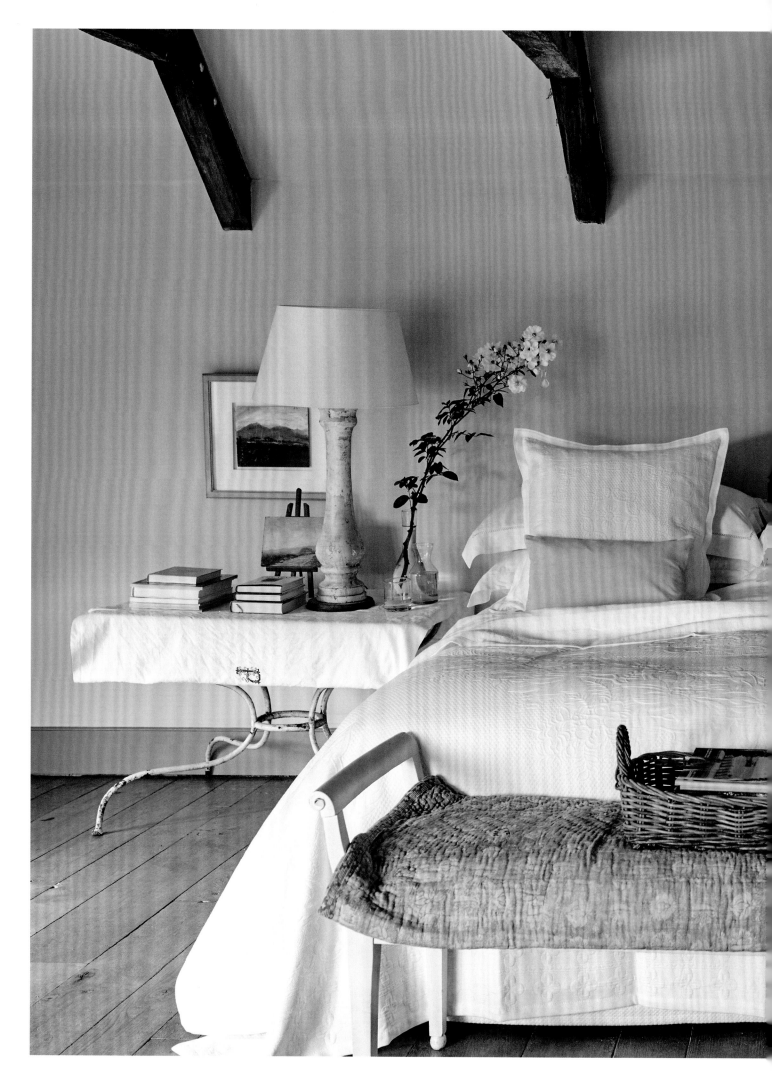

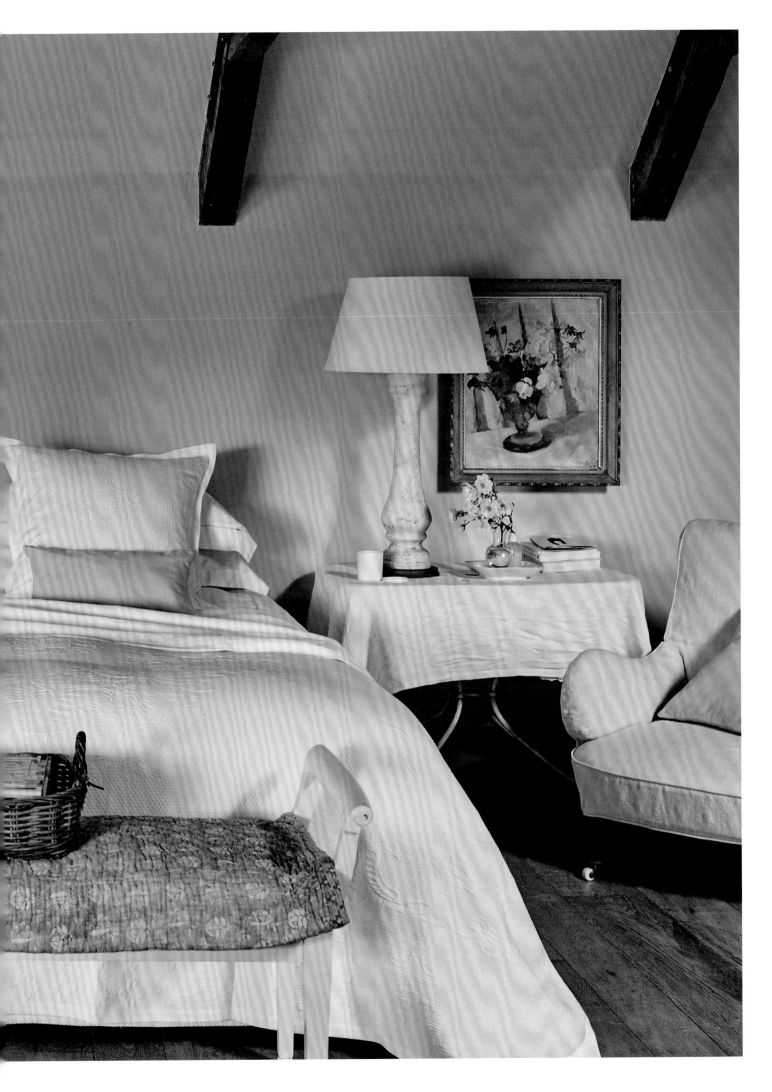

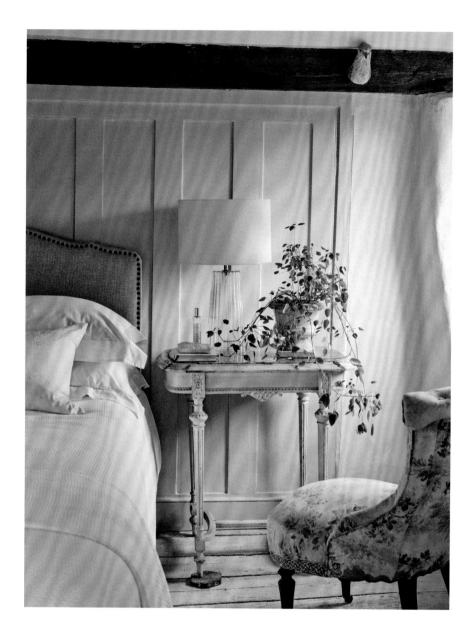

Previous pages – The master bedroom, in the new part of the house, is particularly generous in size, with high ceilings and exposed beams adding to the sense of space. Although they are not the same height or design, the vintage bistro-style metal tables make a delightful pair of informal bedside tables. Covered in linen with monogrammed embroidery, they are large enough to accommodate a table lamp, water glass, vase and books.

Left & opposite – The style of furniture and the faded floral fabrics give more of a French feel to the guest bedroom. This is a welcoming space and, like the master bedroom, its crossbeams are revealed, making it feel light and airy. The plants on the bedside table and side table, hewn from a tree trunk, bring the garden inside.

The master bedroom (see previous pages), in particular, benefits from the luxury of space, as well as views out to the garden. The walls have just a touch of blue mixed in with the white, while the layered vintage pale linens on the bed and draped over the bedside tables add subtle touches of textural pattern and depth. Meanwhile, the reclaimed floorboards ground the space.

The guest bedroom has something of a French feel, with a panelled and painted wall behind the French-style bed, and faded fabrics used for the upholstery offering subtle floral notes.

'There is a slight French quality throughout the house and especially in the bedrooms,' says Mark. 'We both love France and French architecture and that pale Provençal colour palette. It's also about the character that comes from age and imperfection. There's a little bit of texture and colour here and there, but the foundation is always white.'

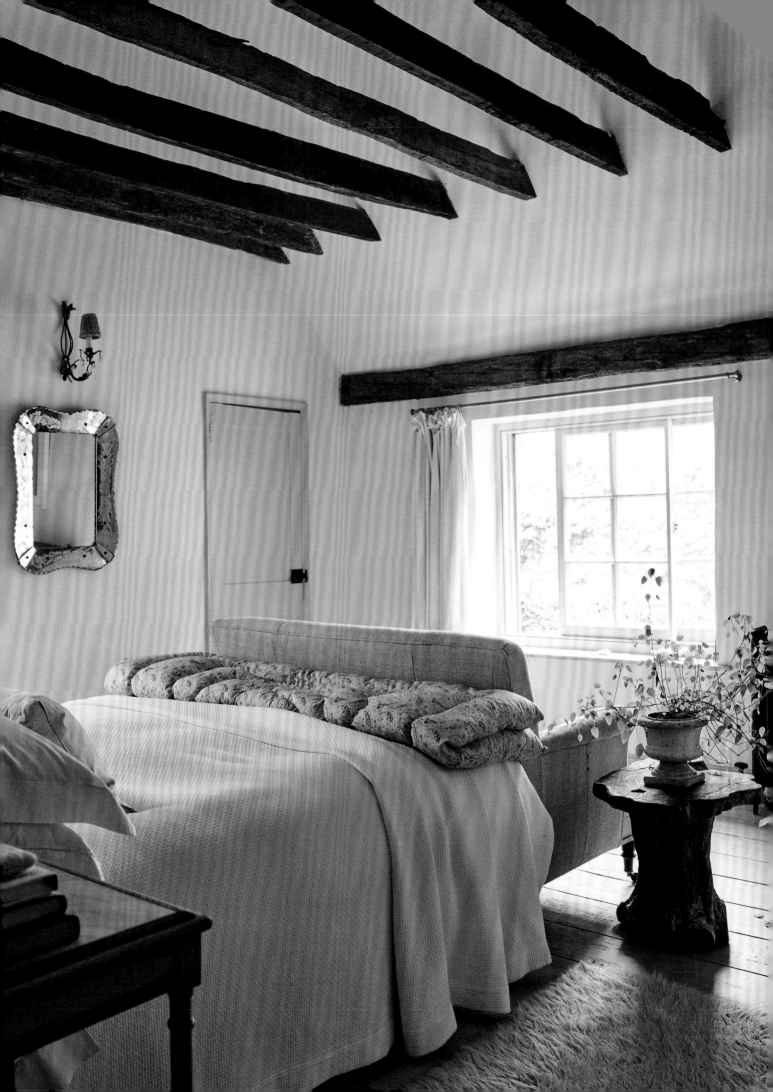

Styling details

— FINISHING TOUCHES —

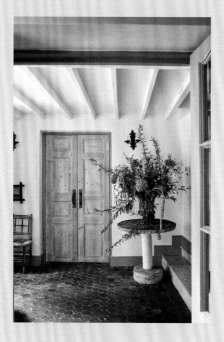

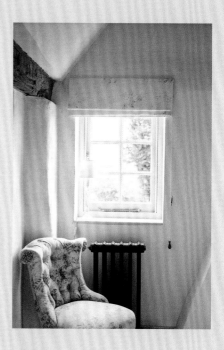

FLORAL NOTES

Mark always keeps a floral display, by way of welcome, in the entrance hall to his home. This thoughtful gesture helps to set the tone for the house as whole, suggesting a place of warmth and hospitality, echoing the history of The Rest as a tavern.

TWIN TALES

These antique mouldings hang on the wall of the landing, forming an understated vignette characterized by slight shifts in colour and texture. The display, with the vintage armchair, turns an unappreciated area into somewhere special.

FADED GLORY

The Roman blinds at the window of the guest bedroom were made with a floral fabric. The bolder colours have all faded, leaving just traces on the bleached linen, but they sit well with the subtle patterned upholstery on the slipper chair.

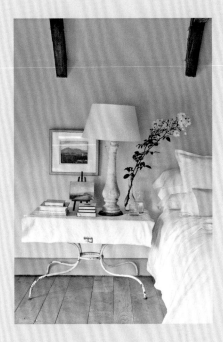

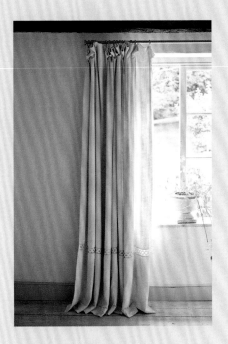

ART IN MINIATURE

Mark and Sally take delight in the small pictures hung low by the bed in the master bedroom. Like a gallery in miniature, the mountain scene hanging on the wall is complemented by a tiny landscape on an easel on the bedside table.

GATHERED THOUGHTS

The curtains at the guest bedroom window, overlooking the garden, pool in gentle folds on the wooden floor. The white, unlined linen is translucent, which allows the sunlight to filter through the fabric, adding to the ethereal effect.

PRESSED LINENS

This vintage English larder cupboard has been imaginatively repurposed as a linen press in the guest bedroom. The mesh doors, which have been left unpainted inside, allow framed glimpses of the pressed bed linen behind them.

A Photographer's Haven

— TIMELESS LIVING IN A RURAL SETTING —

For a photographer who is immersed in image-making and, very often, colour in her working life, her rural Oxfordshire home is a place of retreat. Here, the focus is very much on natural and neutral tones, offering a complete break from the intensity of the creative process.

'I have always been drawn to neutral colours at home, apart from an earlier chapter in my early twenties, when I painted a whole room deep purple with golden stars on,' says the owner of this farmhouse. 'For me, it's a timeless way of decorating a space that doesn't anchor a room in any particular moment or place.'

Above – The windows in this country house look out onto the garden and open farmland beyond. To make the most of the available light and the views, most of the windows are either left bare or dressed very simply.

Opposite – In the converted barn, the main sitting room offers drama and a sense of space. Comfortable armchairs are arranged at either side of the wood-burning stove, but there's also room for a large reading table behind the sofa.

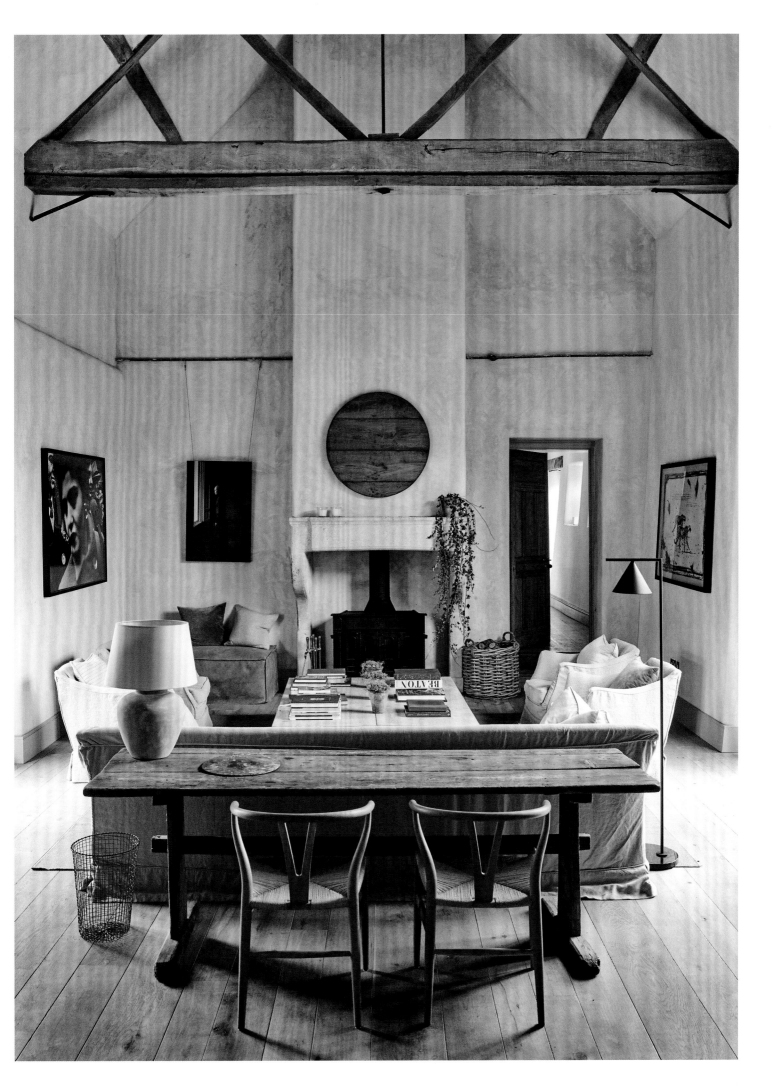

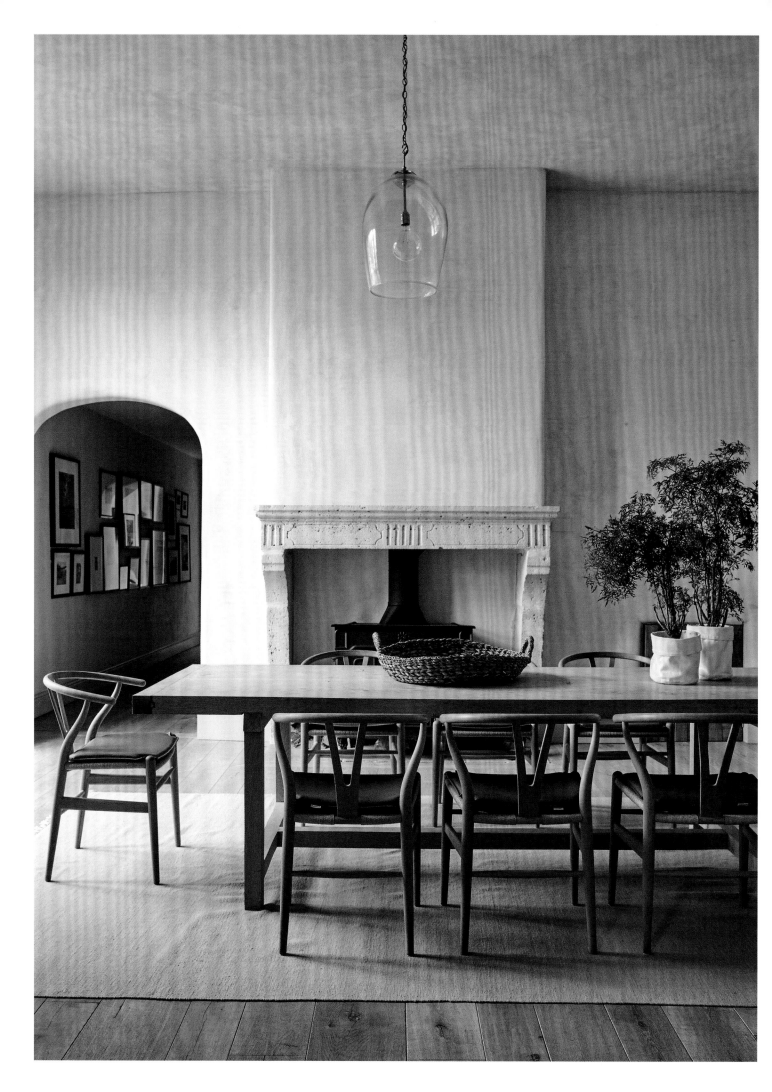

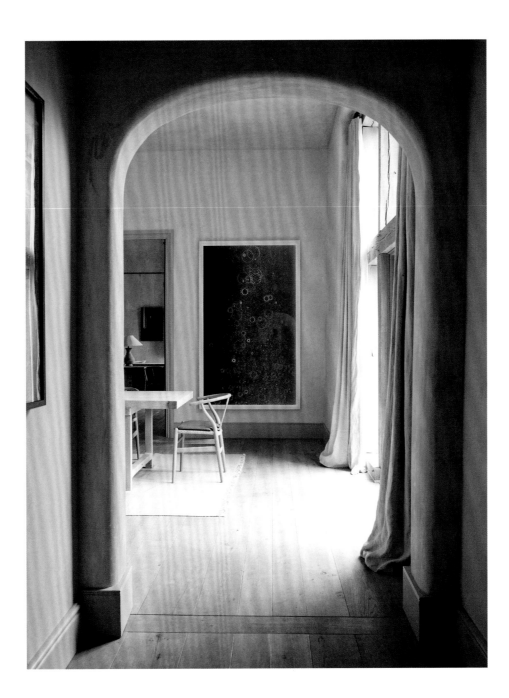

Opposite – The lime-plastered walls create
a soothing backdrop in the dining room, which
features an oak table by the Belgian company
am designs and Wishbone chairs designed by
Hans Wegner. The salvaged stone fireplace was
found in Belgium.

Above – The entrance to the dining room
from the hall has no door, to open out the
space and allow an uninterrupted view of
the large photograph by Adam Fuss on the
bare plastered wall. Beyond the dining table
is a glimpse of the sitting room.

Styling details

— THE ART OF DISPLAY —

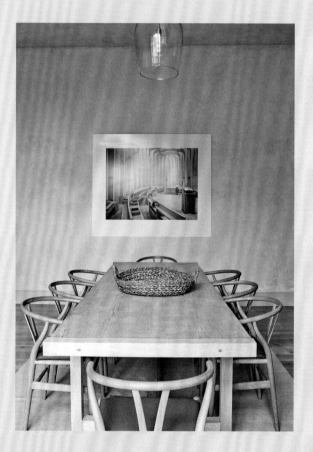

FOCAL POINTS

The parallel lines of the wooden dining table
lead the eye to the black and white photograph
on the lime-plastered wall. As well as accentuating
the importance of the artwork, this placement
creates a pleasing sense of balance and symmetry.

BLACK & WHITE

Displayed in the hallway is a collection of black
and white aviation photographs. The pale walls
and simple mounts and frames allow the images
to stand out, while the overall collage is neatly
contained within a loose rectangular framework
that becomes an installation in itself.

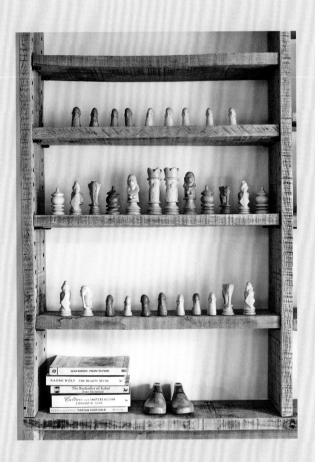

SHELF LIFE

Rustic wooden shelves serve as a picture frame for a collection of carved stone chess pieces. The sculptural and artistic value of these personal treasures is underlined by their thoughtful display on the ladder-like shelving.

GREEN SHOOTS

Garden cuttings take on a fresh resonance against the backdrop of the soft, pale tones of the plain, plastered walls and the limestone mantelpiece.

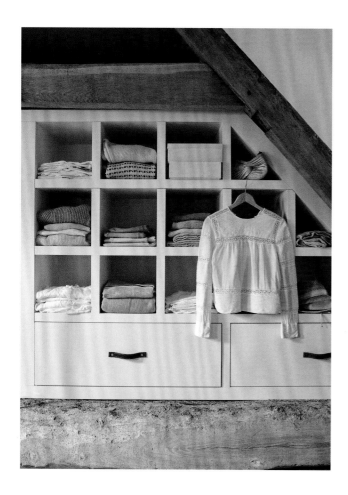

Above – A few steps up from the master
bedroom at the top of the house, the
dressing room makes the best use of all
available space, with drawers and shelves
tucked among the roof beams.

Opposite – The master bedroom is an open,
spacious room with high ceilings reaching up
to the eaves. The white palette used for the
walls and bedding sits well in a space where
the emphasis is on natural materials – in the
exposed beams, wooden floors and sisal on
the stairs leading to the dressing room.

Parts of the original farmhouse date back to the 17th
century, while the adjoining barns are Victorian additions.
The house had been updated and the barns partially
converted by the previous owners, which allowed the
photographer and her husband to build upon strong
foundations for themselves and their two children.

One of the most striking rooms is the main sitting room
in one of the barns – a double-height space with a feature
fireplace, oak floors and lime-plastered walls. The choice
of natural materials throughout the house forms an essential
part of its character for the family.

'There's something about these materials that resonates
in a certain way for us. As we are steered increasingly
towards a digital environment, these natural materials
become more and more important to remain in touch with,'
the owner says.

The neutrality of the walls in the house, which are either
lime-plastered or painted a soft, chalky white, form the
perfect backdrop to a growing collection of black and white
photography and art. This is especially true of hallways
and circulation routes, but also of key spaces such as the
dining room.

'As a photographer, I started to acquire a few pieces about
20 years ago, and since then my husband and I have added
to the collection. Having all these great big neutral walls is
a wonderful way to hang them. I always seem to be drawn
to working in the dining room, which is a favourite space.
There is almost nothing in it, so perhaps it's something
of a self-imposed monastic retreat. But there is this lovely
natural light that fills the room, so it's always warm.'

The bedrooms have a similar sense of restraint, which
allows their essential character to shine through. Those in
the attic spaces have their original roof beams and exposed
timbers, while existing nooks and niches have been cleverly
adapted to create storage for clothes, allowing the bedrooms
themselves to remain ordered and composed.

'The master bedroom is a lovely space and the ceiling is
unusually high,' says the owner. 'The neutral colours of the
floors and walls complement the beams, and the texture of
the wood helps to give a sense of warmth.'

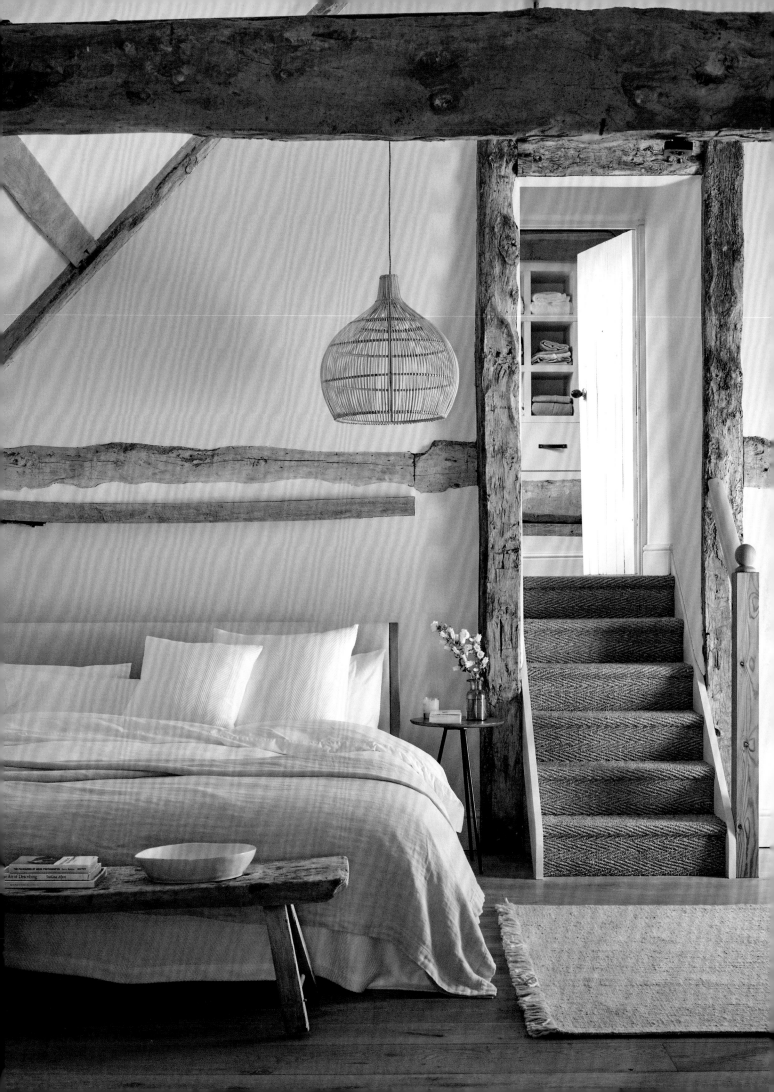

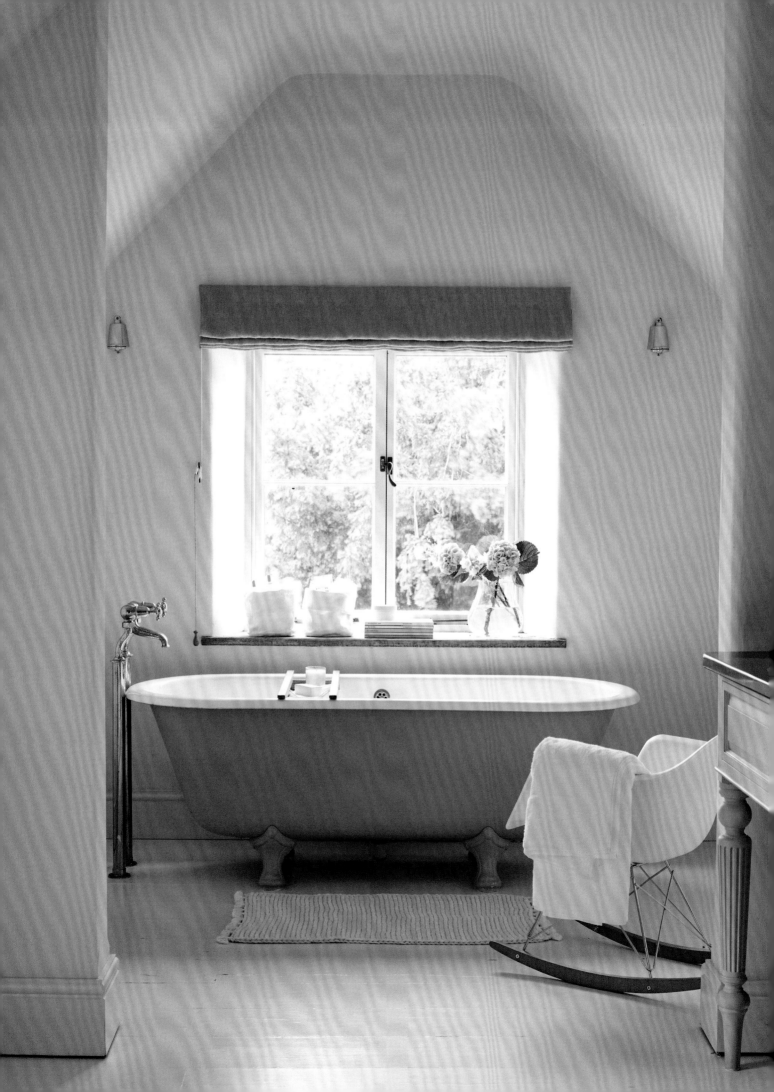

Opposite – Sourced in France, the vintage freestanding bathtub in the master bathroom is neatly centred beneath the window overlooking the garden. The sinuous shape of the white RAR rocking chair by Charles and Ray Eames, made by Vitra, sits well with the rounded contours of the tub.

Right – This rustic bench, positioned at the end of the bed in the master bedroom, is somewhere to display personal objects. The ceramic bowl, with its smooth white glaze, stands out vividly against the grain of the aged blond wood.

The bathrooms, too, benefit from a feeling of light and space. The floorboards of the master bathroom are painted white, which helps to reflect the daylight around the space. The sides of the tub, painted a gentle grey like the washstand, complement the white paintwork of the room. The mid-20th-century white Eames RAR rocking chair sits well with the period elements here, as they are drawn together by the colour palette. This helps to reinforce the restful spirit of the farmhouse overall, but there is also a degree of positive flexibility to this home.

'There is a sense of calm functionality about the house as a whole,' the photographer says. 'It allows for creative thinking but, conversely, with very little, the main living spaces can quickly change and fill up with family and friends and burst back into life.'

Styling details

— FINISHING TOUCHES —

COUNTRY SEAT

This integrated wooden window seat makes clever
use of a space that would otherwise be wasted and
is used to best advantage dressed with a selection
of comfortable, textured cushions. A window
unencumbered by curtains or blinds allows the
view to be fully appreciated.

BATHING BEAUTIES

Simple cotton canvas baskets with a fold-over
rim from The White Company are an easy and
attractive way to keep bathroom staples tidy.

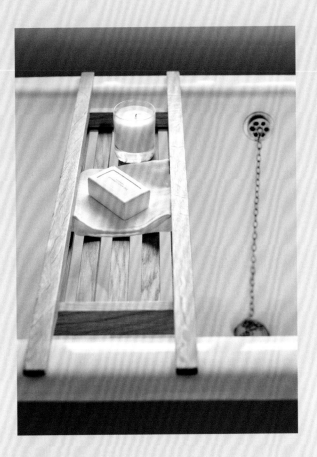

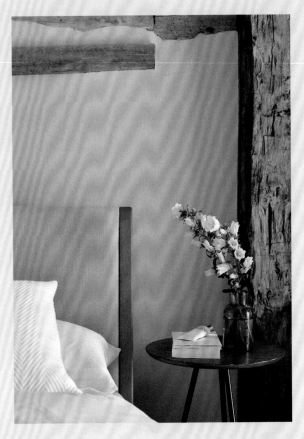

NEAT & TIDY

This bath rack offers a small waterside shelf for a bar of soap, wash cloth and scented candle. Made of wood, it adds textural depth that is in keeping with the rustic location.

SIDE ORDERS

Small and light bedside tables offer flexibility as well as utility. In the master bedroom this table is just large enough for a vase of garden flowers and a favourite book, but is never in danger of overwhelming or complicating the space.

Cottage Calm

Antique dealers Karen and Anthony Cull are drawn to objects that have a natural texture and a rich patina. Their company – Anton & K – based in the Cotswolds, specializes in French, Spanish and Scandinavian furniture with a particular character. The pieces all have a timeless feel that comes partly from the materials used and partly from the imperfections that have appeared through years of use. Their own cottage could be described in much the same way, defined by its curated feel in combination with a palette of whites, off-whites and soft greys.

'We lived in the Mediterranean before we moved back to Britain and we always used white on our walls in Mallorca, along with white linen sofas,' says Karen. 'So, in a way, our taste has not changed that much and the whites and neutrals make me feel uplifted, even on a dark winter's day.'

Above – The cottage serves as a catalyst and canvas for Karen and Anthony's collecting, with characterful furniture, ceramics and carved pieces on show throughout the house. In the guest bedroom, the top of a fitted cupboard becomes a display surface for a 19th-century Swedish carved wooden horse.

Opposite – Chosen for their length and width, as well as their character, the floorboards in the sitting room are reclaimed boards from an old cheese factory in Holland. The walls, ceilings and beams are painted in a white eggshell paint, while the doors are a soft grey, for a subtle contrast.

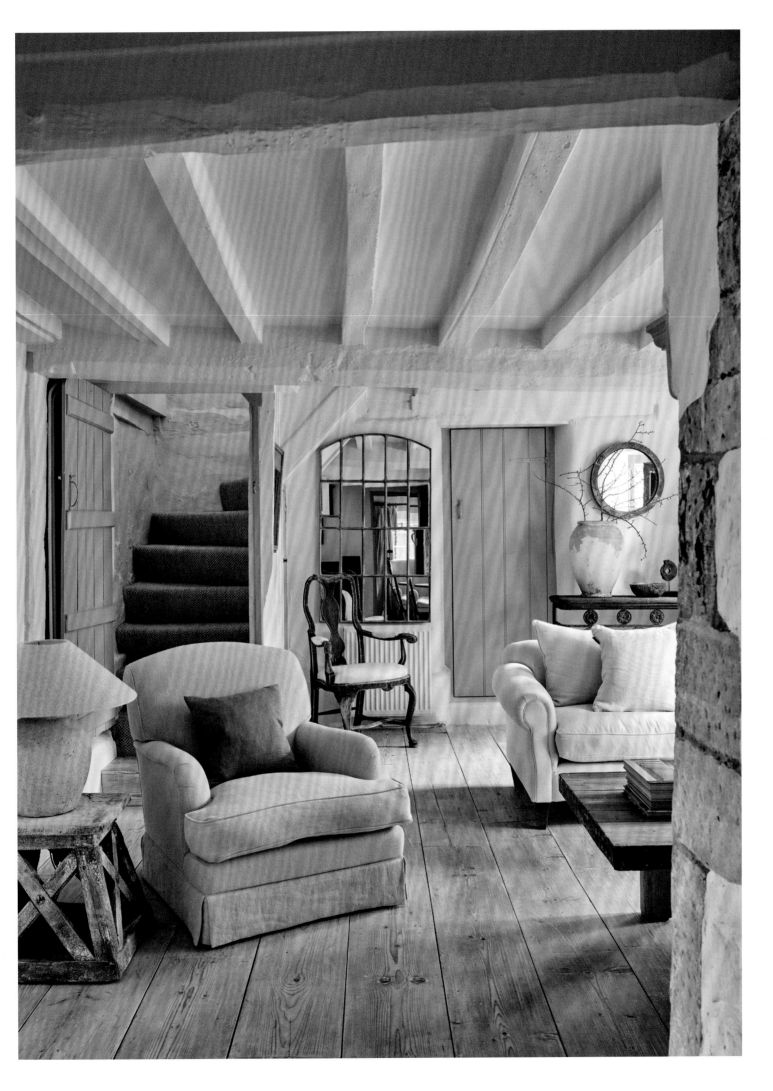

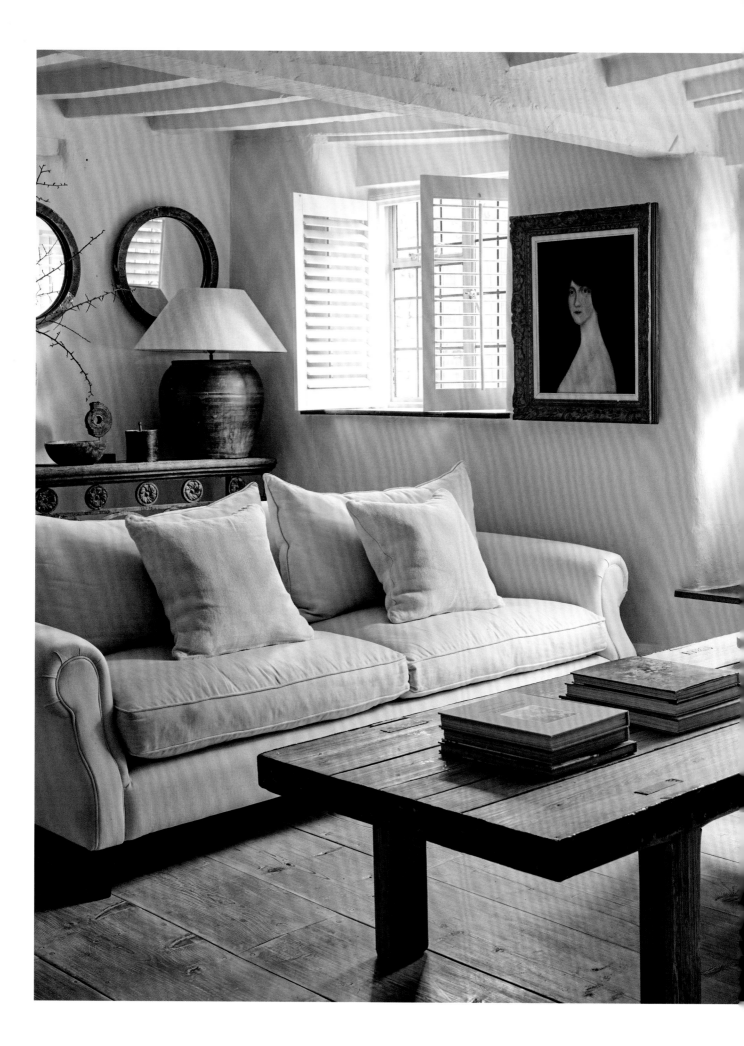

Left – The sofa from Flamant in the sitting room is layered with pale linen cushions, which are repeated on the window seat, softening the space. The seating faces the fire, which comes into its own during the winter evenings, when the shutters are closed and the space takes on a warm glow.

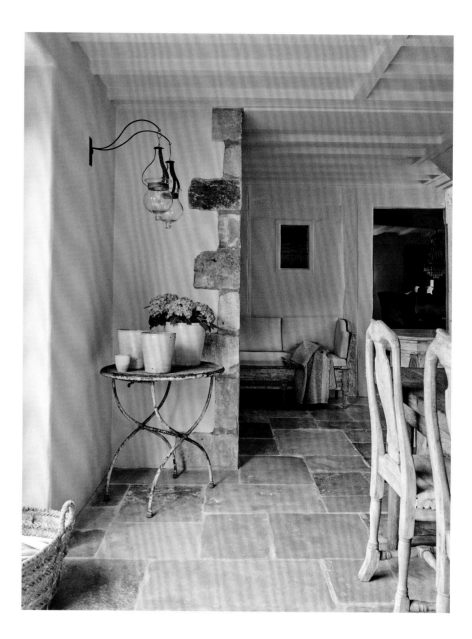

Right & opposite – The kitchen and dining areas in the newer part of the cottage are united by the reclaimed 18th-century Cotswold flagstones used for the flooring, which have a pale tone to them. This space benefits from a wealth of natural light spilling in from the garden via bifold doors. Much of the furniture here is antique French and Scandinavian.

The oldest parts of the stone-built cottage date back to the 17th century. With its wide wooden floorboards, hidden staircase (tucked behind a doorway), fireplace and exposed beams, this thatched portion is full of charm. The sitting room features a blend of soft whites – with the woodwork painted in eggshell rather than gloss – and pale greys used on the doors and detailing. The upholstered sofa and chairs are in neutral linens, while much of the other furniture is made of wood with natural finishes.

'We love the oversized fireplace in the sitting room and the natural stone walls, which have been left exposed in places,' says Karen. 'When the fire is lit and the candles are flickering, it's a very cosy space, but it's also light and bright in the summer. The bare floorboards are reclaimed from an old Dutch factory and we chose them because we wanted something extra-wide.'

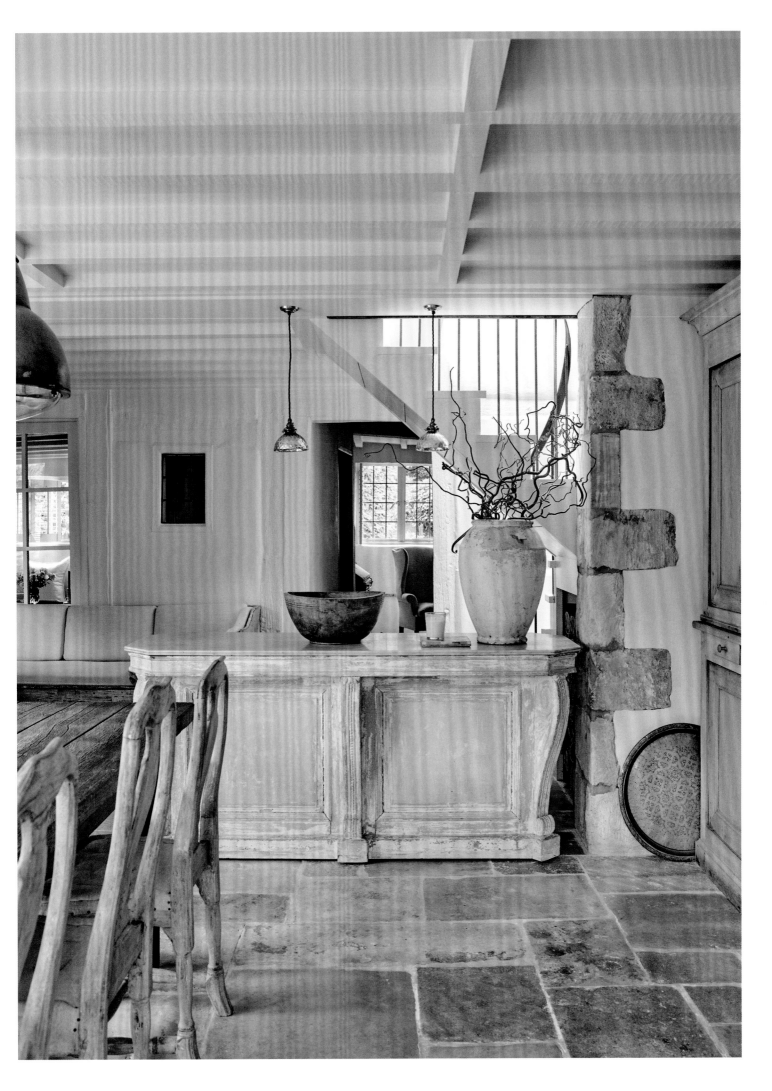

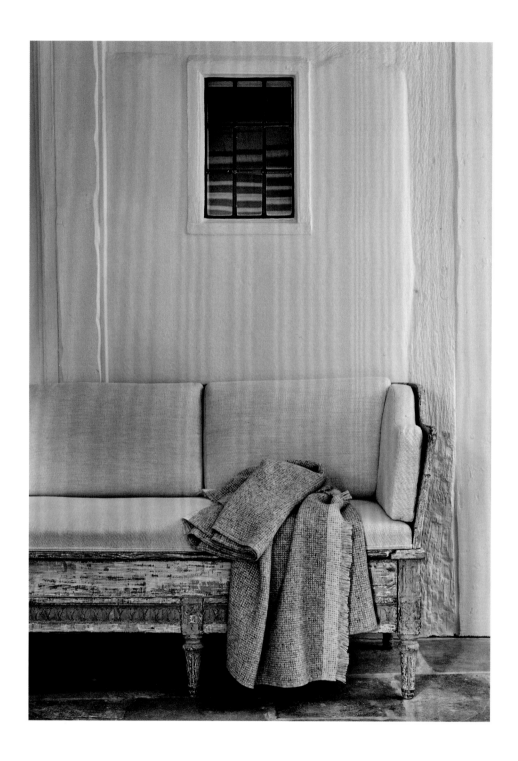

Above – In the hallway, the antique
Scandinavian bench has been refreshed
with new, white linen cushions, which
complement the old, distressed
paintwork and patina of the bench.
The alpaca throw introduces an extra
layer of tone and texture.

Opposite – The reading room in
the old part of the cottage is a more
intimate, secluded space. It combines
comfortable wing chairs with dramatic
elements, such as the antique crystal
chandelier and stone table with a slate
top, which Karen found in Provence.

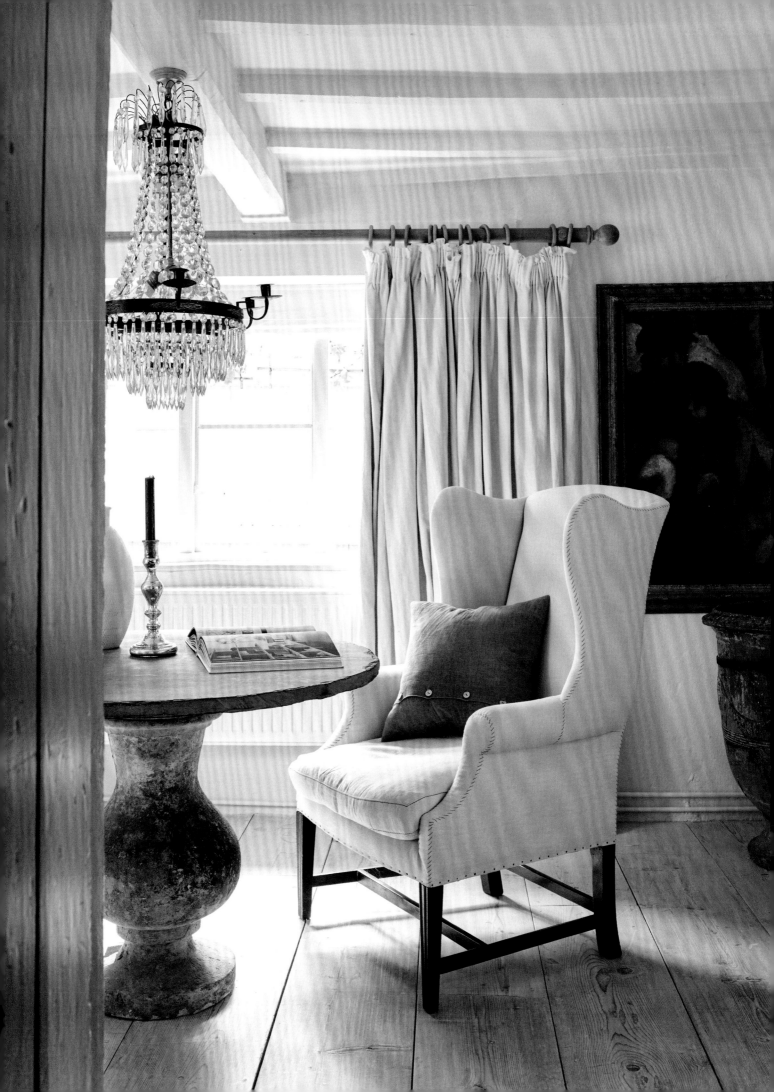

Styling details

NATURAL TEXTURES

For Karen and Anthony, the combination of natural textures and the patina of vintage pieces is a true delight. Here, the contrast of wooden surfaces and pale ceramics creates a subtle but engaging composition, accentuated by the muted backdrop of the walls and timber-topped console.

SHUTTER ACTION

The window seat in the sitting room makes long curtains inappropriate, but plantation shutters offer a perfect solution at this modest window. Simple and effective, these wooden shutters are also highly flexible in terms of regulating both the amount of daylight and the level of cosiness in the space.

BIRD LIFE

The appeal of these antique decoy birds lies in their texture as much as their form. Perched on the mantelpiece in the sitting room, their worn wood and faded paint speak of time and heritage without being too precious. Part of their impact, of course, lies in their relationship to one another.

MIRRORED MOMENTS

Vintage mirrors are a feature throughout the cottage, helping to circulate light and enhance the overall sense of space. They are also dynamic pictures in themselves, with added character drawn from the patina of both the frames and the antique mirrored glass.

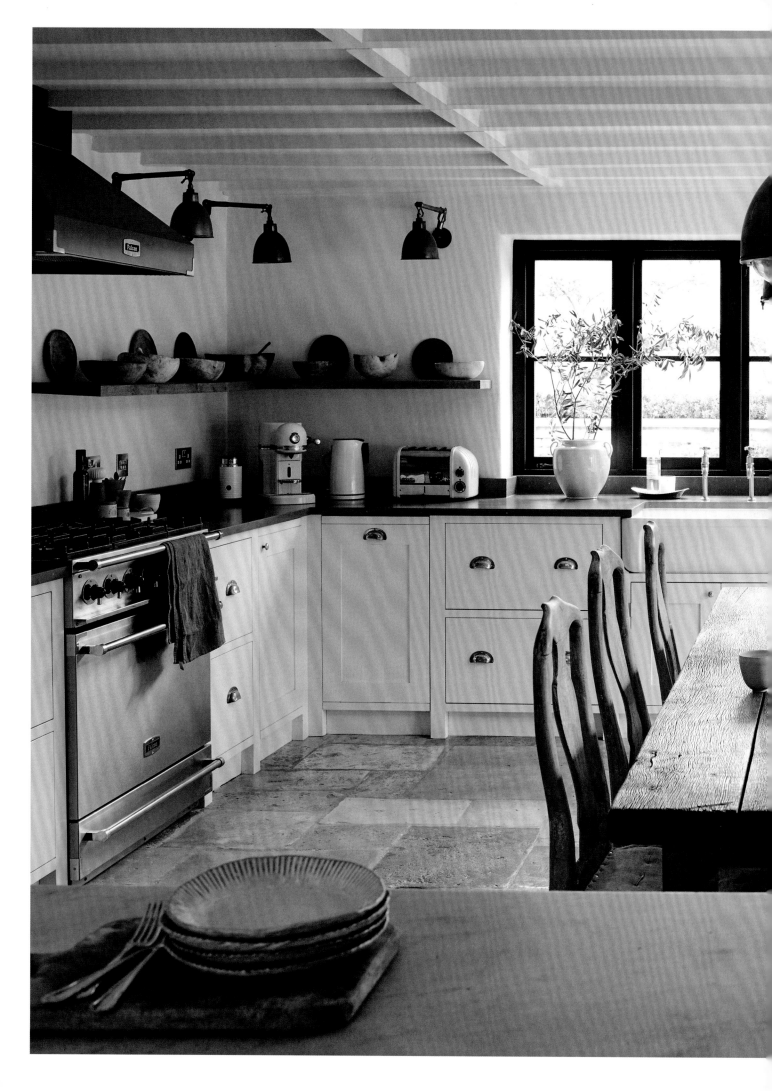

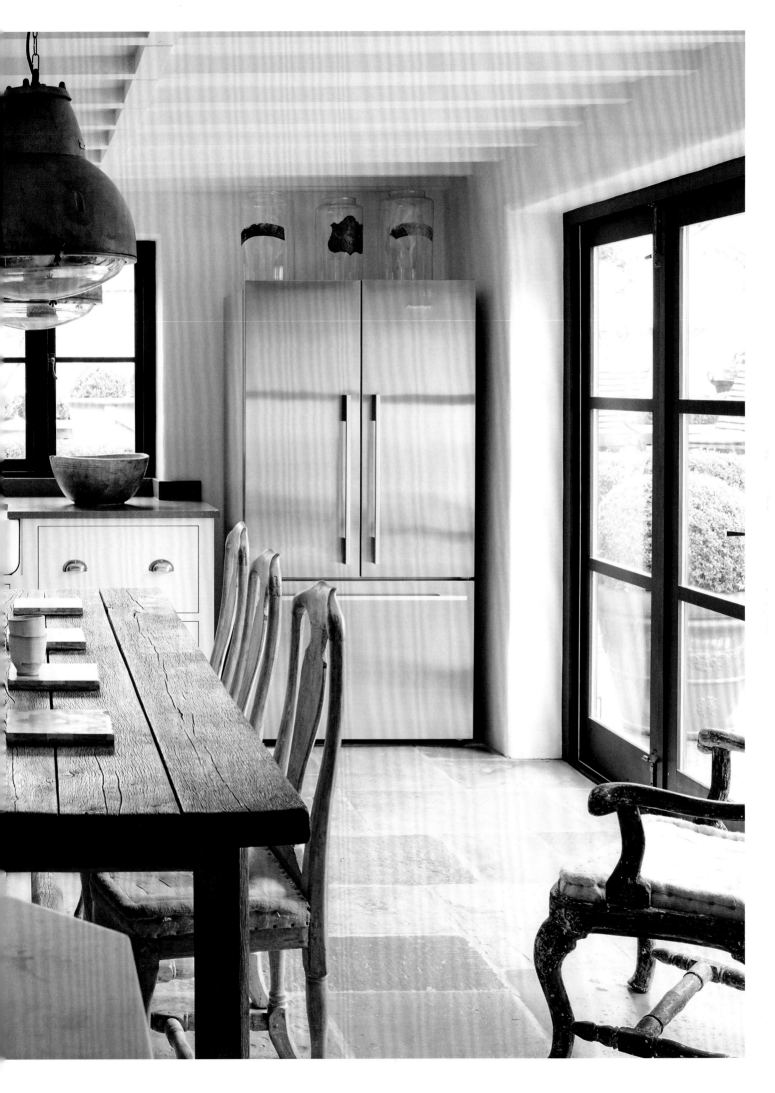

Styling details

— IN THE KITCHEN —

GLAZE OF GLORY

The simple glazes on this collection of French, English and European stoneware shine out against the neutral canvas of soft white walls and ceiling. For the most part, the old cider bottles and jars have a simple provenance, yet there is a sculptural beauty about them, which is enhanced by the common palette of soft earth tones.

NATURAL EDGES

This collection of wooden boards and platters in the kitchen sits well alongside the antique farmhouse cupboard with its worn and rustic texture. The rounded shapes offer a pleasing contrast to the harder edges and surfaces of the worktop and range.

OUT ON THE TILES

Instead of gracing a floor or a wall, four decorative tiles have been laid out in a line on the wooden dining table to form a protective surface. As well as taking on a fresh purpose, the tiles introduce a subtle touch of pattern against the deeply grained wood.

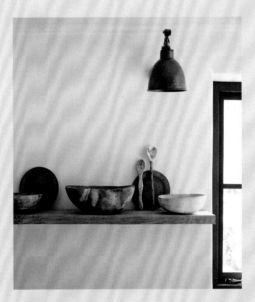

PLATE & PLATTER

Bread and chopping boards double as serving surfaces and platters for the kitchen table.

KITCHEN CARVERY

Simple wooden shelves in the kitchen make a pleasing display surface for a collection of carved bowls, plates and serving spoons, united by their craftsmanship and artisanal character.

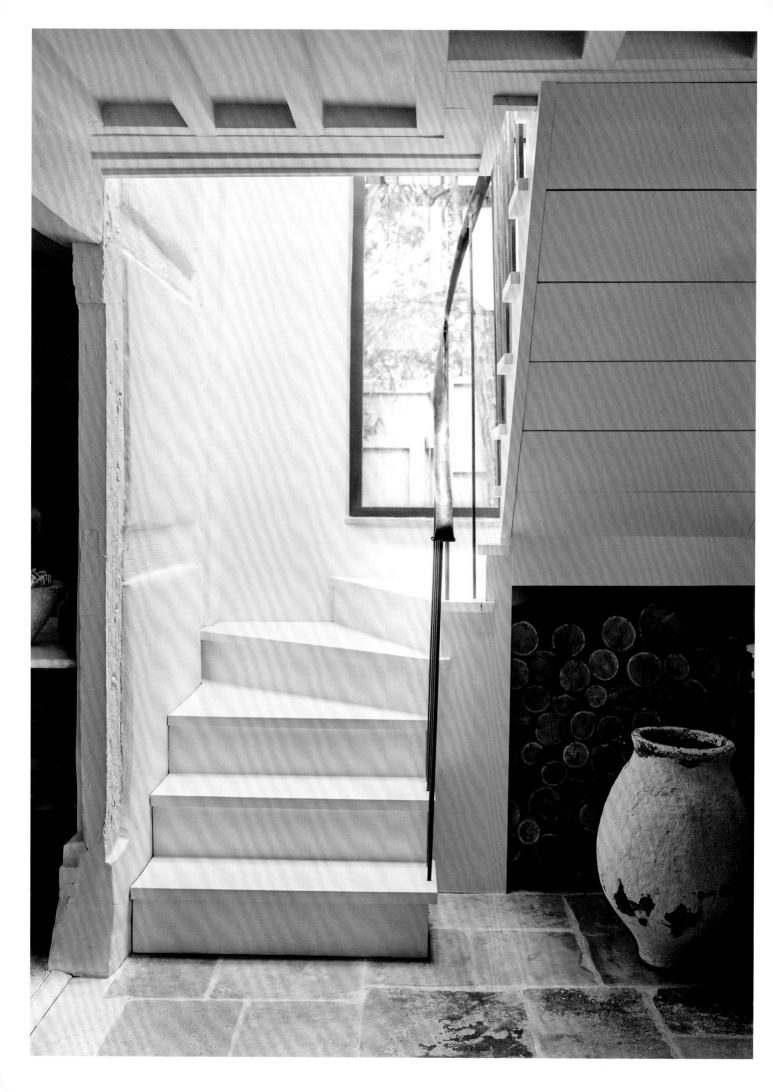

Pages 168–169 – The spacious kitchen, where there is also room for a large dining table, is situated in the new part of the house; the metal-framed glass doors to one side open up to connect the space with the adjoining terrace and the garden beyond.

Opposite – The new staircase sits between the new and old parts of the cottage. The custom-made stairs were painted in white eggshell paint, and the iron railings and banister were made by the local ironmonger. The space under the stairs serves as a wood store.

Right – A mid-century French wicker armchair sits on the landing at the top of the new staircase. The large skylight above brings daylight deep into the house and complements the tall window on the stairs, which overlooks the garden.

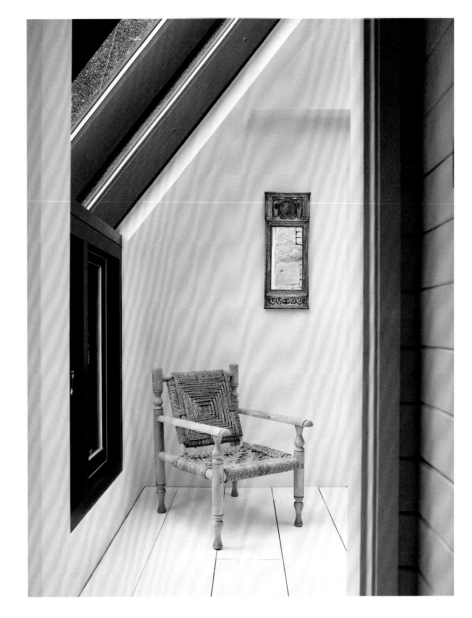

The original part of the cottage flows into a new, two-storey extension built in a sympathetic style with local stone. Here, on the ground floor, Karen and Anthony have created a kitchen and dining room that connects with the rear garden. For them, as former restaurateurs, the kitchen is a key part of the house – a spacious and practical room with an array of custom-made units and worktops designed around the range in a U-shape. Like the walls and ceilings, the units are in white but there are darker tones in the stone worktops, window frames and salvaged lighting. The floors are reclaimed 18th-century Cotswold flagstones, with space enough for a large vintage dining table in the centre of the room.

'We also have a utility room, which used to be our old kitchen before we extended,' says Karen. 'The dishwasher, washing machine and boiler are all in there, so that's ideal for helping to keep the kitchen itself clutter-free. We have these bifold doors to the garden – and to an outside dining area – and I love the amount of natural light that floods inside.'

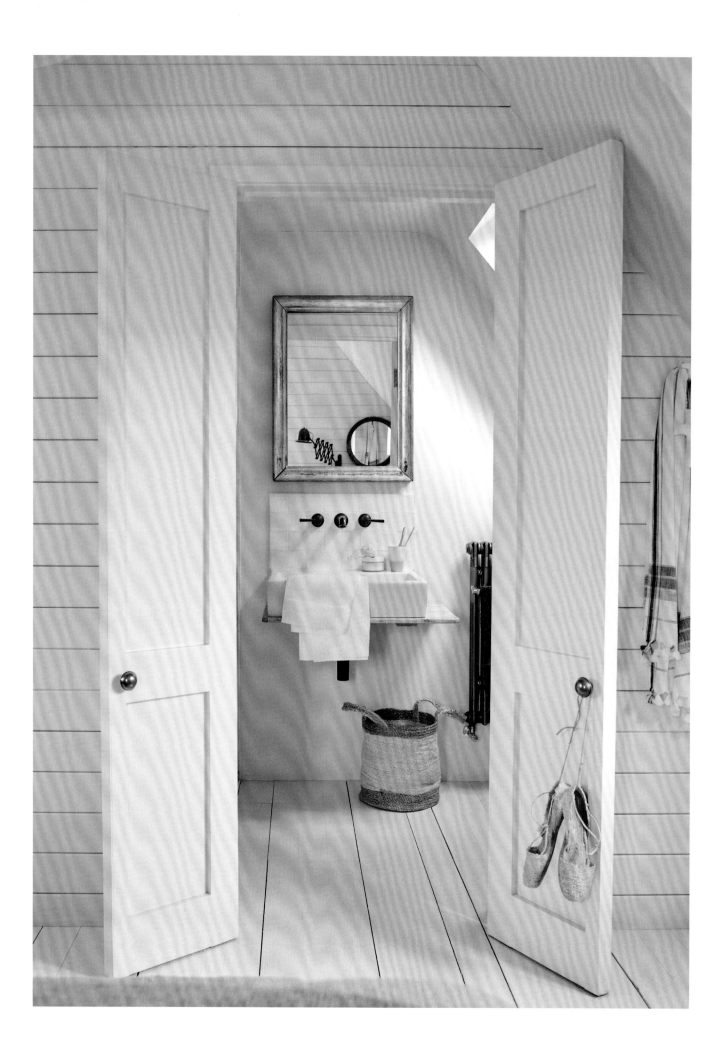

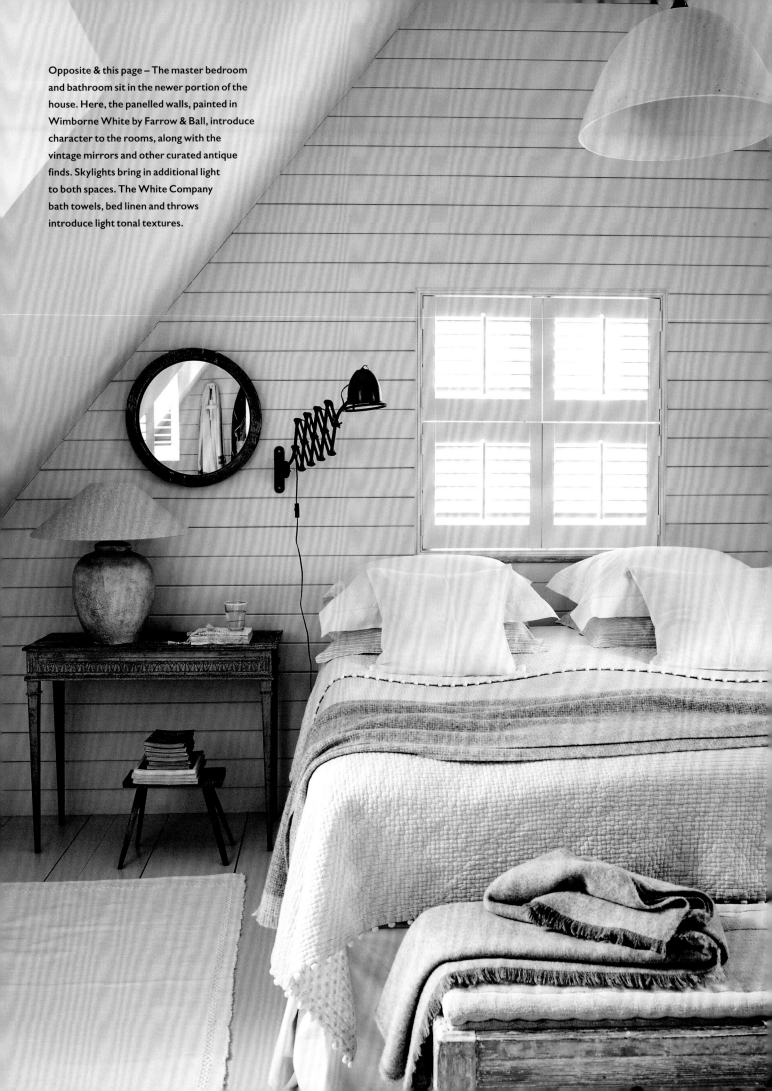

Opposite & this page – The master bedroom and bathroom sit in the newer portion of the house. Here, the panelled walls, painted in Wimborne White by Farrow & Ball, introduce character to the rooms, along with the vintage mirrors and other curated antique finds. Skylights bring in additional light to both spaces. The White Company bath towels, bed linen and throws introduce light tonal textures.

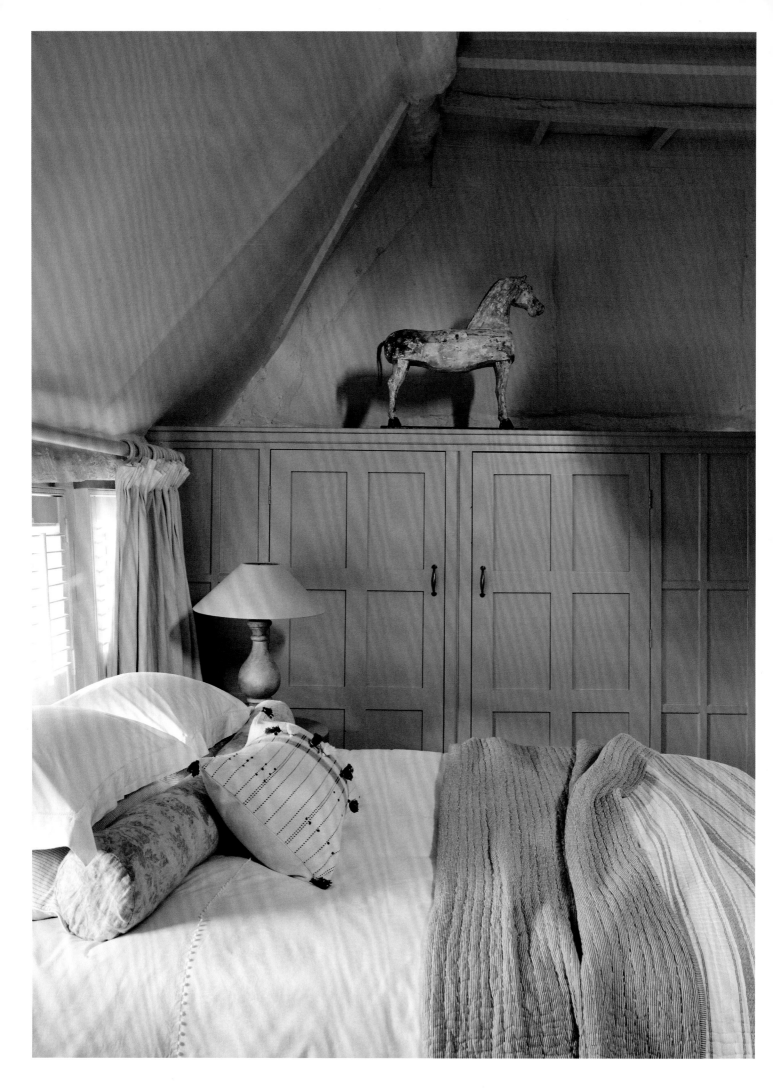

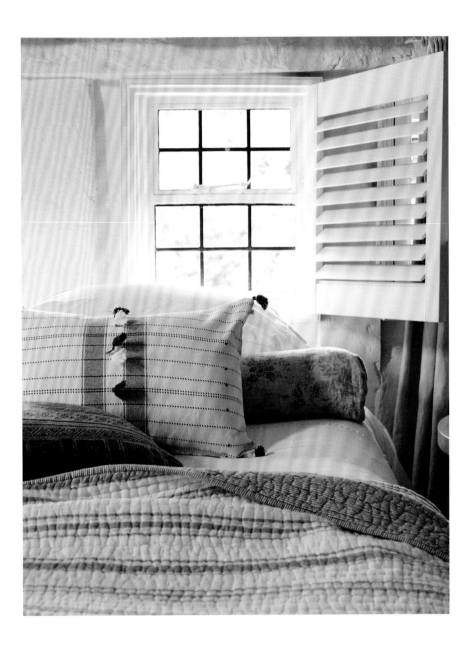

Opposite & right – The guest bedroom is a restful retreat in the original 17th-century part of the cottage. Against one wall, fitted cupboards keep the space uncluttered. The small window above the bed has been layered with shutters and a curtain, to allow for flexibility in the amount of light let in.

The master bedroom (see previous page) is situated upstairs in the new part of the cottage. Here, Karen and Anthony used the same reclaimed Dutch floorboards as in the sitting room but treated them to give a light grey-white finish. The pitched roofline helps to frame the bed, as does the use of panelling on the walls.

'Because this whole space is new, we really wanted to add character and texture here,' says Karen. 'So we used the painted panelling on the end wall and the wall to the en suite bathroom. We wanted to give it a light and bright feeling.'

The white palette of the master bedroom continues through to the bathroom alongside, helping to tie the two spaces together. The guest bedroom, in the older part of the cottage, has a more rustic feel and features fitted cupboards painted grey, which stand out well against the white walls and bed linen.

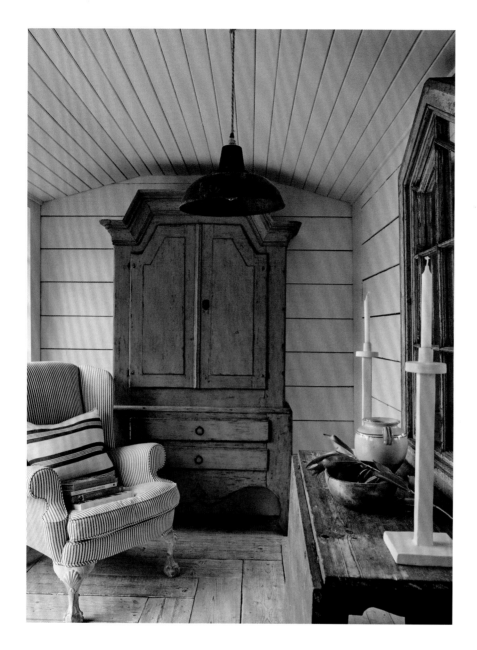

Left & opposite – The new summer house in the garden is a small but perfectly formed haven, rather like an echo of the cottage in miniature. The vintage folding table acts as a focal point between the ticking-covered armchairs, while the tall, blue 19th-century Swedish cupboard introduces a splash of faded colour.

More recently, Karen and Anthony added a separate summer house in the garden using reclaimed timber and a salvaged corrugated roof. With its white-painted wooden walls and ceiling, the interior has something of a Mediterranean feel, offering another reminder of their former life in Mallorca. It's also home to part of the Culls' growing collection of vases and ceramics.

'We often start the day in the summer house with a coffee and sometimes work in there as well,' says Karen. 'And we are drawn to white and pale ceramics but, again, it's also about the authentic patina. Being dealers ourselves, we always choose antique pieces along with natural wooden bowls and plates from Scandinavia, which contrast really well with the ceramics.'

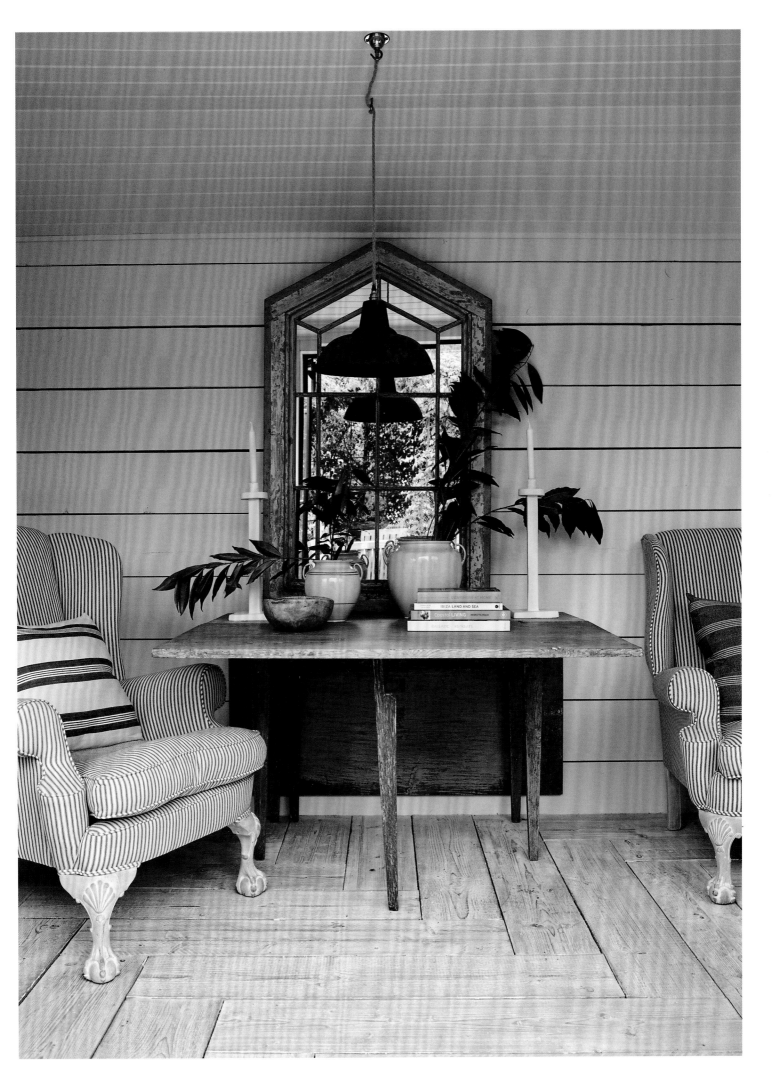

House of Warmth

'Much like a friendship, it takes a while to get to know a house,' says Meg Meadon. 'It's a relationship that needs to evolve over the years.' It is sound advice that Meg, an interior design consultant, has followed with the design of her own family home, as well as passing on to a select number of clients. The Oxfordshire house that she shares with her husband William and their two daughters has evolved gradually over time and is infused with a warm and welcoming spirit.

'We have put our hearts and souls into this house but it has really been worth it because it is a very special place for us,' Meg says. 'It's a wonderful home and garden for the children and I knew that we hadn't done such a crazy thing when I overheard a friend of one of my daughter's calling it "The Magic House".'

Above & opposite – Meg and William's home has a restful character, defined by calm, neutral colours and soft, rounded edges. The use of lime plaster helps to achieve this aesthetic, creating sinuous curves around the windows and doors – as in this living room – rather than hard, straight lines.

Overleaf – The main living room is an open and inviting space in the converted barn alongside the main house. The exposed and lime-washed beams, stone floors, woollen rug and salvaged French fireplace sit well within the quiet colour palette that Meg and William prefer. The sofa is from Rose Uniacke.

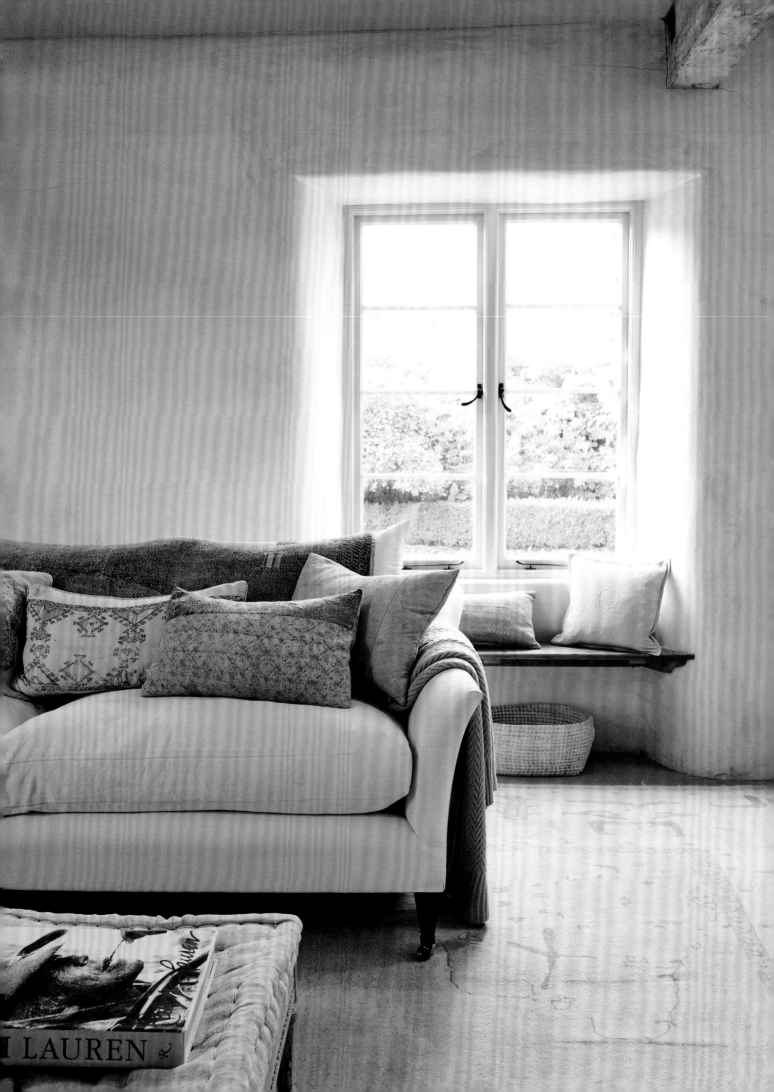

LAUREN

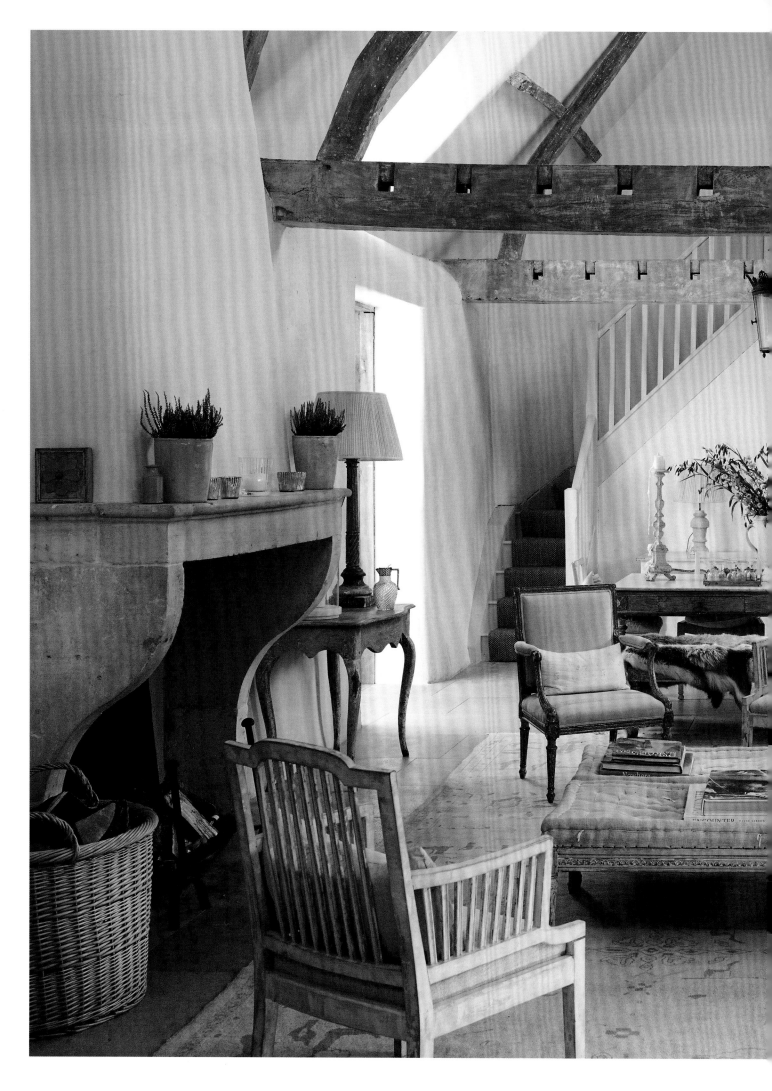

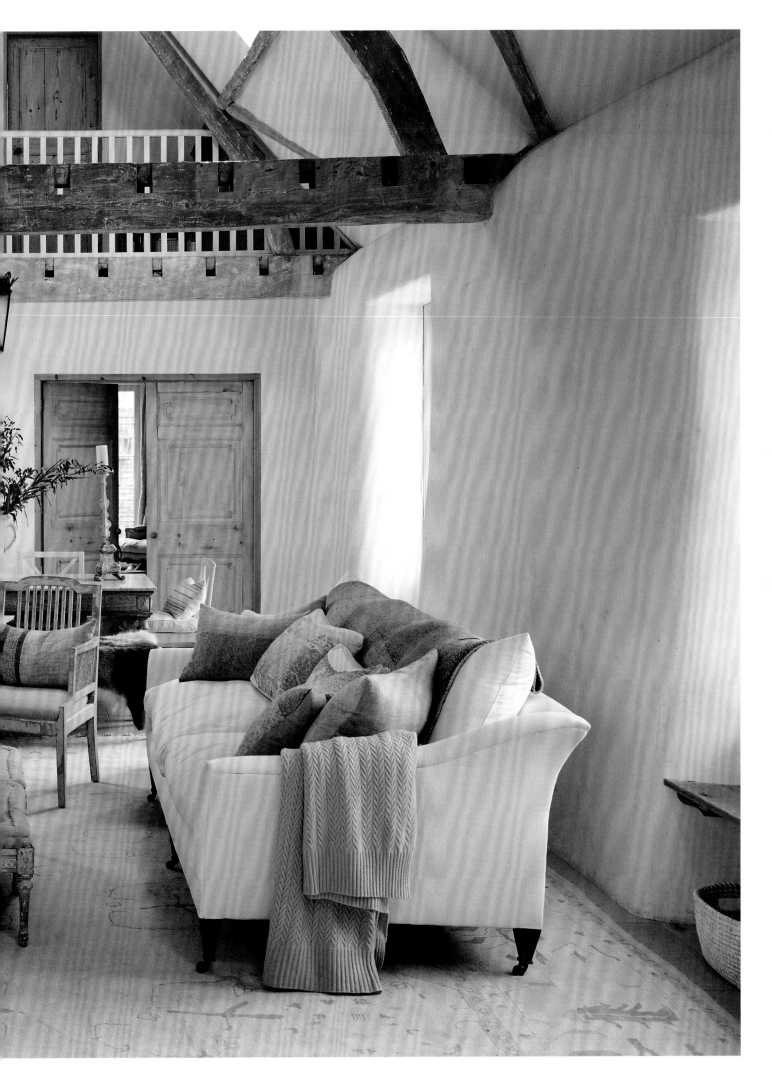

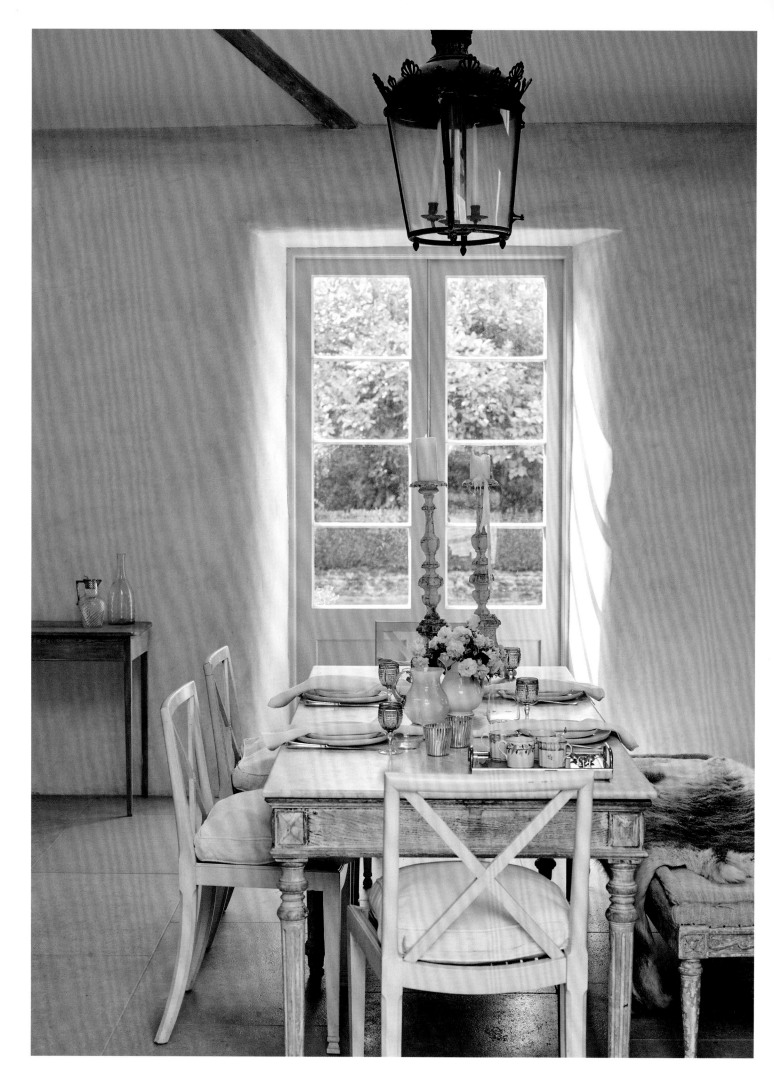

Opposite & above – The restored and converted barn has enough room for not only a cosy seating area around the fireplace but also a dining space, with an antique dining table, bench and chairs, and views out to the garden. A pale, neutral palette has been used for all the furniture and decoration.

Above – In the hallway, a freestanding vintage wardrobe provides welcome storage space for this busy family. Elsewhere, fitted cupboards and hideaways help to keep the house uncluttered and in good order – an essential ingredient for a calm home environment.

The main part of the house dates back to the 18th century and the Queen Anne period, but over the course of time, various outbuildings and barns have been added onto or alongside it. Meg and William fell in love with the house and its setting, a quiet rural hamlet, as soon as they saw it, but it needed a good deal of work. After moving to Oxfordshire from London, where Meg worked for Sotheby's and then in advertising, the couple began updating the building, raising ceilings and moving a number of walls and windows.

'We rebuilt much of the interiors and reroofed the house as well, but we didn't touch the Queen Anne façade or anything that was listed,' says Meg. 'It had been changed around hugely in the Sixties and our principal aim was to put the charm back into the house. But it was also very dark when we bought it, and I much prefer a more neutral and restful colour palette, so that you can then add a pop of colour to warm it up with cushions and rugs. The house really lends itself to pale, chalky colours, and many of the rooms interlink, so the flow between them is also very important.'

Meg decided to restore and convert the barn alongside the main house as a new and spacious family living room, offering a more open alternative to the traditional drawing room. The walls were lime-plastered and the original beams lime-washed, and Meg found a large French limestone fireplace that became the focal point of the room.

'We love the scale of the barn, with its high ceilings, the enormous fireplace and the old doors. Friends have tried to encourage me to put modern art on the walls, but I feel that the lime plaster speaks for itself and is a work of art in its own right. When the room is lit by candles at night, I feel as though I'm in a French chateau,' she says.

Styling details

— THE ART OF DISPLAY —

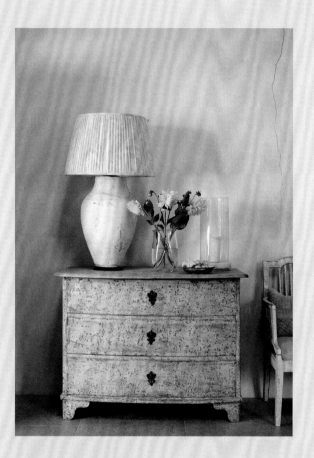

FLORAL TOUCHES

A simple bunch of dahlias from the garden gives a lift to this display in the living room. Although their colours and tones are restrained, the flowers stand out beautifully against the lime-plastered walls and the vintage chest of drawers.

OLIVE BRANCHES

A weathered clay olive jar, filled with a selection of branches from the garden, creates a pleasing composition in the hallway. The combination of calm, organic colours and materials helps to set the decorative tone for the house as a whole.

STONE TONES

The matt surfaces of the French limestone fireplace
and lime-plastered walls allow even minor shifts in
texture to stand out, such as the reflective glazes
on the pieces of stoneware on the mantelpiece,
which catch both the light and the eye.

ROSY PICTURE

A single white rose on a linen napkin not only
enhances this place setting but also makes the
guest feel special and cared for. Modest gestures
such as this can transform an everyday event into
something memorable.

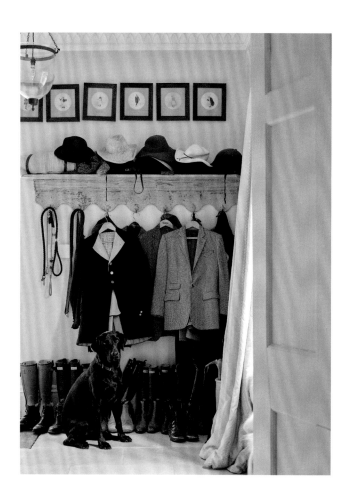

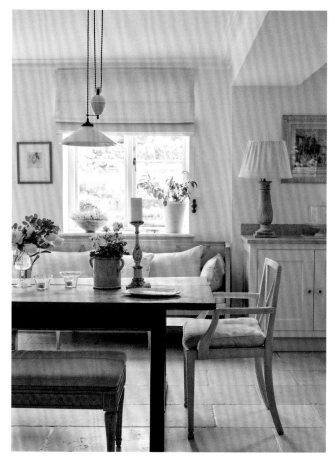

Above – 'A boot room is essential in a country house, small or large,' says Meg. 'You need somewhere to put the muddy Wellingtons and coats, but the only problem is training everyone to use it, rather than dumping everything by the front door.'

Above right & opposite – The family kitchen is a welcoming, light-filled room, decorated in soothing neutral tones like the rest of the house. The Thomas & Thomas kitchen units are painted in Slipper Satin by Farrow & Ball, with complementary shades on the island and freestanding cupboards.

Transforming the kitchen was a priority for the family. Meg combined two separate rooms to create one large kitchen with space enough for not just an Aga range, kitchen units and an island but also a dining table and an antique Swedish-style sofa by the back door to the garden. Starting from scratch, Meg found French limestone flagstones to tie the scheme together and adopted a neutral and natural range of tones and textures throughout the space.

'I was strongly advised not to have limestone worktops but I do love them because it's such a natural material and I never tire of it. And I love the look of the chalky Swedish furniture on the stone floors. It's all very soft in tone and suits the house.'

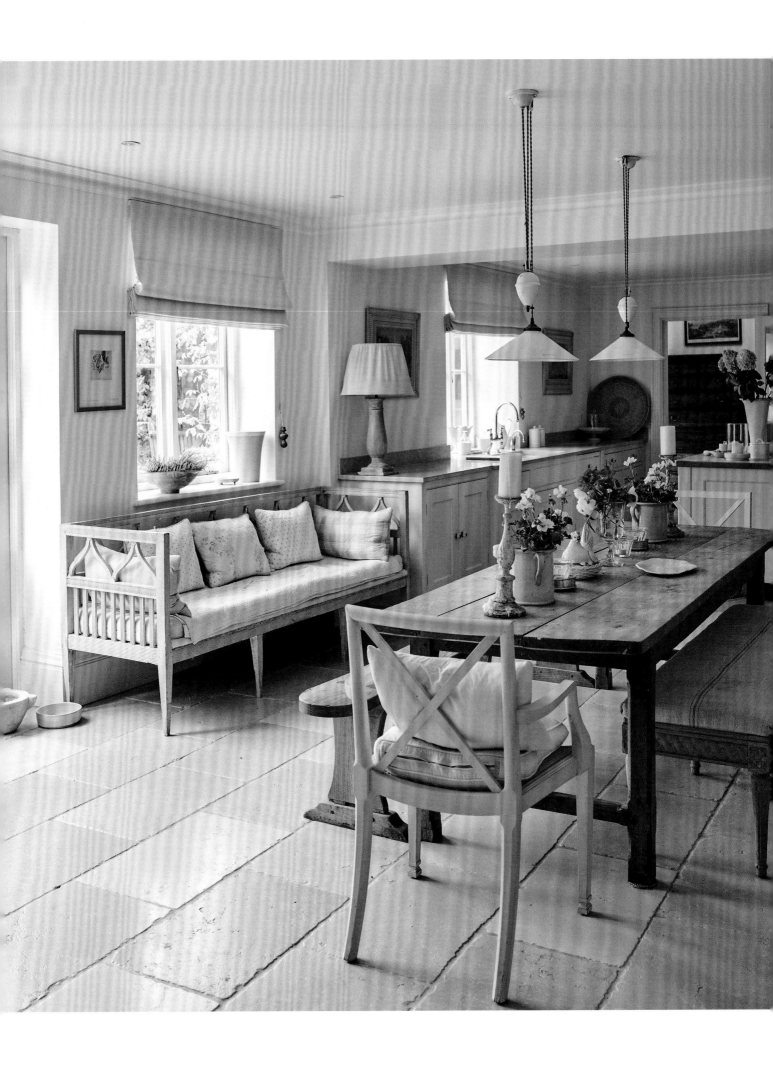

190 COUNTRY

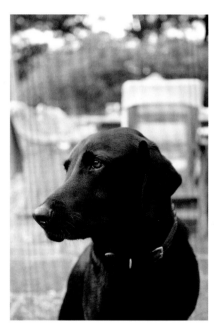

Above & above right – Flagstone floors
in the hallway are highly practical for this
country house, where the doors are often
left wide open in spring and summer and
there is a constant stream of traffic from
the family and Ned the labrador.

Opposite – The restored garden offers
a choice of outdoor rooms, including
this flagstone terrace to one side of
the house. The dining table, bought at
auction, is Spanish oak, to which Meg
added a limestone top.

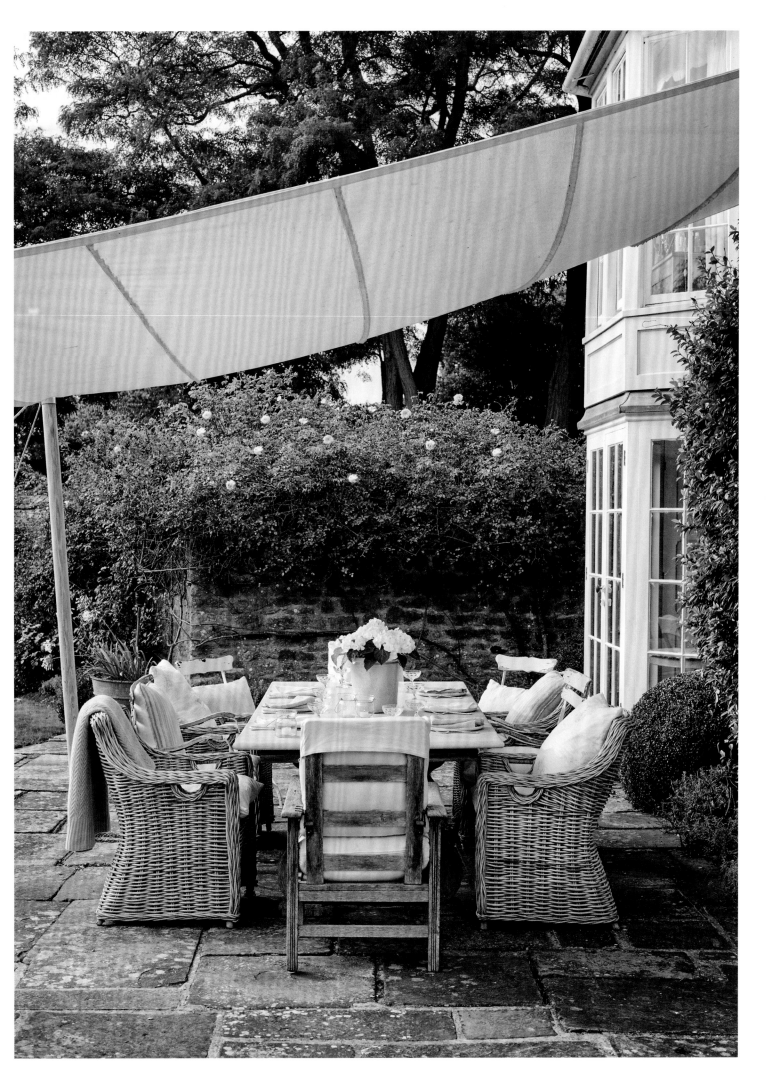

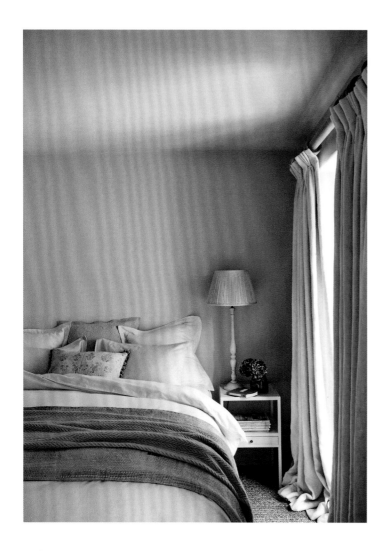

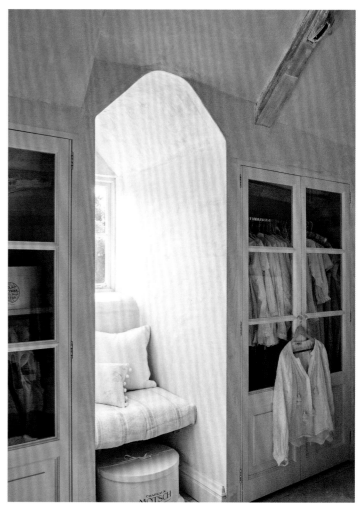

Above – The bedrooms are quiet and calm
spaces, decorated in a colour scheme that
is in tune with the rest of the house.

Above right & opposite – The dressing room
features a sequence of fitted cupboards,
with a window seat slotted between them.
The glass in the cupboard doors helps to
reflect light through the space, while their
design makes the most of the proportions
and scale of this attic room.

Just as the main living spaces are given clarity and order
through the use of fitted and custom-made furniture,
Meg has taken a similar approach in the bedroom suites.
In the dressing room alongside the master bedroom and
bathroom, built-in wardrobes with partially glass-fronted
doors are arranged on either side of an integrated window
seat, while additional cupboards help to frame the doorway
through to the bathroom.

'It was very important to me to have lots of wardrobe
space and I love the glass doors, as they help throw light
through the room,' says Meg. 'We didn't want to lose the
window, of course, so we created that little window seat
space between the wardrobes, which is rather cosy.'

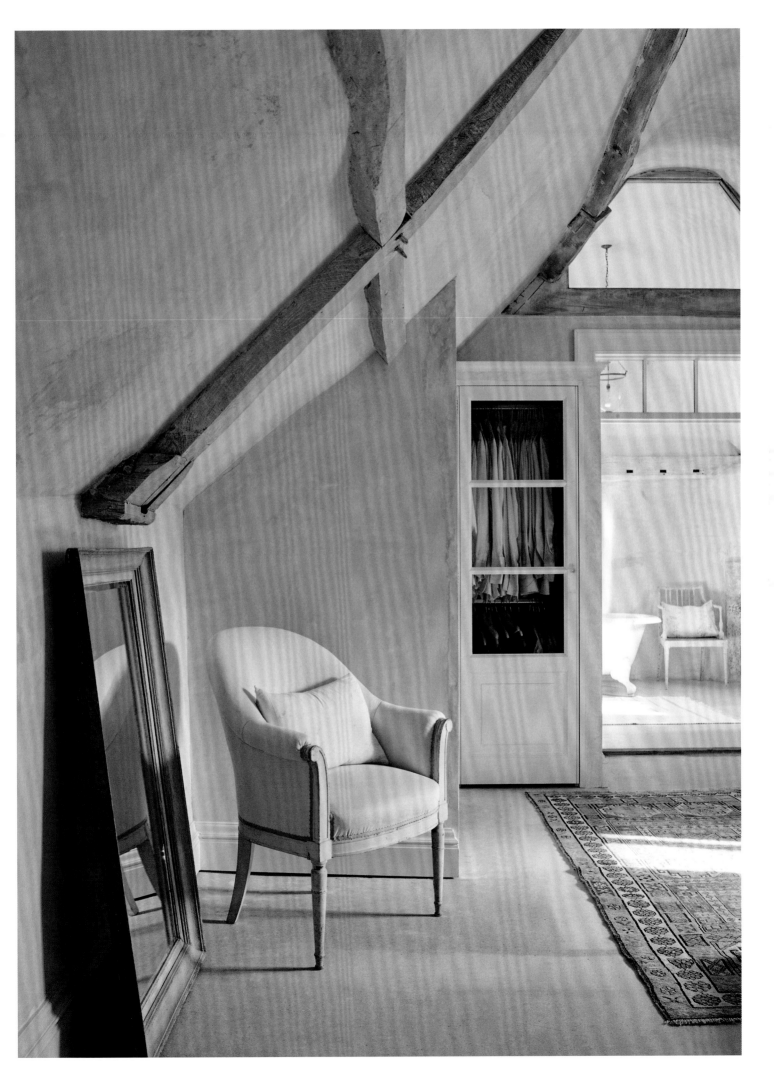

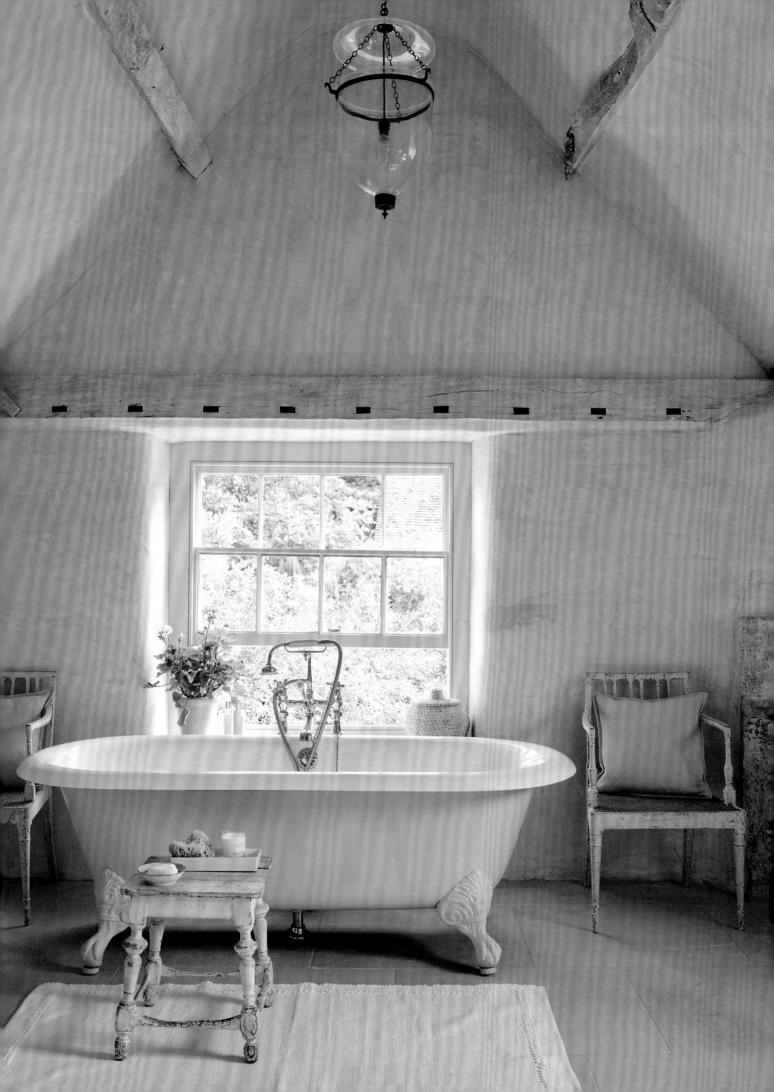

Opposite, below & right – The high exposed ceiling in the master bathroom enhances the sense of space, while lime-plastered walls create a gentle backdrop. Alongside the bathtub, a little wooden stool keeps bathing essentials within easy reach. The vanity unit was made from an old oak chest with the addition of a basin and a marble top.

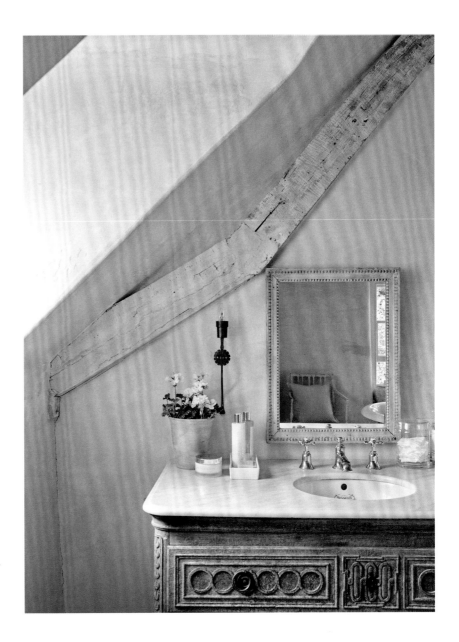

The master bathroom also features lime-plastered walls and stone floors, creating a complementary pairing of soothing pale notes and textures. The white, freestanding bathtub has been set in front of the window, to give a peaceful view of the trees outside.

'We changed the window to add more light, and put in a little fireplace,' Meg says. 'I found an antique oak chest that I put a basin into and added a marble top. I love all these soft colours in the house and the way they flow together. It certainly has a lot of charm now and plenty of light, which is just what we wanted.'

Styling details

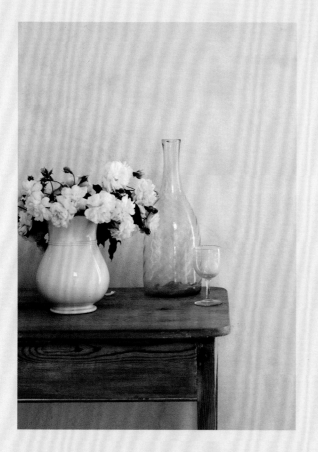

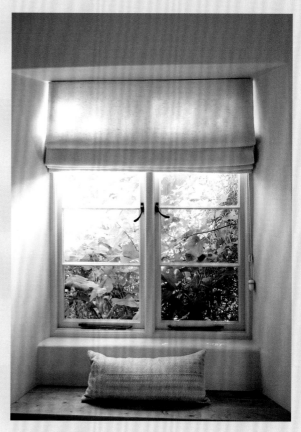

FLORAL NOTES

A plain wooden side table alongside the dining area is brought to life with white and pale pink roses set in a simple, white glazed vase, combined with some vintage glassware.

GARDEN SEAT

The house features a number of window seats and benches, which not only provide extra seating but also add character to a room. Softened with a cushion in vintage linen and a translucent blind, this seat connects with a burst of greenery outside.

 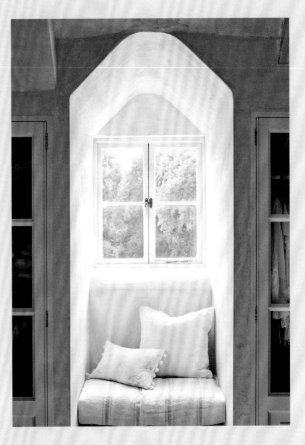

TESTING TIMES

Meg takes her own good time deciding on new paint colours, making swatches on pieces of card and placing them on the walls to see how they respond to the room and the changing light throughout the day, as seen here in the hallway.

FINDING A NICHE

One of Meg's passions is for vintage linens, as used for the cushions and seat covering on the window in the dressing room. The pale, faded patterns give only hints of colour, so they do not overwhelm a quiet, contemplative niche.

III

COAST

The Pool House

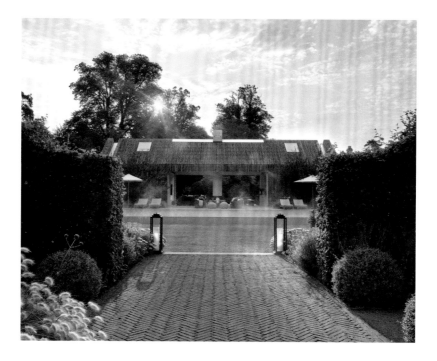

Enclosed within a walled garden, Chrissie and Nick's Pool House takes its inspiration from the natural world. This enticing family escape is their favourite place for relaxing and entertaining, while offering a constant sense of connection with the adjacent pool and surrounding landscape.

The outline of the house, designed by architects Michaelis Boyd, is distinctly modern but takes its cues from a classic greenhouse in its use of transparency and skylights. The steel-framed, timber-clad refuge offers a seamless link between its central living area and the terraces alongside through large retractable glass doors, which help to draw the landscape into the house.

'The architects were very clever designing a modern building that sits so comfortably in its classic setting,' says Chrissie. 'The timber cladding has aged to this lovely soft grey, which works so well with the stone terraces, the trees and the garden.'

Above – The gentle grey cladding of the Pool House blends into the natural backdrop, as viewed from the kitchen garden. The herringbone brick path forms an axial line through the kitchen garden, with beds either side offering seasonal vegetables, fruits and flowers.

Opposite – When the glass doors of the Pool House slide back, the sense of transparency increases and the borders between inside and out fall away. The contemporary outline of the building is influenced by period glasshouses and vernacular wooden barns.

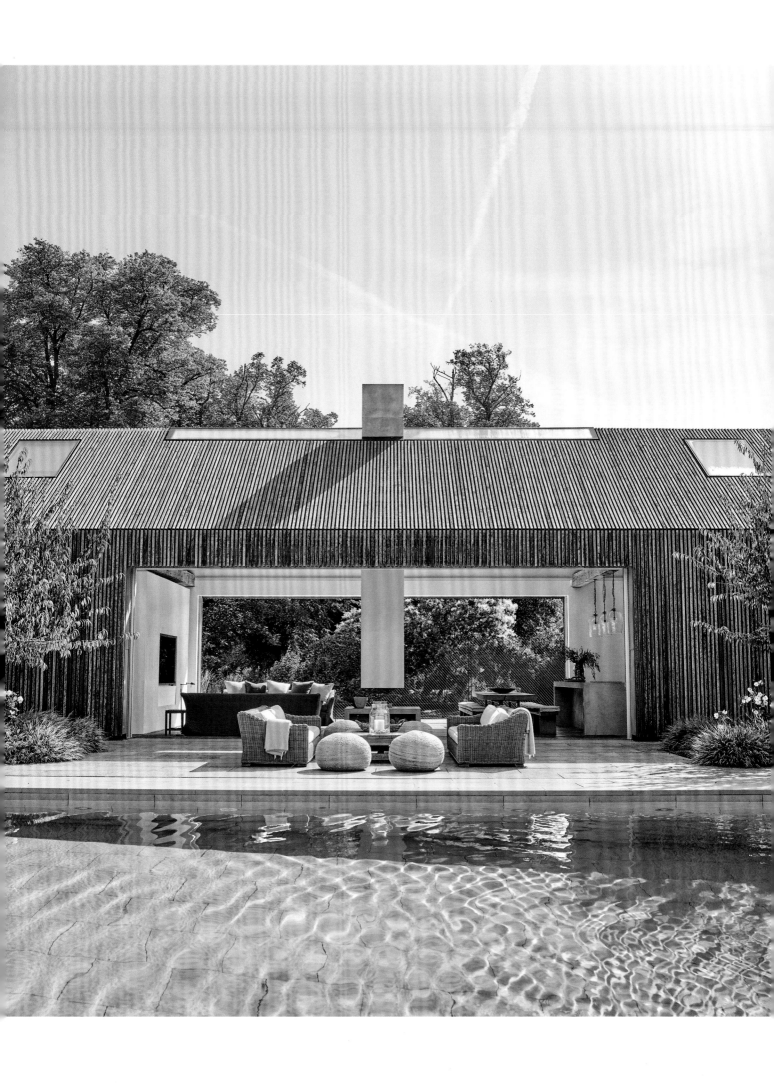

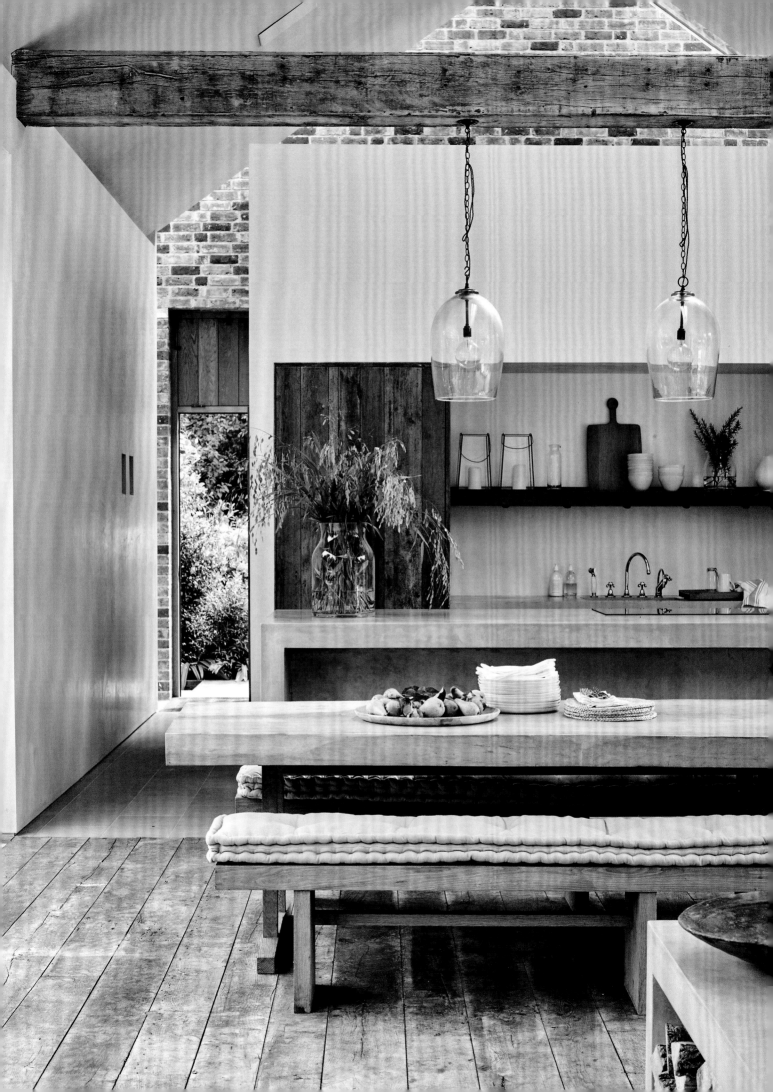

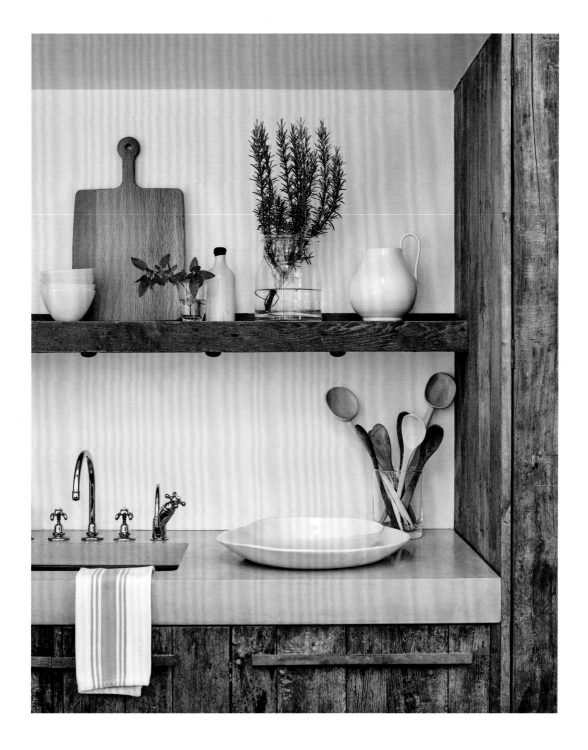

Opposite – The kitchen and dining area sit to one side of the open-plan living space at the heart of the Pool House. The custom-made oak dining table and benches, with padded cushions, seat 12 comfortably. Pendant lights with glass shades provide floating lanterns over the concrete island.

Above – A hard-wearing concrete countertop is functional and practical, while establishing a pleasing contrast with the raw and reclaimed timbers of the storage cupboards and shelves. The shelving offers opportunities to display decorative elements as well as kitchen staples.

Below & below right – The Pool House offers an
enticing set of textural contrasts, with an emphasis
on natural materials. A cashmere throw from
The White Company sits upon a jute stool, while
sculptural ceramic bowls appear to float on the
concrete surface of the central hearth.

Opposite & overleaf – The traditional idea of
a central hearth has been reinterpreted, here,
in the form of a modern fireplace at the heart of
the Pool House. The fire and its suspended flue
form a point of separation between the dining area
and the informal seating zone.

Chrissie spent a great deal of time on the planning stages
for the interior spaces, working out every detail to suit the
family. The central zone holds a floating fireplace – which
comes into its own during the colder months – along with
a comfortable, relaxed seating area to one side and a dining
area to the other.

'The planning work that we did up front really paid off,'
Chrissie says. 'It isn't a huge space so everything needed
to have its place to create a sense of order.' Chrissie asked
Rose Uniacke to help her with the internal finishes again.
'I love working with Rose; she has great taste and she really
understands me!'

Beyond the dining area is the kitchen. Here, a concrete
island in a pale grey works well against the soft, off-white
finish of the tadelakt (Moroccan plaster) walls, while the
island itself offers storage, twin dishwashers and a flush
stovetop. Pendant lighting bathes the island with soft light
in the evenings. Integrated cupboards and storage hold
china and glass, while the central bank of shelves above the
galley worktop and sink provides opportunities for display.

'It is very calm and peaceful but also very practical,' says
Chrissie. 'We wanted elements like the wooden floors to feel
a little weathered, worn and loved. It's all about using white
in the right way and in the right places, which makes it feel
very calm, peaceful and restorative.'

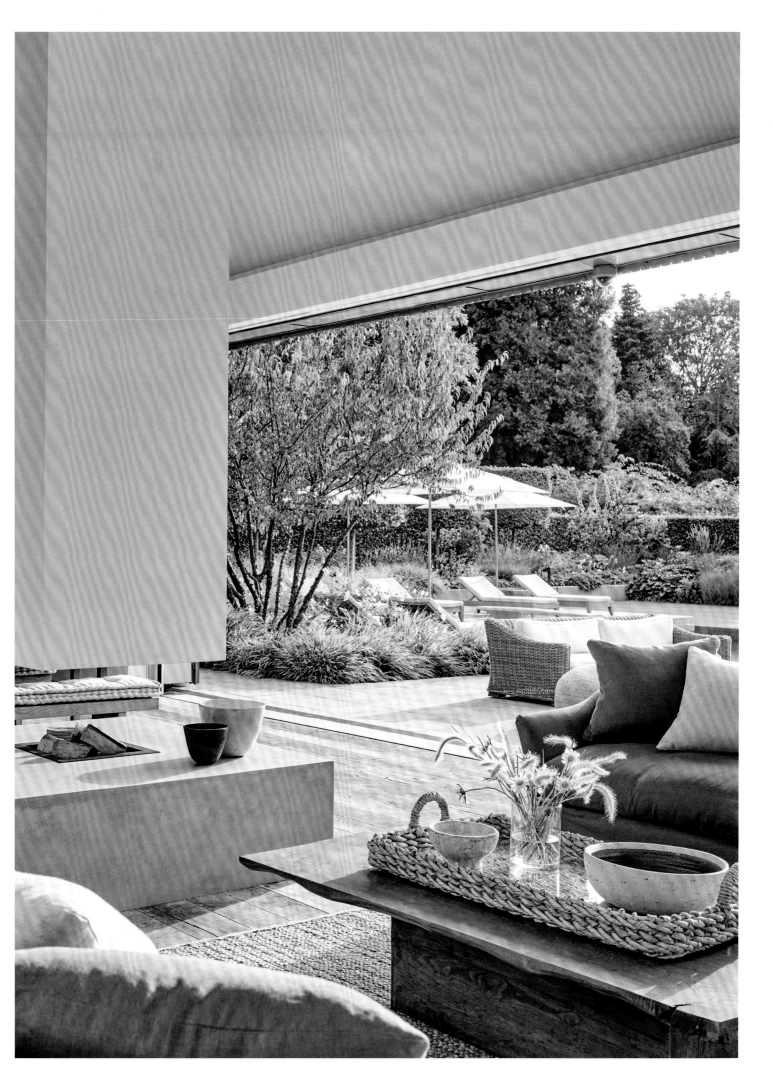

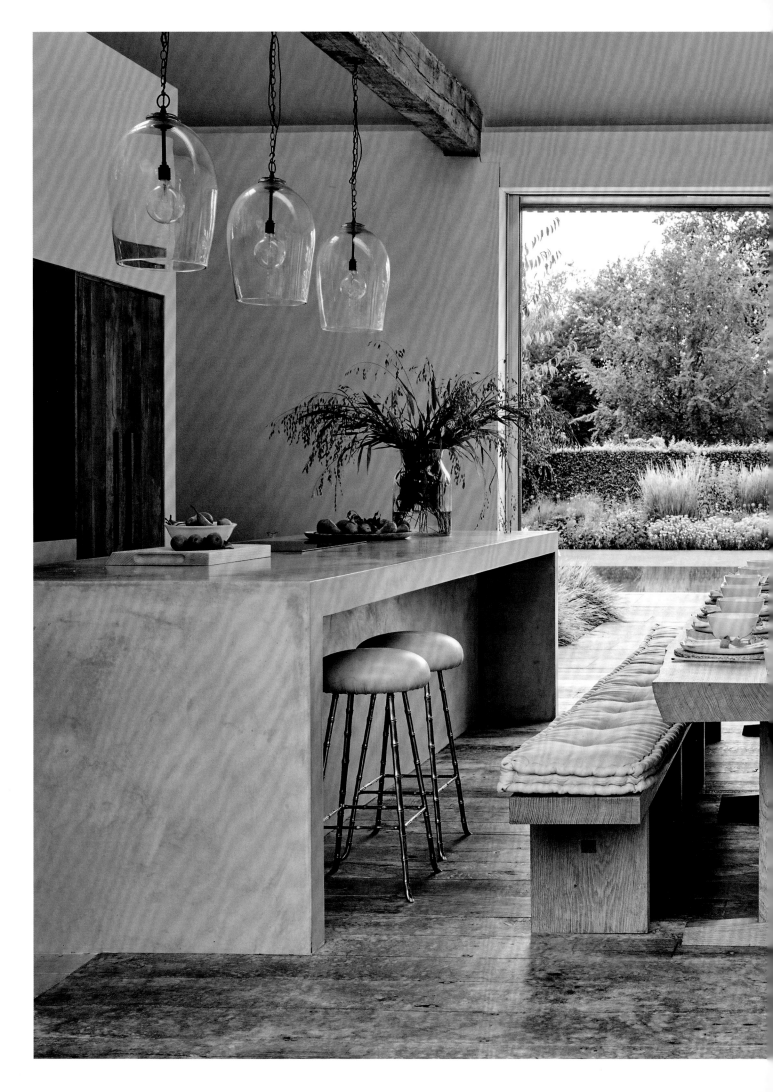

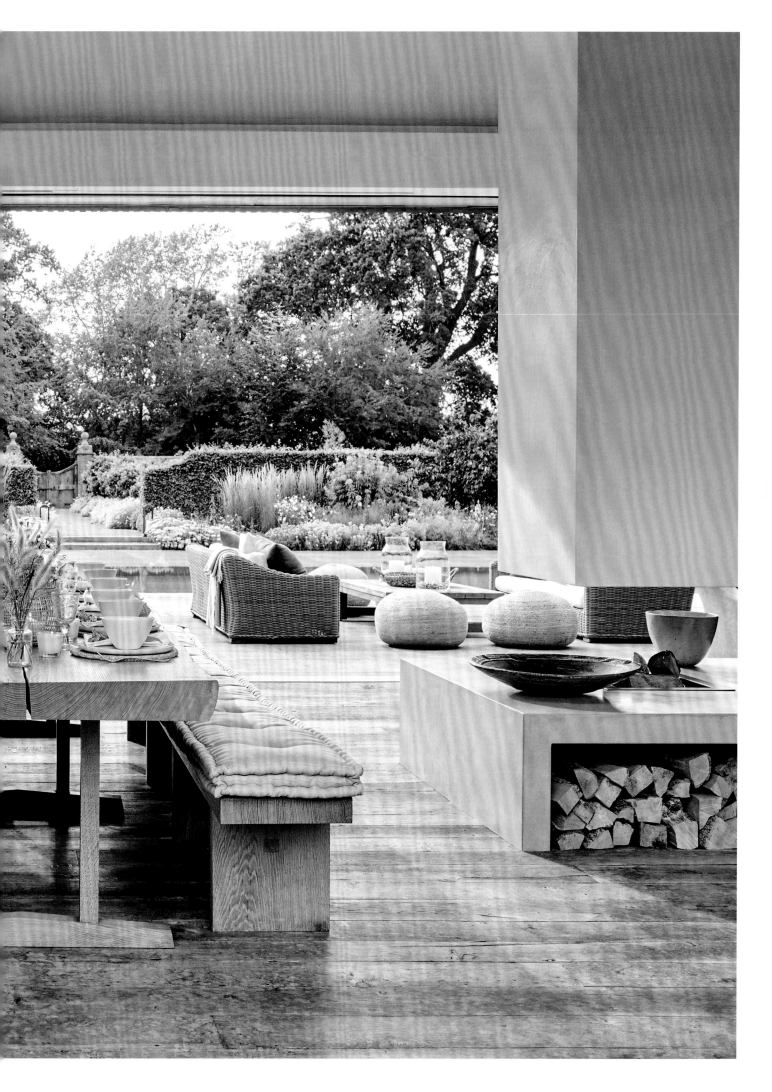

Styling details

— IN THE KITCHEN —

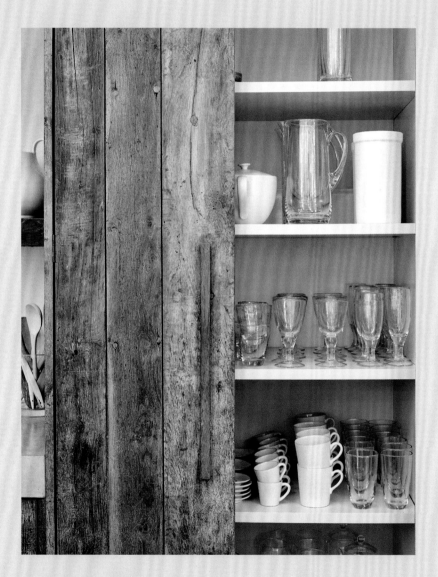

SECRET ORDER

Given that the Pool House is a place for entertaining, a generous supply of glassware and china is essential. The cupboards in the kitchen, faced with reclaimed timber, hide neat ranks of wine glasses, tumblers, mugs and coffee cups. The rough texture of the wood contrasts with the smooth surfaces of the contents of the cupboards and also with the crisp lines of the concrete worktops, generating an organic interplay between rough and smooth.

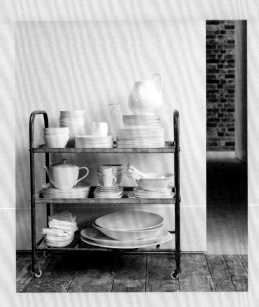

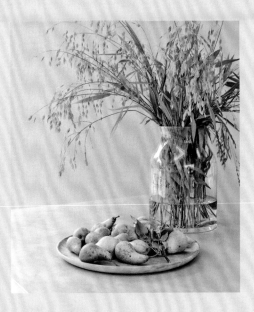

À LA CART

Another loved staple of the Pool House is this vintage trolley, loaded with plates and other china. A kitchen classic, it offers a useful backup when setting tables and serving meals.

NATURE'S BOUNTY

The walled garden is a ready source of grasses and greenery for simple displays in glass vases and jars. This vein of organic simplicity carries through to a platter of pears, which were from the tree outside.

LAND OF PLENTY

A vintage wooden bowl acts as a circular picture frame for this sculptural collection of white aubergines picked from the garden.

LAYERED DISHES

The enduring principle of creating decorative tablescapes through multiplication and repetition carries over to more functional parts of the kitchen, where layered stacks of china platters and dishes have a pleasing character of their own.

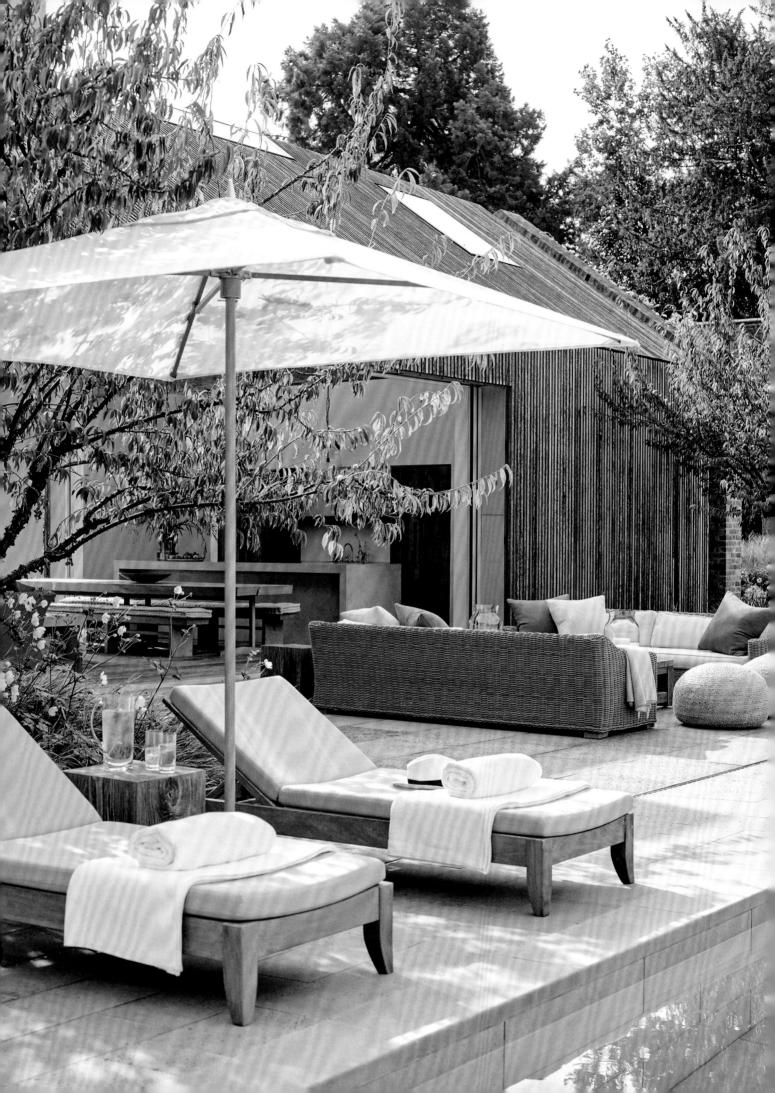

Opposite – The emphasis on natural textures continues through to the pool terrace, where the sun loungers and side tables are in timber and the stools and sofas in wicker and jute. This focus on natural materials is in keeping with the garden setting, yet these choices are also practical as they can be left outside all year round.

This page – White waffle towels, layered for a spa-like quality, populate the sun loungers by the pool. The needs of Chrissie and Nick's dog Mouse are met by the comfortable sofas and cushions, which have an elegance and a hard-wearing practicality suited to both owners and pets!

Above the kitchen and the bank of storage spaces is a mezzanine level, which holds a discreet pilates room. Together, they form part of a neat, white cube floating within the open volume of the house. This idea is repeated at the other end of the Pool House, where a second cube anchors the spa area, complete with showers, changing rooms and storage for towels. Pocket doors are usually hidden away, yet can be drawn across to provide privacy when needed.

Throughout the spa area, the restrained and peaceful palette of materials sings out. The shower area at the far end of the Pool House features stone floors with integrated soakaways, tadelakt walls to one side (from which the shower heads and taps emerge simply and gracefully) and a wall of characterful bare brick to the other.

'Tadelakt is a natural, textured finish and slightly reflective, with a soft sheen and movement, so it naturally creates atmosphere,' says Rose. 'It is also durable and waterproof, so it's very practical in wet areas. I liked the idea of the rippled finish on the walls relating to the water in the pool. But the softness and sheen complements and contrasts with the natural roughness of the brick and wood; all of the materials that we used are very natural.'

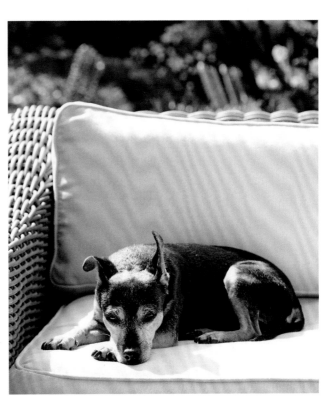

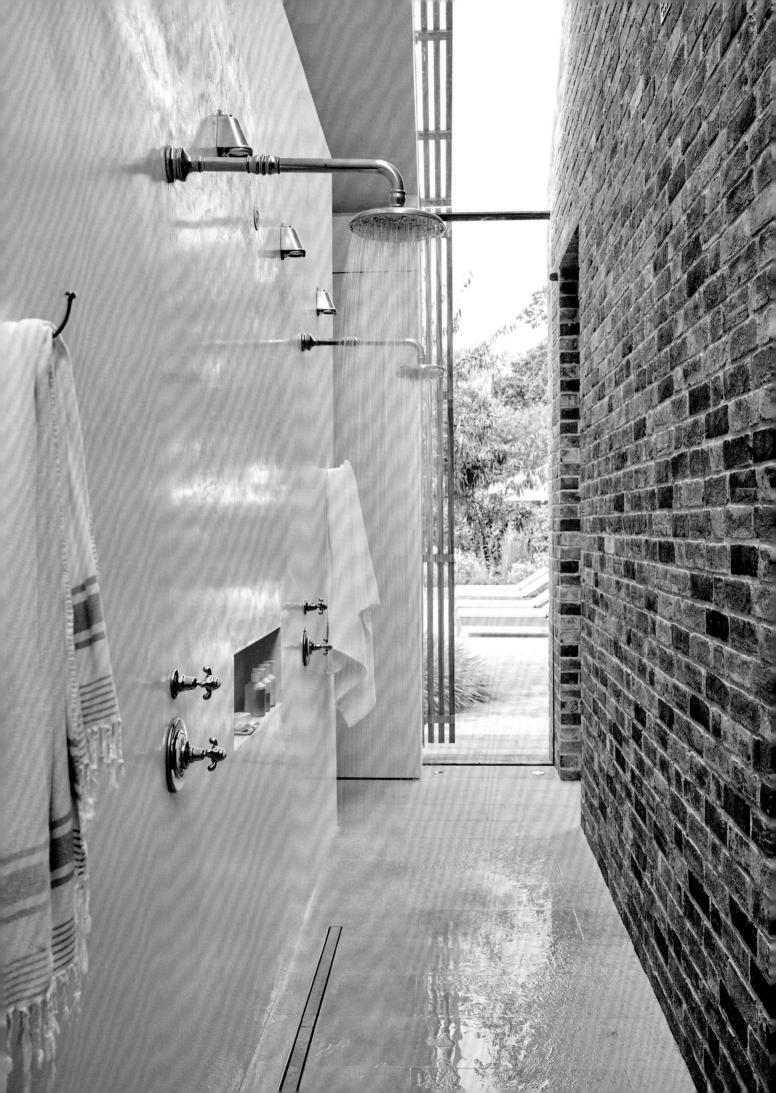

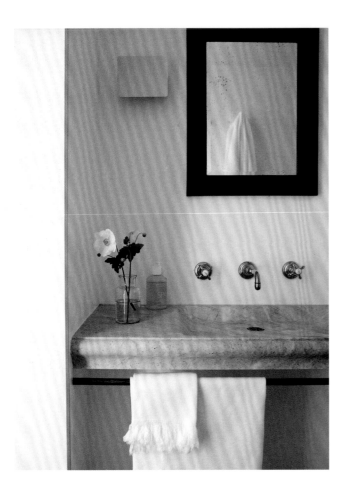

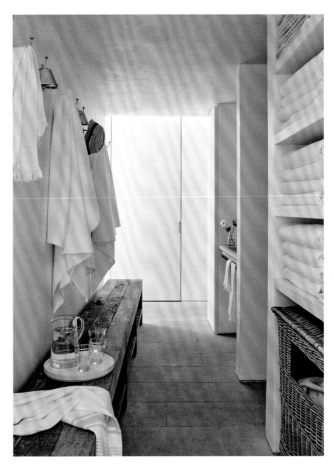

Opposite – The shower taps and spouts emerge
from the tadelakt walls, while a simple niche
hosts shower treats. Water flows away through
neat slots in the floor. The smooth tadelakt
contrasts with the rougher texture of the
exposed brickwork, while the slim, vertical
window frames a glimpse of the garden.

Above & right – This discreet portion of the
spa, beneath the mezzanine, offers a space for
changing. The marble sink, by Rose Uniacke,
is cut from a block of French Bleu de Savoie.
'I like the way it floats in the space, with its
soft contours and gentle curves but with the
weight and solidity of the stone,' she says.
Lightweight hammam towels are also very
useful for the sauna.

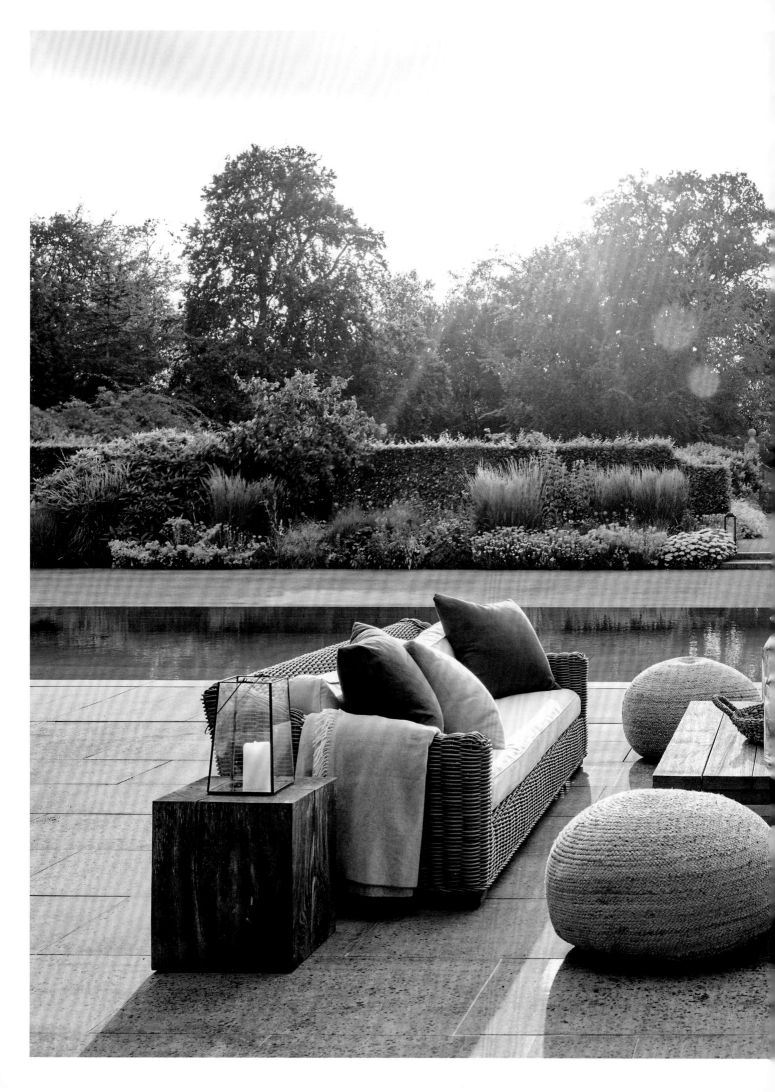

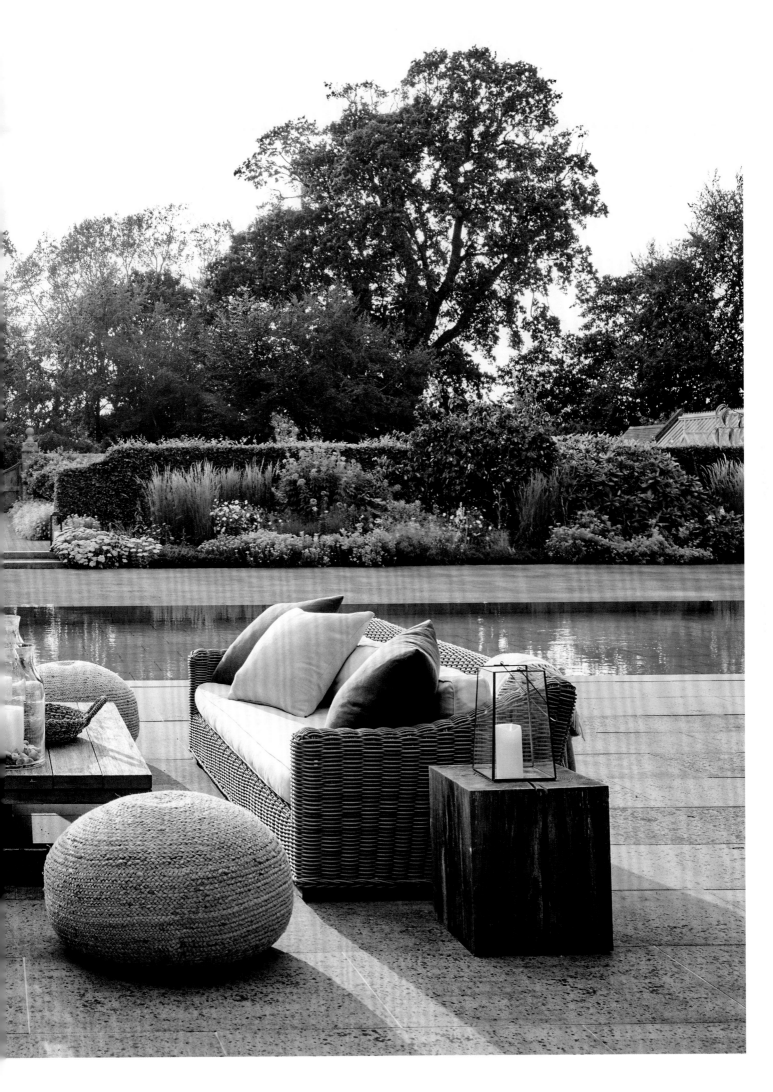

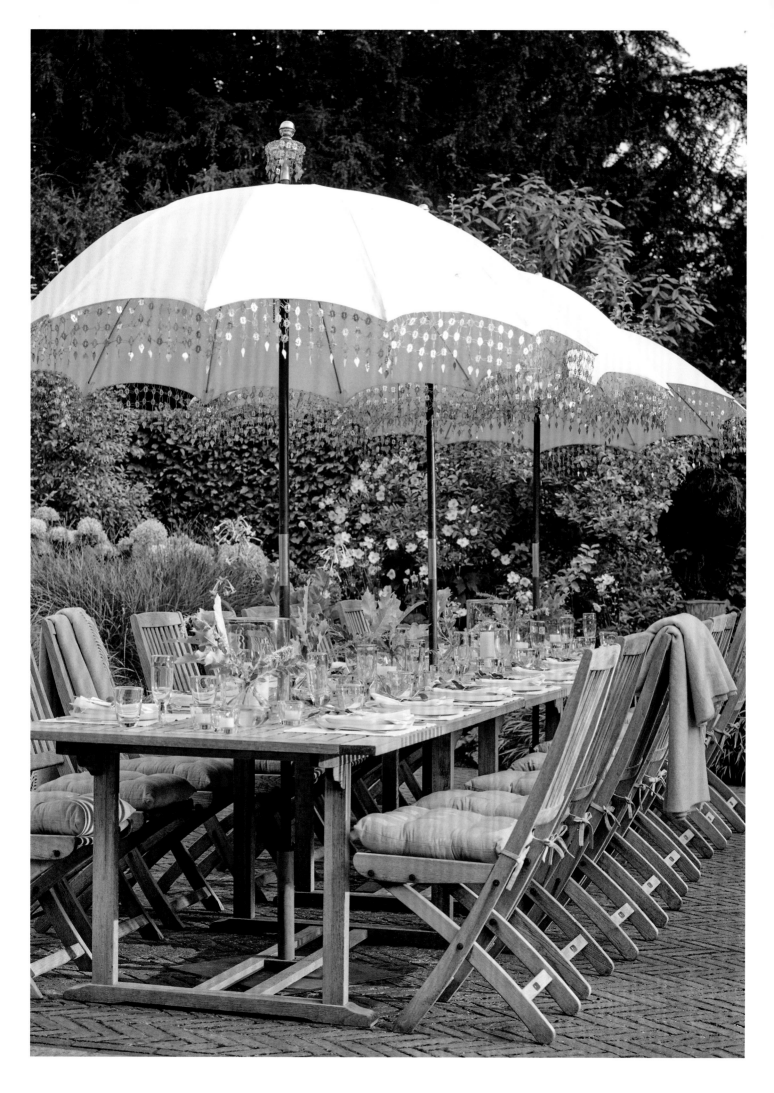

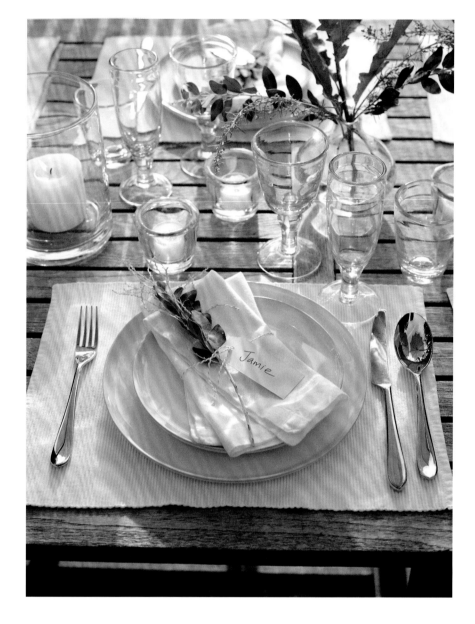

Previous pages – The vista from the Pool House, across the terrace and pool towards the walled garden. From here, there is a sense of the layered spaces in the garden itself, from the lawn to the beds of grasses and flowers, to the hedges and kitchen garden beyond. To the far right, there is a glimpse of the greenhouse.

Opposite & right – The outdoor table on the terrace is a much-loved space for summer lunches. White, Moroccan-style parasols shelter family and friends, while soft cushions ensure comfort. Thoughtful place settings – with Orford glassware and Artisan crockery from The White Company – offer a personal touch, and a collection of candles carries the evening beyond sunset with grace and delight.

The walled garden itself has been lovingly restored and replanted to a design by landscape architect Robert Myers. With its central banks of glass to either side, which slide away in warmer weather, the Pool House frames a key vista of this garden, looking down the central pathway to the original timber gateway at its far end, set into the old brick walls.

'We wanted the Pool House to sit very naturally in the garden environment,' says Chrissie. 'So the materials we used were brick, wood and stone because we were looking for something that felt organic and as though it really belonged here. There's a lovely combination of new and old that helps to make it feel at one with nature.'

In spring, summer and autumn, the terraces become vibrant outdoor rooms, like an extension of the living spaces within. Overlooking the pool, there are areas for relaxing and reading, as well as an outdoor dining room, protected in high summer by a line of parasols. The walled garden is a series of green spaces, or rooms, defined by box hedges and verdant planting.

Left & opposite – Repurposed garden buildings sit at the entrance to the walled garden. They now act as an inviting porch and form a kind of hallway with a simple table and bench to house welcoming candles and greenery. For Chrissie, these simple structures are all about complementary textures. As you enter the walled garden, the combination of brick floors and walls, together with raw timber and panelling, is a source of inspiration in itself, suggesting how aesthetic pleasure can be drawn from rustic imperfection.

'When we moved here ten years ago, the walled garden was almost derelict. I'm so happy we have managed to breathe life back into it,' says Chrissie. 'It has become a very special place for us as a family. We wanted a space where we could spend time together and enjoy with friends. We can swim, play games and feel like we have escaped a little from the rigour of normal life. I think it's probably my most favourite place to be.'

Shingle House

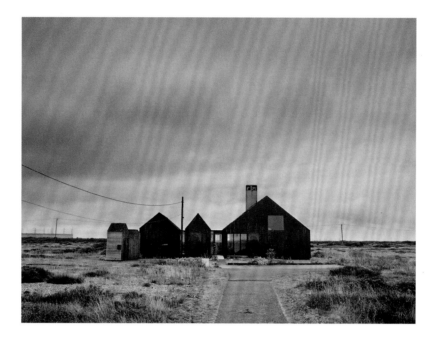

The houses within Living Architecture's portfolio are ambassadors of contemporary architecture and design. Founded by the philosopher and writer Alain de Botton, the company offers the opportunity to stay in one of a number of beautiful and exemplary modern homes in a range of rural locations. One of the most mesmerizing of these is Shingle House, in Dungeness on the Kent coast, which takes inspiration from the local fishermen's cottages.

'Dungeness is really a pilgrimage destination for many, and Shingle House manages the very difficult feat of being true to the traditions of the area but also alive to the possibilities of contemporary architecture,' says de Botton. 'When I stayed with my family, we loved being able to walk out of the house and straight onto that vast shingle beach, and my two boys particularly loved the miniature steam railway that runs past the house. The place is full of things to explore.'

Above – Like many of the cabins along the beach at Dungeness, the wooden exterior of Shingle House has been stained black, so that the building makes a graphic outline against the sky. Its shape is a modern echo of the traditional fisherman's cottage and outbuildings that once stood here.

Opposite – The mezzanine lounge makes an extraordinary observatory, looking out over the shingle beach towards the sea. The large picture window, surrounded by white tongue-and-groove panelling, frames the view perfectly and is best appreciated from the Russell Pinch armchair.

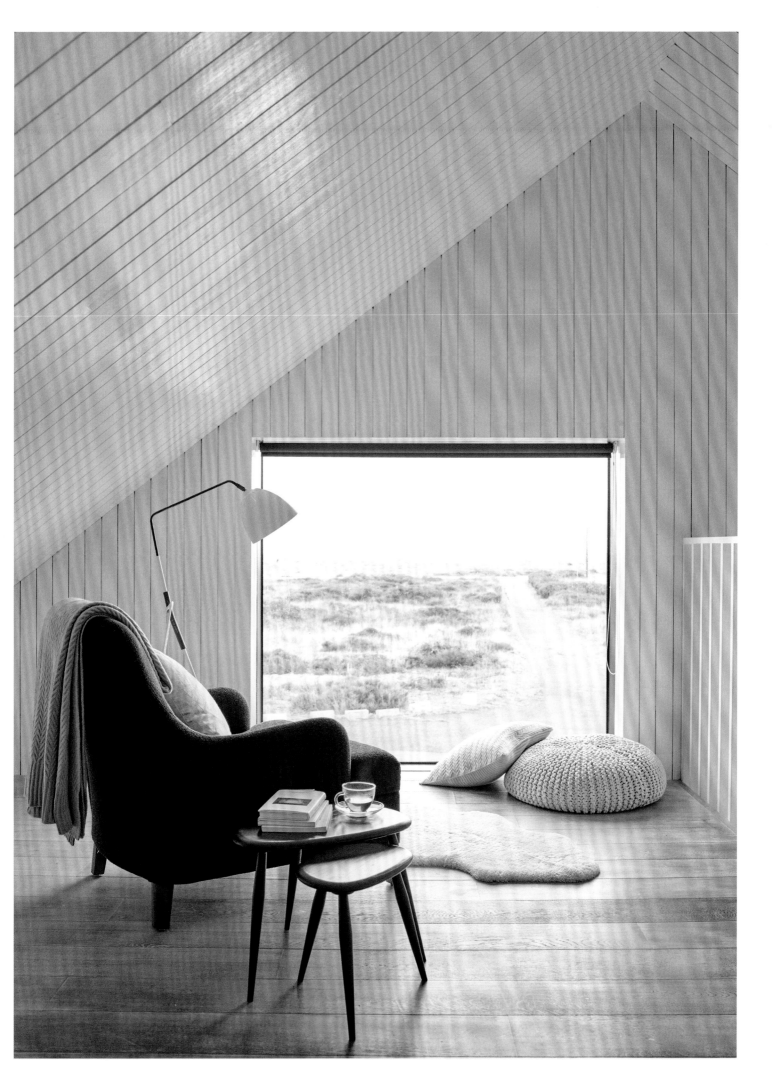

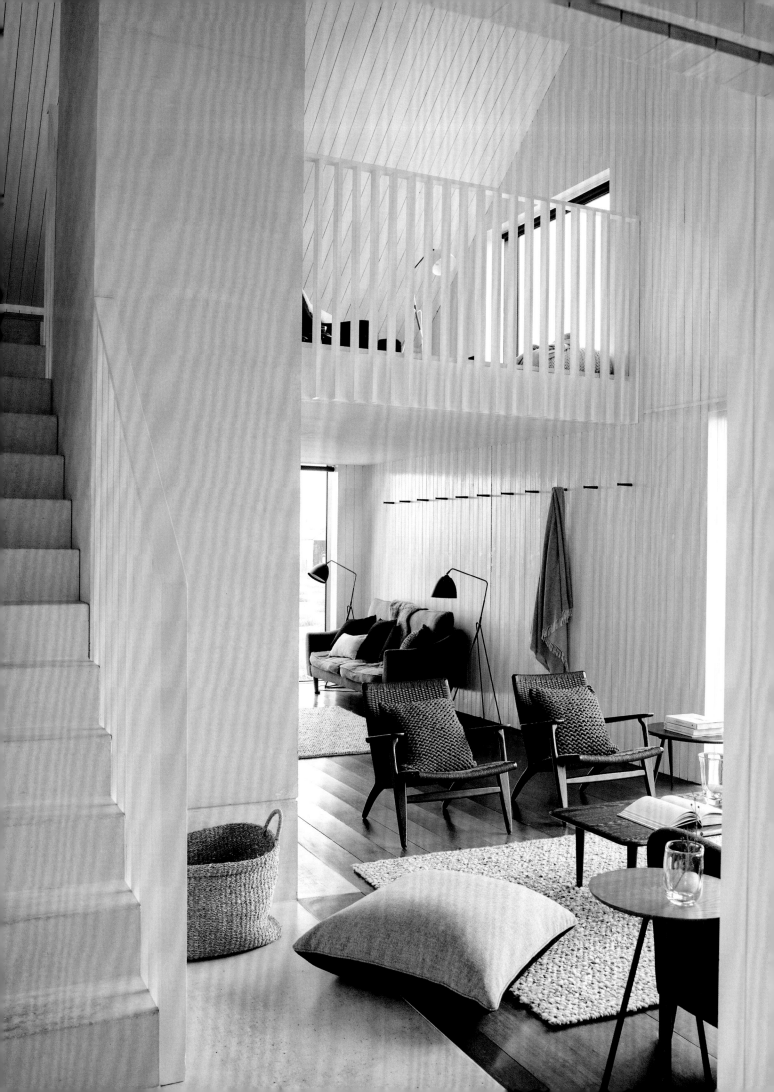

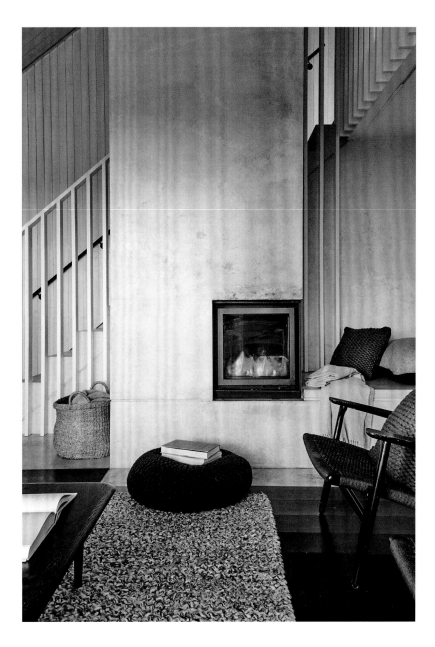

Opposite – The living room and mezzanine level above are unified by white tongue-and-groove panelling on the walls and ceilings. To create contrast, the furniture, including twin armchairs by Hans Wegner and a sofa by Russell Pinch, is mainly black and grey. The Örsjö standing lamps assume a sculptural quality against the neutral walls.

Right – The concrete chimney with its integrated fireplace, which leaves the clean lines of the living room uninterrupted, form not only a focal point but also a towering spine at the centre of the main part of the house. Although relatively small, the wood burner is efficient, sending warmth throughout the open-plan space.

Shingle House, designed by Alan Pert of NORD Architecture, is partly inspired by its location and partly by the local fishermen's houses, which – like the new building – are covered in wood and stained black. But inside the house, the decoration opts for a fresh, white palette by way of contrast, at the same time picking up on the beach-house tradition. The interiors are elegant and characterful, but also playful and relatively restrained in terms of colour and pattern, allowing the focus to remain on the far-reaching views of the coast, framed by the picture windows.

The main living room features white tongue-and-groove panelled walls and a warming fireplace. There are plenty of natural textures, including the dark purpleheart wooden floors and grey woollen rugs that help to delineate different parts of the space. A mezzanine level acts as a kind of lookout, made comfortable by the armchair facing the sea. The carefully curated collection of furniture includes pieces by Hans Wegner, Tom Dixon, Donna Wilson and Russell Pinch.

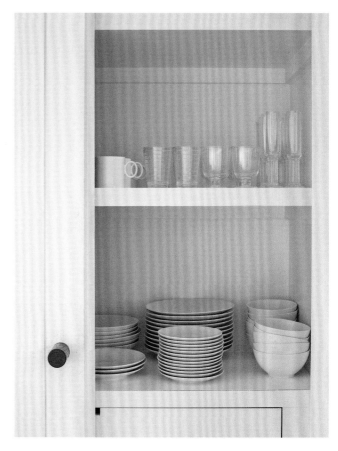

Above & above right – The custom-designed kitchen by NORD Architecture has plenty of storage, with neat stacks of china and glassware hidden away in cupboards. There are windows above both the sink and the stove, so that the views can still be enjoyed when cooking or preparing food.

Opposite – The folding glass doors to one side of the kitchen and dining room allow the space to be opened up during fine weather, to connect with the rear courtyard. From here, you can catch glimpses of the miniature railway steam trains.

The staggered formation of the house was modelled on the old fisherman's cottage, fish shop and smokehouse that once stood together on the site. The single-storey, open-plan kitchen and dining room are situated at the far end of the run, forming an outrigger to the main building, yet they are blessed with a sense of space, height and volume, which comes from the high, pitched roof and the use of tongue-and-groove panelling throughout. The white-painted wood surfaces help to tie the spaces together, while bouncing sunlight around the room.

'We liked the idea of having these individual blocks that do different things,' says architect Alan Pert. 'Each one has a sense of drama of its own, whether it relates to the view or something else that's going on. But it's also practical, comfortable and intimate. If it was overdesigned, it would become too slick and we didn't want to design a precious interior that you would have to tiptoe around.'

The kitchen itself is a custom design, with some lovely detailing, such as the brass taps. A wealth of integrated storage conceals the pots and pans, china and glassware, allowing the work surfaces to remain clear. Set in a U-shape, the units and worktops are highly ergonomic.

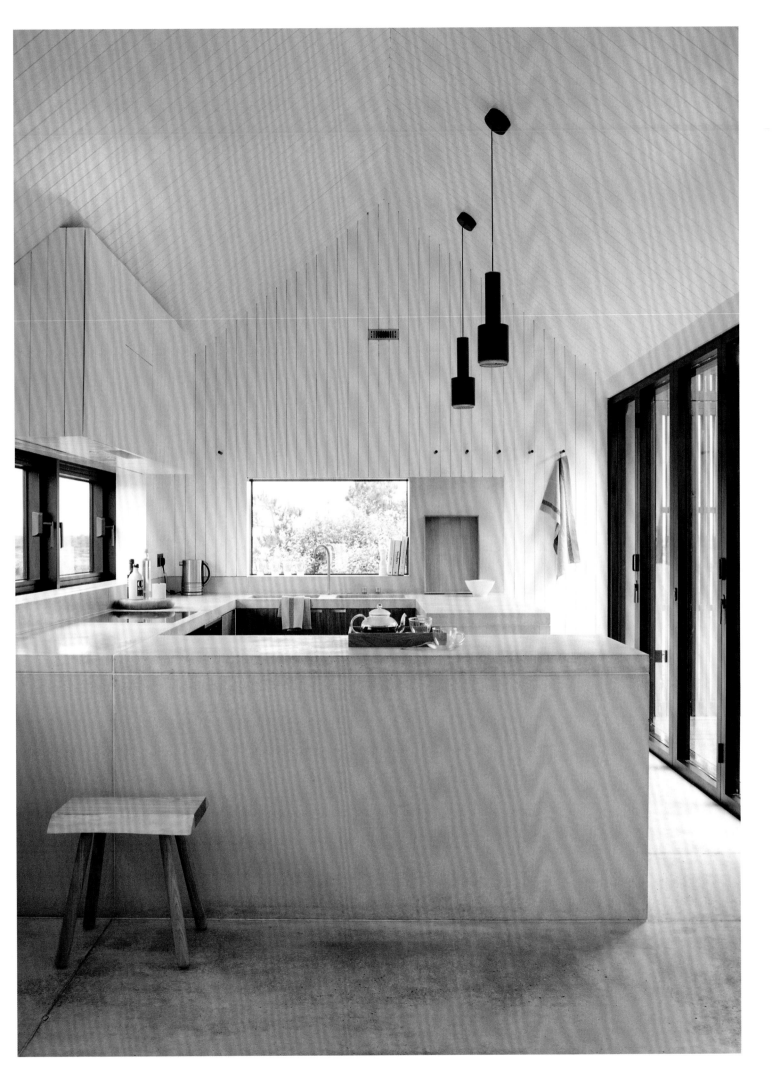

Opposite – The dining area sits in the same portion of the cabin as the adjacent kitchen. This outrigger to the main building is like a house in miniature, with its high, pitched roof and self-contained feel.

There is a soothing, almost Shaker-style simplicity to the dining area alongside the kitchen. Pegs are set directly into the panelling, and a long built-in bench runs along one wall, reducing the need for more freestanding chairs around the dining table. The dark elements in this black and white colour scheme, such as the soft furnishings, Jasper Morrison chairs and twin Alvar Aalto pendant lights over the dining table, stand out against the white and natural wood background. Full-height folding glass doors to one side allow the space to open up to the landscape, while a long, slot window in the gable end frames a view of the beach like a panoramic postcard.

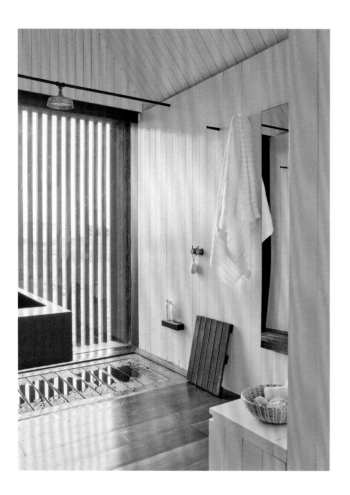

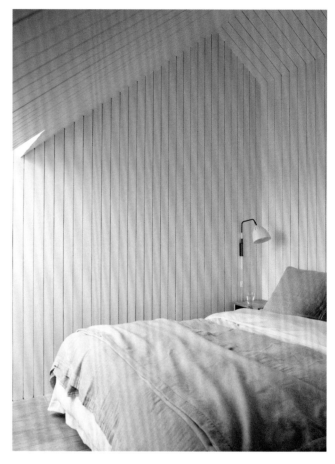

Above – This shower room on the ground floor has the luxurious feel of an upmarket spa. The partial screen over the large window offers privacy but also glimpses of the beach and the sea while showering, giving the impression – almost – of an outdoor bathing experience.

Above right – Shingle House has four bedrooms – three on the ground floor and this one in the eaves. This part of the house, set slightly apart from the rest, has an escapist quality, with the sense of calm enhanced by the soothing palette of whites and greys.

Opposite – The en suite bathroom serving the bedroom on the upper level has a sculptural bathtub and a black and white colour scheme in keeping with the other areas in the house. The eaves give a cocooning feel, yet the large skylight, which lets in a wealth of daylight, leads the eye upwards.

The four bedrooms are light and restful spaces, where the emphasis is on natural textures and connections with the landscape outside. Appropriately enough for its coastal setting, the house places a particular focus on the rituals of bathing, with a bathhouse on the ground floor offering a wet room with a view of the sea via a partially screened picture window. In the bathroom on the upper storey, the curves of the bathtub are enhanced by its dark outer surface, continuing the black and white theme that plays such an important part in the design of this modern masterpiece on the beach.

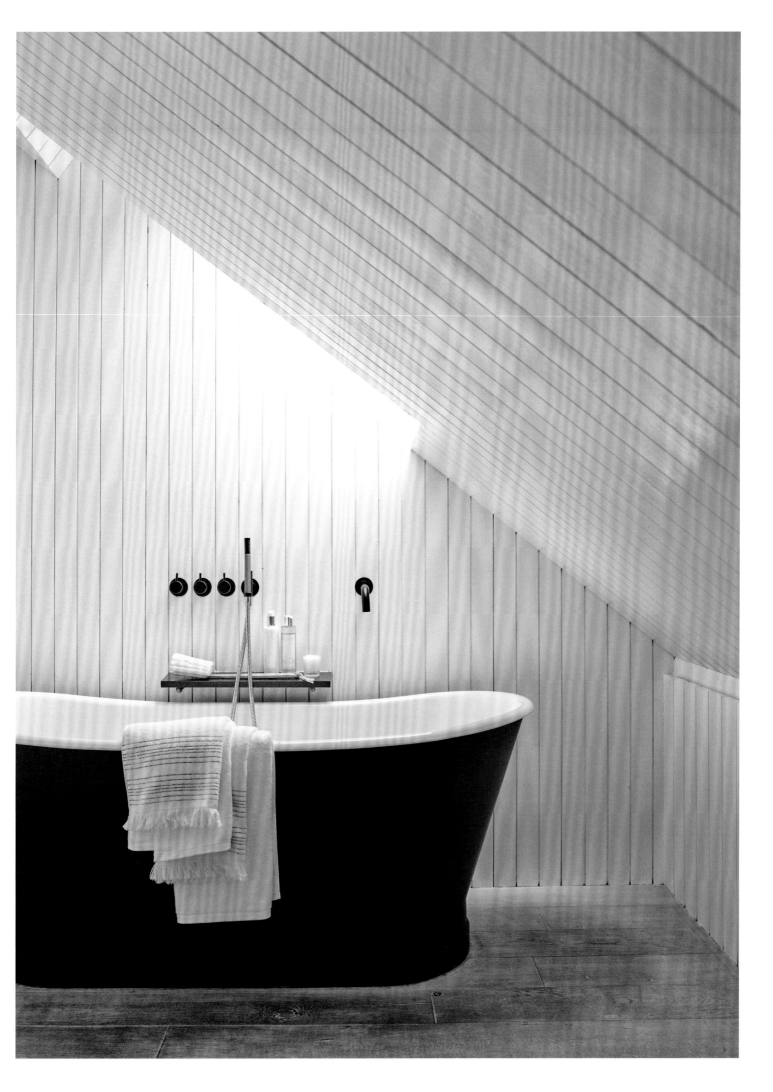

Styling details

— BY THE BEACH —

SEASIDE SOJOURN

The large picture window on the mezzanine level offers the perfect spot for relaxing and unwinding. Here, a softly textured floor cushion, pillow and throw provide all the necessary comforts for lying back and gazing out to sea, following the switching tides.

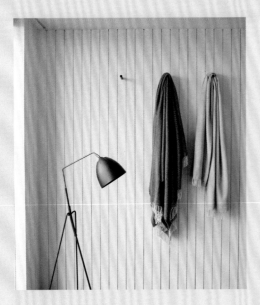

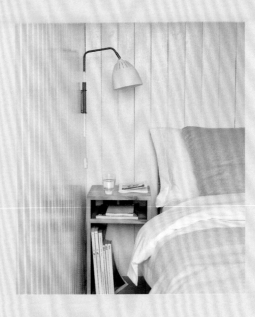

SHAKER MODERN

One of the most endearing and repeated motifs in Shingle House is the Shaker-style pegs fixed to the panelled walls. Not only practical, they also provide opportunities to create simple wallscapes. The Örsjö floorlamp completes the scene.

HAND CRAFT

The crafted quality of the house is combined with thoughtful ergonomics. In the simple bedrooms, for instance, a wall-mounted reading lamp and a small bedside table, with books and magazines, are really all that anyone would need in a sleeping space.

TWIN TALES

In the dining room at one end of the house, two Shaker pegs, a panoramic postcard window with a view of the dunes, and two Jasper Morrison black chairs against a white panelled wall make a striking composition with the wooden floor.

NESTING INSTINCTS

Nesting tables, such as these classic Ercol designs with their gentle curves and tapered legs, offer an engaging level of flexibility as side surfaces. Like the Russell Pinch armchair alongside, the dark tables punctuate the white space and give added interest.

To the Lighthouse

'Everybody loves that moment when they arrive at a lighthouse,' says architect Sally Mackereth. 'The idea of sleeping in a round room in this tower with a view of the sea and the sound of the waves is wonderful. It's a kind of fantasy.'

Tempted by the idea of working with such a characterful building, but also giving her children a taste of the freedom that she enjoyed as a child, Sally and her family decided to buy this lighthouse in a quiet Norfolk village, where it feels as though time has stood still. The village still has a general store, a post office, a fish and chip shop and a real pub, along with that feeling of liberation that comes only from stepping off the beaten track.

'We live in London during the week, and urban life can be very restrictive, especially for the children,' Sally says. 'When they were little, Julian, their father, and I would bundle them into the car on a Friday night and they would fall asleep on the way to Norfolk as we felt the city peel away. We would all arrive in the dark and then the children would wake up in the morning in the lighthouse. That is really magical.'

Above – A compass dial inside the dome of the lighthouse lantern has been attached to the weather vane on the very top of the tower. This gives not only an internal indication of wind direction but is also an engaging kinetic feature in itself.

Opposite – Sally designed the new lighthouse lantern as an observatory, looking out across the sea. This inviting belvedere features a built-in banquette, concealing a minibar, while the stairs lead up to a sleeping platform on the mezzanine level.

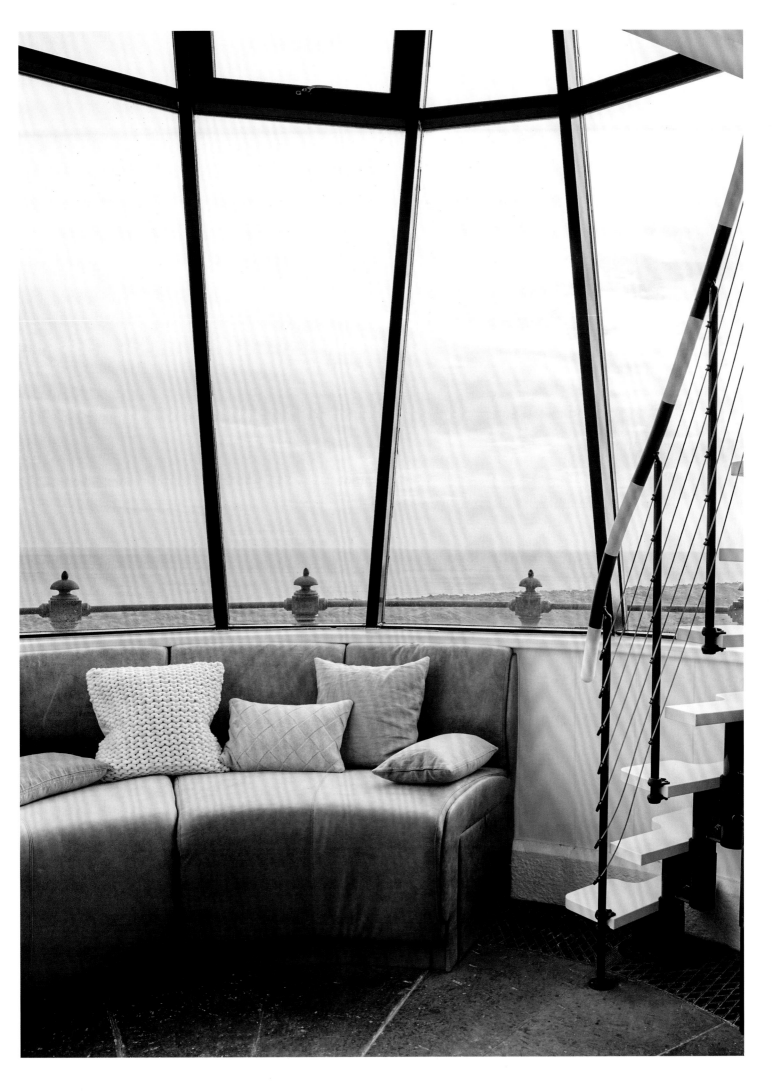

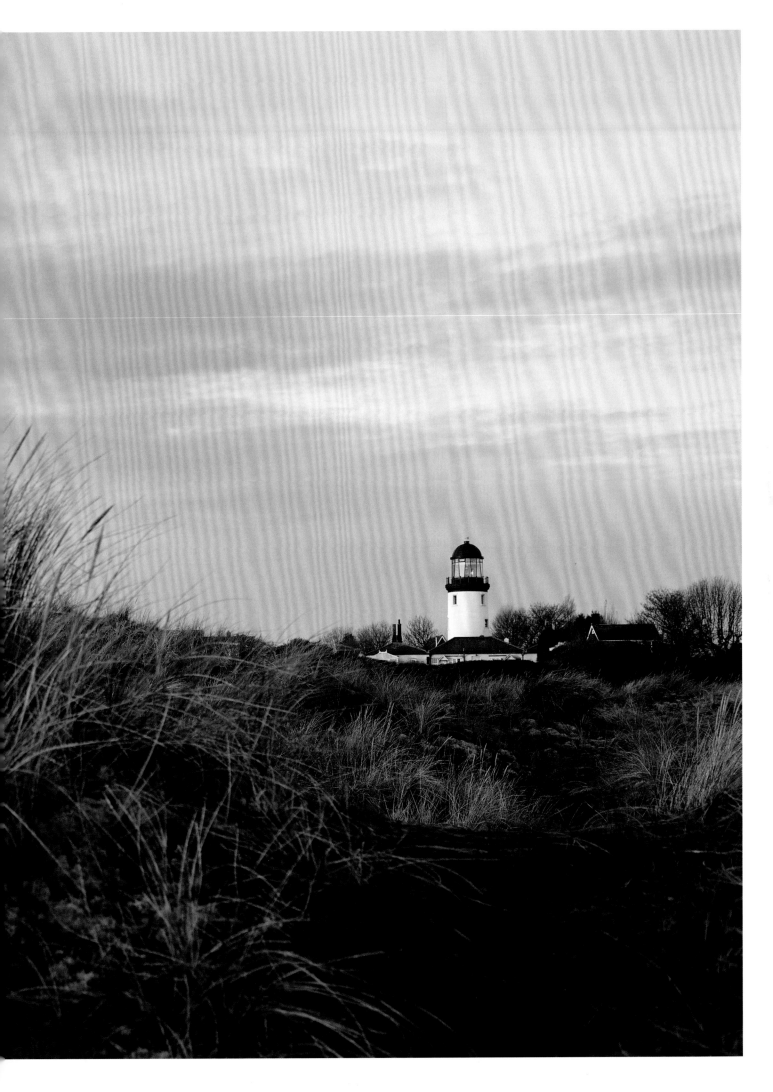

Previous pages – The lighthouse is set back from
the beach, with sand dunes helping to protect the
tower and the village from the sea. The natural dip
in the dunes forms part of a nature reserve and
offers shelter when walking and playing outdoors.

Right – The circular sitting room is located on the
ground floor in the base of the lighthouse, where
the walls, ceilings and sculpted staircase are painted
white. Darker elements, such as the banisters and
the Jean Prouvé wall-mounted light, stand out
all the more against this pale backdrop.

The first lighthouse on this site dates back to the 17th century.
It was later rebuilt after a fire and then altered over the years. It stopped
serving as a working lighthouse in the Twenties and was turned into
a home, while the original lantern was auctioned off and shipped to
the Bahamas for fresh service. By the time Sally and her family bought
the lighthouse, it had been domesticated, which included the addition
of nylon carpets on the stairs, but the original bones were clearly there.

'It does have a wonderful history going back to Elizabethan times,
when there was a wooden tower with a bonfire on the top,' Sally says.
'It's also mentioned in Daniel Defoe's *Robinson Crusoe*. We think that
originally it was painted red but it was rather a faded, non-colour
when we arrived. I think it had been painted white at one point,
so we painted the main tower in white with a black base and collar.'

Sally restored the lighthouse in two phases, relishing the
opportunity to work on a building so full of stories. She created
a ground floor and a single-storey extension holding the combined
kitchen and dining room, as well as bathrooms. Warmed by a wood-
burning stove, the white-painted dining room flows out onto a deck
and into the garden via a set of floor-to-ceiling folding glass doors.

'I thought that painting things white was a really good starting
point here, as it does make it feel like a beach house. There's
something rather beautiful about white floor paint and finishes.
Architects do tend to get hung up on the detail of everything but
here we just wanted something much more straightforward and
needed a home that felt like an easy place to be.'

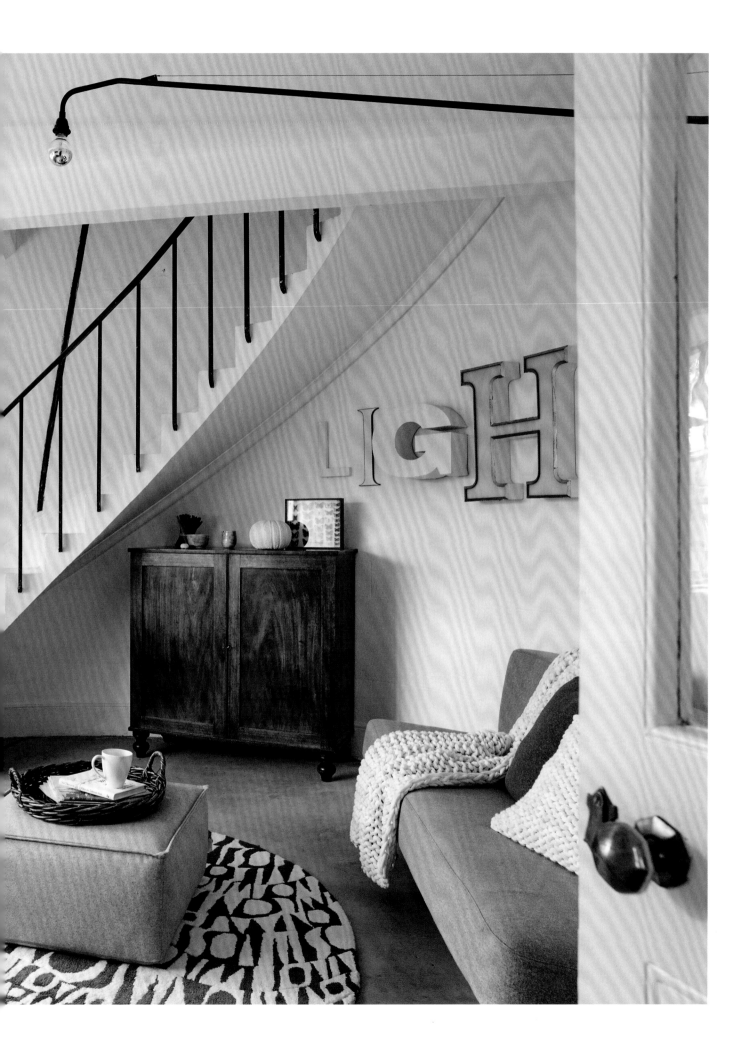

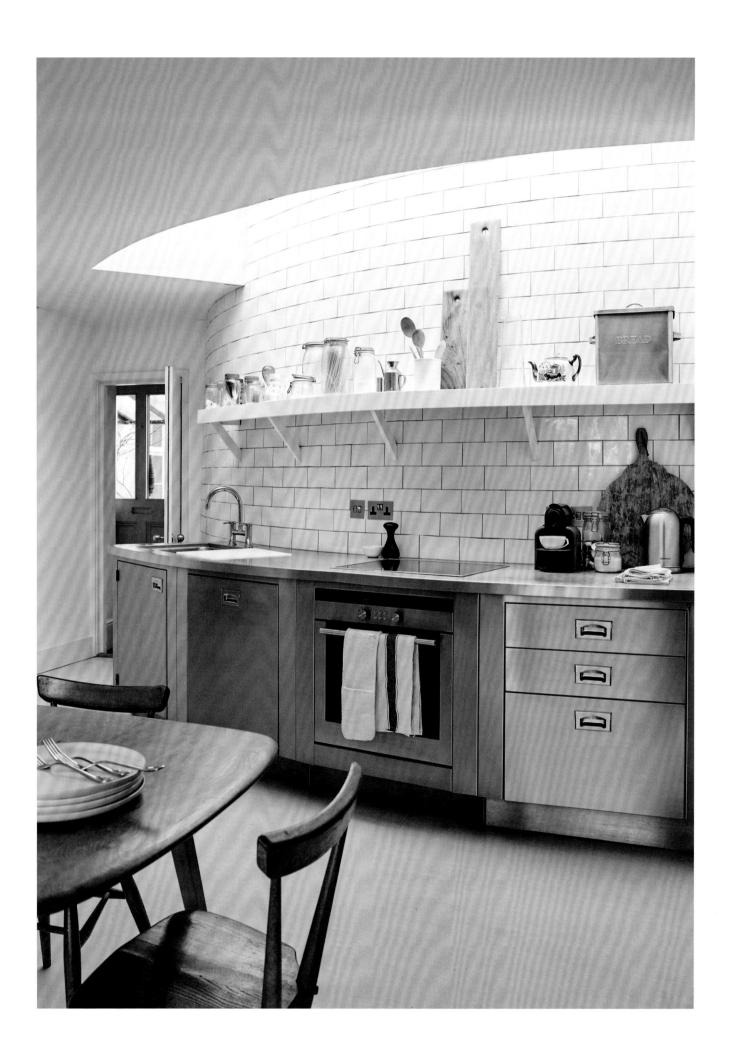

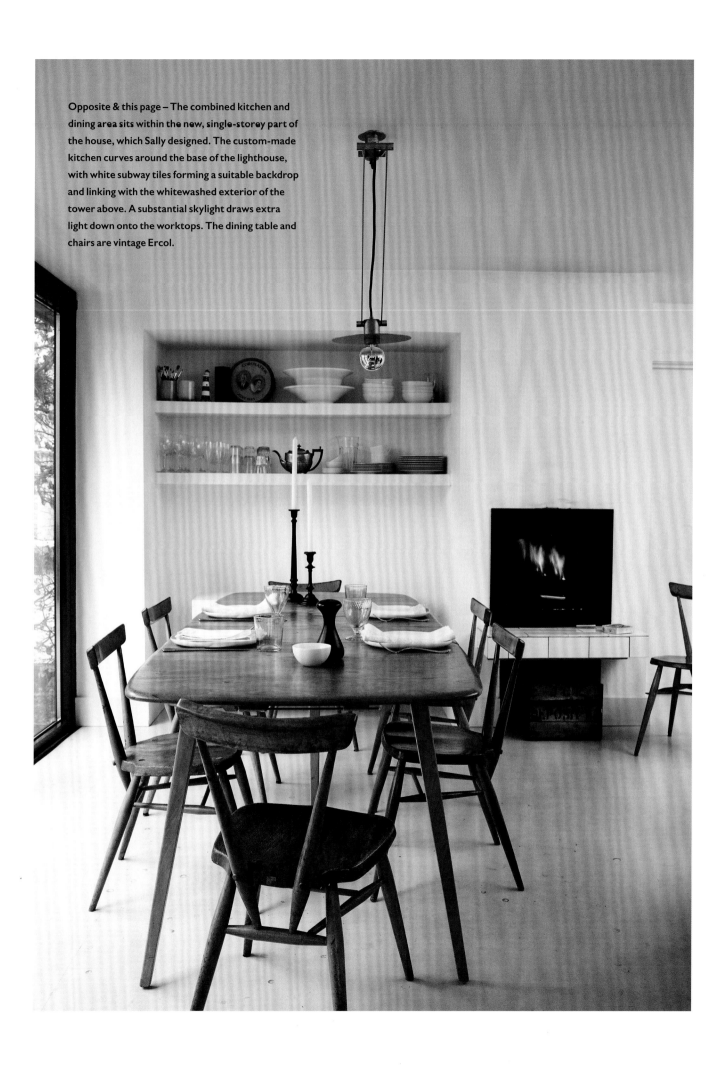

Opposite & this page – The combined kitchen and dining area sits within the new, single-storey part of the house, which Sally designed. The custom-made kitchen curves around the base of the lighthouse, with white subway tiles forming a suitable backdrop and linking with the whitewashed exterior of the tower above. A substantial skylight draws extra light down onto the worktops. The dining table and chairs are vintage Ercol.

Styling details

— COASTAL LIVING —

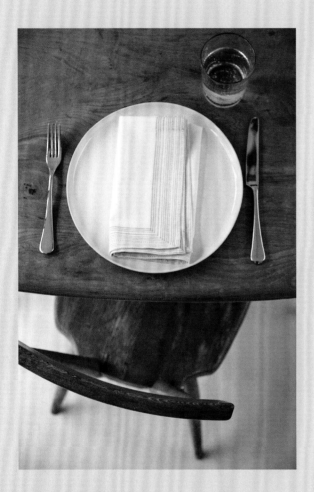

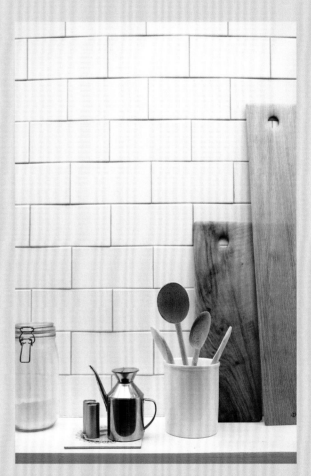

CASUAL DINING

The vintage Ercol dining table and chairs in the new part of the lighthouse offer an easy, unpretentious setting for casual suppers. Crisp white china and white napkins make a lovely contrast against the wood and bring a touch of order.

BOARDS & LODGING

In the kitchen, ranks of bread boards double as serving platters and chopping boards. Their organic, textural beauty makes them the perfect choice for the informality of the lighthouse and its coastal location.

COASTAL CRAFT

Part of the pleasure of seaside living is embracing
the curiosities and treasures that are a unique
part of it. Beach bags, coastal maps and other
exclusively maritime delights feel very much at
home here.

BEACHCOMBING

Found objects, from rounded pebbles to sculpted
shells washed up on the shore, make perfect
displays in a lighthouse. Such simple discoveries
are a vital ingredient in compositions dependent
on a sense of place.

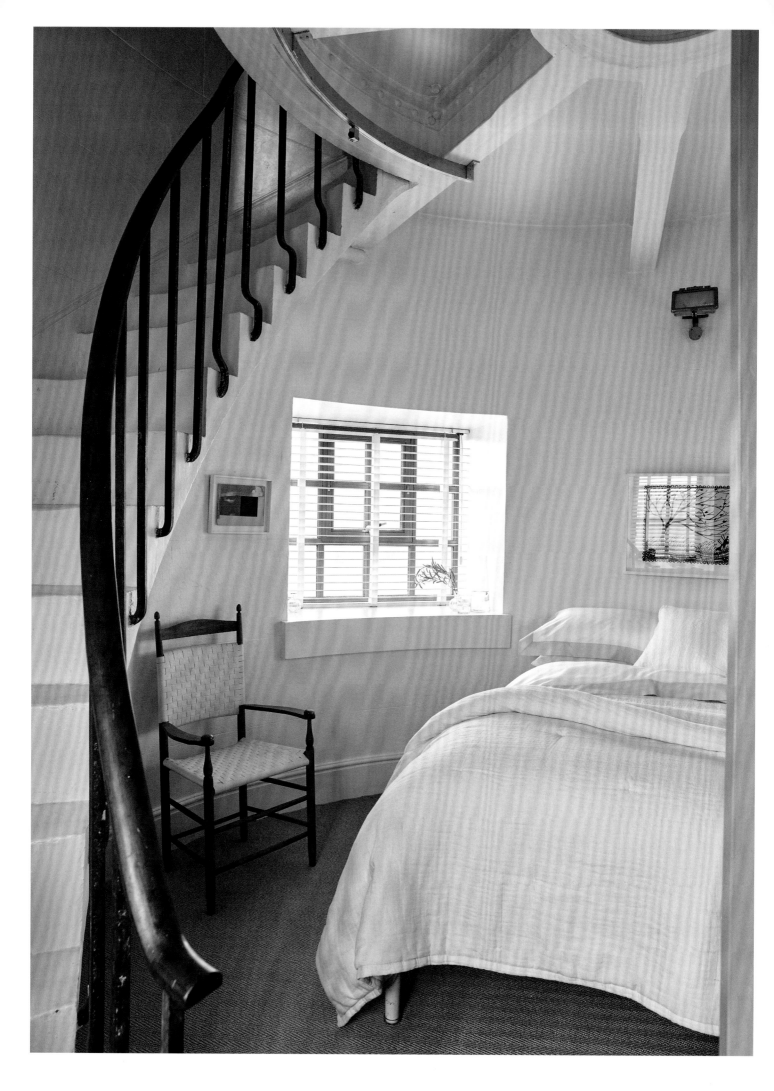

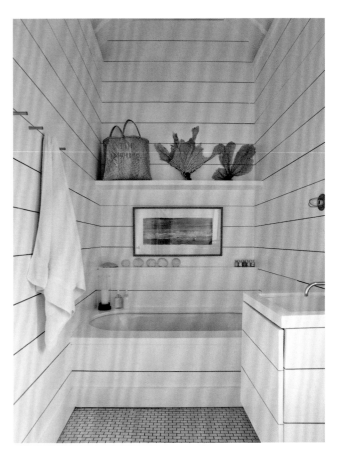

Opposite & above – The master bedroom is located in one of the circular spaces of the lighthouse itself. Pale bed linen complements the white walls and the dramatic steel ceiling, also picked out in white, while simple Venetian blinds dress the windows.

Above right – This small but perfectly formed bathroom sits in the new part of the house. White tongue-and-groove walls bring a coastal aesthetic, while display ledges and shelves help to frame the bathtub. Shaker-style pegs are simple but practical additions.

The round rooms in the tower were updated and converted into a series of family-friendly spaces, beginning with the sitting room on the ground floor. The curving staircase was restored and the banisters stained black, which stand out against the neutral palette used elsewhere. Heading upwards, the children's bedroom features fitted bunk beds, also in white, which lend the space the feel of a ship's cabin. Above the bed in the master bedroom is the sculptural propeller-shaped steel floor plate that helps to support the lighthouse. This, too, is painted white.

'Before we bought the lighthouse, we used to spend family holidays in places like Harbour Island in the Bahamas, where everyone, literally, whitewashes their house at the turn of the season,' says Sally. 'There is such a relaxed and unprecious quality to the beach-house feel and it does have this calm simplicity to it.'

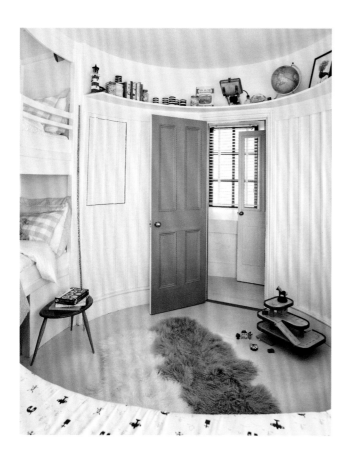

Above & above right – A high shelf placed around the curved wall in the children's bedroom creates a valuable storage and display space for books, seaside treasures and ceramics. A woollen rug adds softness and texture.

Opposite – In a room reminiscent of a ship's cabin, white custom-made bunk beds fit snugly against the curved wall, with storage baskets slotted in underneath, so that not an inch of space is wasted. One of the beds doubles as seating.

Some years after the first phase of work devoted to restoring and extending the lighthouse, Sally decided that she would like to reinstate the lantern at the top of the tower. She designed a steel-framed glass observatory, which manages to feel both authentic and contemporary. Taking inspiration from her children's sketches of the lighthouse, Sally created a new lantern that holds a built-in banquette for best appreciating the open views of the sea. Glasses, cups and a minibar are tucked away within integrated drawers to avoid the long trip back down to ground level.

'The leather banquette has this rather lovely murky green colour that echoes the sea. And then the lantern itself is double-height, so there was also space for a mezzanine at the top with a bed on it, and from there you have a 360-degree view, looking inland as well as across the sea. I always had this burning desire to reinstate the lantern because it did feel, before, as though it was incomplete. Now it's whole again.'

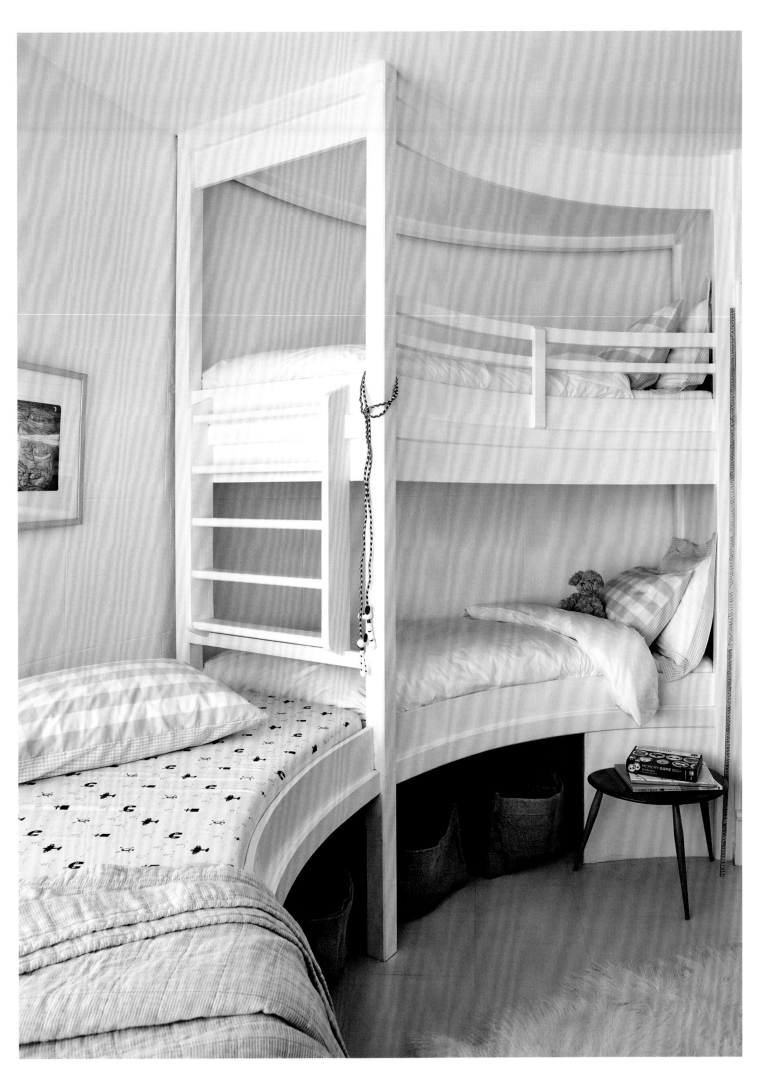

Contributors

City Sanctuary
see pages 44–55

WILLIAM SMALLEY

As an architect, William's portfolio includes residential projects in both the UK and overseas, and in town and country. He founded his own practice in 2010, having studied architecture at the University of Edinburgh, followed by five years of work with James Gorst Architects. His varied sources of inspiration include Barbara Hepworth, Luis Barragán, Peter Zumthor and Filippo Brunelleschi. William stresses the importance of 'creating buildings and places that are pleasant spaces to be', advice that he followed with the design of his London apartment.

williamsmalley.com

Courtyard Oasis
see pages 56–65

BETH DADSWELL

Beth began her first career as a press journalist and stylist after studying at the London College of Fashion. She became increasingly involved with interior design through a series of homes that she worked on for herself and her partner Andrew Wilbourne, a graphic designer. One of their latest projects is the conversion of a former dairy into a family home, which coincided with the launch of Beth's atelier, Imperfect Interiors. Her studio's many projects include townhouses, apartments and coastal retreats, with a focus on creating characterful and original spaces.

imperfectinteriors.co.uk

Townhouse Living
see pages 66–81

HARRY & REBECCA WHITTAKER

Having studied architecture at Oxford Polytechnic, Harry Whittaker began working in Shrewsbury, specializing in high-end residential projects and conservation work. He became a partner in the Bath office of Chris Dyson Architects and then founded his own firm, Bath Conservation Architects, taking a light and intelligent touch to period buildings while updating them for modern living. He shares his own home in Bradford on Avon with his wife Rebecca, a relationship counsellor. They have a mutual love of historic buildings, individual interiors, gentle colours and antiques.

bathconservationarchitects.com

The Rest
see pages 120–45

MARK & SALLY WINSTANLEY

Mark's passion for design runs all the way through his working life and throughout his own home. He studied textile design at Loughborough College of Art & Design and went on to work at Laura Ashley, where he spent many years as the company's Creative Director, focused on home furnishings collections and catalogues. Mark is now Chief Creative Officer at The White Company. He is an avid collector and curator, and his Sussex home is layered with countless personal treasures, including art, furniture, linens and glassware. His wife Sally also worked with Laura Ashley for many years and is now a freelance art director.

thewhitecompany.com

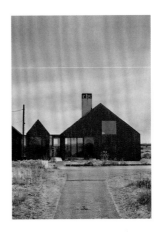

Cottage Calm
see pages 158–79

House of Warmth
see pages 180–97

Shingle House
see pages 220–31

To the Lighthouse
see pages 232–45

KAREN & ANTHONY CULL

Antiques dealers Karen and Anthony have a warehouse showroom in the Cotswold town of Winchcombe, where they present a lovingly curated collection of furniture and individual decorative pieces. Their favourite periods and provenances include 18th- and 19th-century French and Scandinavian design, and they have a particular soft spot for pieces rich in patina and history. Having lived in Spain for many years, they have a love of sunlight and outdoor living, explored in the design of their own home, which also features their collections of ceramics and stoneware.

antonandk.co.uk

MEG MEADON

Oxfordshire-based design and interiors consultant Meg Meadon started out working in the Arms & Armour department of Sotheby's auction house. Later, she moved into the advertising industry, working as an art director and campaign producer for major retail groups. Having settled back into the country with her family, Meg now combines her expertise in antiques and art direction through her work as a freelance consultant, advising private clients on the look and feel of their own homes.

meg.meadon@gmail.com

LIVING ARCHITECTURE/ NORD ARCHITECTURE

Living Architecture was founded in 2006 by the writer and philosopher Alain de Botton, a great supporter of modern architecture. The idea was to create a collection of new and custom-built holiday houses around Britain that would allow guests to experience and enjoy contemporary architecture and design for themselves. Set in sublime locations, the collection includes work by leading architects such as John Pawson, Peter Zumthor and Michael Hopkins. Shingle House in Dungeness was designed by NORD – the Northern Office for Research & Design – which was founded by Alan Pert and Robin Lee.

livingarchitecture.co.uk

SALLY MACKERETH

Working from self-designed offices near St Pancras in London, architect Sally Mackereth balances residential, cultural and commercial projects in the UK and internationally. Having studied at the Architectural Association, she cofounded her first atelier, Wells Mackereth, which was followed 18 years later by Studio Mackereth. Her work fuses architecture and interiors within rounded, cohesive projects, where both have equal importance and attention. Sally also teaches at the Royal College of Art.

studiomackereth.com

Contributors

Creative Director
MARK WINSTANLEY

Chief Creative Officer of The White Company, Mark has worked closely with founder Chrissie Rucker for more than a decade, building and growing the brand across all categories. Today, his responsibilities cover all creative aspects of the company, including the home collections, brochures and the visual presentation of the stores in the UK and abroad. He lives in Sussex and Norfolk. His family home is featured on pages 120–45.

thewhitecompany.com

Contributing Editor
DOMINIC BRADBURY

Dominic is a writer and journalist specializing in design and architecture. He writes for magazines and newspapers in the UK and internationally, including *The Times*, *Financial Times*, the *Guardian* and *House & Garden*. His many books include *The Iconic House*, *Mid-Century Modern Complete*, *Modernist Design Complete* and *Off the Grid: Houses for Escape*. He lives in Norfolk.

dominicbradbury.net

Photographer
CHRIS EVERARD

As well as taking all of the pictures in this book, Chris works for many magazines and newspapers, including the *Telegraph*, *Homes & Gardens* and *Living Etc*. Much of his work revolves around interior design and lifestyle, with a long list of commercial clients, including The White Company, The Water Monopoly, Mulberry and many others. Chris studied fine art before moving into photography, and his extensive portfolio also includes portraits, still lifes and landscapes. He lives in London and Norfolk.

chris-everard.com

Stylist
ELKIE BROWN

Elkie works in both the UK and the USA as a stylist specializing in interiors. She began her career as a merchandiser and buyer before moving into styling, and her work has been featured in numerous magazines, newspapers and books. Elkie works closely with many leading photographers and art directors, while her commercial client list includes companies such as The White Company, House of Fraser and Williams Sonoma among others. Her Pinterest account has more than 600,000 followers.

elkiebrown.com

Sourcebook

Alex MacArthur Interiors
The Monastery
Conduit Hill
Rye
East Sussex TN31 7LE
alexmacarthur.co.uk

Ann Boyd Design
01608 811177
07780 700337

Beechfield Reclamation
The White Horse Yard
Beechfield Road
Hopton Park Industrial Estate
Devizes
Wiltshire SN10 2DX
beechfieldreclamation.co.uk

Cadogan Contemporary
87 Old Brompton Road
London SW7 3LD
cadogancontemporary.com

Clerk Ink Well Letterpress
 Posters
clerkinkwell.com

Cliffe Gallery Antiques
39 Cliffe High Street
Lewes
East Sussex BN7 2AN

Crystal Palace Antiques
Imperial House,
Jasper Road
London SE19 1SG
crystalpalaceantiques.com

Drummonds
642 Kings Road
London SW6 2DU
drummonds-uk.com

Farrow & Ball
(Various locations)
farrow-ball.com

Hadlow Down Antiques
Hastingford Farm
Hastingford Lane
Hadlow Down
East Sussex TN22 4DY
hadlowdownantiques.co.uk
(By appointment only)

Hilary Batstone
84 Bourne Street
London SW1W 8HQ
hilarybatstone.com

Jaime Frankfurt
 Art Advisor
Jaime Frankfurt LLC
228 West 22nd St.
New York, NY, 10011
(+001) 212-206-110

John Cullen Lighting
Unit 24, Talina Centre
Bagley's Lane
London SW6 2BW
johncullenlighting.com

Lacy Gallery
203 Westbourne Grove
London W11 2SB
lacygallery.co.uk

Mandarin Stone
(Various locations)
mandarinstone.com

Michaelis Boyd Architects
108 Palace Gardens Terrace
London W8 4RT
michaelisboyd.com

Nicky Dobree Interior
 Design Ltd
39 Moreton Street
London SW1V 2NY
nickydobree.com

No. 1 Lewes Antiques
1 Cliffe High Street
Lewes, East Sussex BN7 2AH
theshoplewes.com

Norfolk Decorative Antiques
8E Millers Close
Fakenham Industrial Estate
Norfolk NR21 8NW
antiquelighting.co.uk

Paffron & Scott Antiques
4 Briston Road
Melton Constable
Norfolk NR24 2DA
paffronandscott.co.uk

Paint & Paper Library
3 Elystan Street
London SW3 3NT
paintandpaperlibrary.com

Petersham Nurseries
Church Lane
Off Petersham Road
Richmond
Surrey TW10 7AB
petershamnurseries.com

Retrouvius
1016 Harrow Road
Kensal Green
London NW10 5NS
retrouvius.com

Rose Uniacke
76–84 Pimlico Road
London SW1W 8PL
roseuniacke.com

Streett Marburg Antiques
297 Lillie Road
London SW6 7LL
streettmarburg.co.uk

Takero Shimazaki Architects
6A Peacock Yard
Iliffe Street
London SE17 3LH
t-sa.co.uk

Trainspotters
Units 3 & 4 New Mills
Libbys Drive
Stroud GL5 1RN
trainspotters.co.uk

Wells Reclamation
Coxley
Wells
Somerset BA5 1RQ
wellsreclamation.com

Wilson Stephens & Jones Fine
 & Decorative Art
71 Westbourne Park Road
London W2 5QH
wilsonstephensandjones.com

The White Company Stores

UK

ABERDEEN
Union Square Mall, Guild Square,
Aberdeen AB11 5RG

BATH
15–16 Northgate Street, Bath, Avon BA1 5AS

BEVERLEY
44 Toll Gavel, 2 Cross Street,
Beverley, Hull HU17 9AX

BICESTER
2 Pingle Drive, Bicester, Oxon OX26 6WD

BIRMINGHAM GRAND CENTRAL
Unit 2B, Stephenson Place,
Birmingham B2 4BF

BLUEWATER
Unit L103, Bluewater Shopping Centre,
Lower Guildhall, Greenhithe, Kent
DA9 9ST

BRENT CROSS
Upper Ground Level Metropolitan Mall,
Brent Cross Shopping Centre, London
NW4 3FP

BRIGHTON
4 North Street, Brighton BN1 1EB

BRISTOL
Unit 134/135 Upper Level, The Mall at
Cribbs Causeway, Bristol BS34 5DG

BROMLEY
The Glades Shopping Centre,
High Street, Bromley BR1 1DN

CAMBRIDGE
SU 53 Upper Mall, Grand Arcade,
Cambridge CB2 3BJ

CAMP HOPSON
7–11 Northbrook Street, Newbury
RG14 1DN

CANARY WHARF
Unit 70, Jubilee Place, Canary Wharf,
London E14 5NY

CARDIFF
Unit LG, 22–23 & 24, St David's Mall,
Cardiff CF10 2DP

CHELMSFORD
Bond Street, Chelmsford CM1 1GH

CHELTENHAM
84 The Promenade, Cheltenham GL50 1NB

CHESTER
19 Northgate Street, Chester CH1 2HA

CHICHESTER
73 North Street, Chichester PO19 1LB

COVENT GARDEN
Slingsby Place, St Martin's Courtyard,
London WC2E 9AB

EDINBURGH
88 George Street, Edinburgh EH2 3BU

ELYS WIMBLEDON
3rd Floor, 16 George's Road, Wimbledon,
London SW19 4DP

EXETER
230 High Street, Exeter EX4 3NE

FENWICK NEWCASTLE
Northumberland Street,
Newcastle upon Tyne NE1 7DE

GLASGOW
123 Buchanan Street, Glasgow G1 2JA

GUILDFORD
Unit 6B, Tunsgate Quarter,
Guildford GU1 3QY

HARRODS
2nd & 4th Floors, Harrods,
87–135 Brompton Road, London SW1X 7XL

HARROGATE
8 James Street, Harrogate HG1 1RB

KINGSTON
14–16 Market Place, Kingston, Surrey
KT1 1JP

LEEDS
Unit 4 Victoria Gate, Harewood Street,
Leeds LS2 7AR

LIVERPOOL ONE
9 Peter's Lane, Liverpool L1 3DE

MANCHESTER
21–23 King Street, Manchester M2 6AW

MARLOW
30–32 High Street, Marlow SL7 1AW

MARYLEBONE HIGH STREET
112–114 Marylebone High Street,
London W1U 4SA

MEADOWHALL
24 Park Lane, Meadowhall, Sheffield S9 1EL

MILTON KEYNES
32 Silbury Arcade, The Centre:MK,
Milton Keynes MK9 3AG

NEWCASTLE
Unit SU5, Monument Mall,
Newcastle upon Tyne NE1 7AL

NORWICH
22–23 Gentleman's Walk, Norwich
NR2 1NA

NOTTINGHAM
15 St Peter's Gate, Nottingham NG1 2JF

OXFORD
7/8 Queen Street, Oxford OX1 1EJ

PORTSMOUTH
Unit 60, Gunwharf Quays, Portsmouth
PO1 3TZ

SELFRIDGES BIRMINGHAM
Upper Mall East, Bullring,
Birmingham B5 4BP

SELFRIDGES LONDON
400 Oxford Street, London W1A 1AB

SELFRIDGES TRAFFORD
1 The Dome, The Trafford Centre,
Manchester M17 8DA

SOLIHULL
Mall Square Shopping Centre, 2 Mill Lane,
Solihull B91 3AX

ST ALBANS
5 Christopher Place Shopping Centre,
St Albans AL3 5DQ

ST PANCRAS
Arcade Unit 9, St Pancras Station,
London NW1 2QP

STAMFORD
19 High Street, Stamford PE9 2AL

STRATFORD UPON AVON
23 Bridge Street, Stratford upon Avon
CV37 6AD

SYMONS STREET
4 Symons Street, London SW3 2TJ

TRURO
14/15 Boscawan Street, Truro TR1 2QU

TUNBRIDGE WELLS
28–30 High Street, Tunbridge Wells
TN1 1XF

VOISINS
PO Box 9, 26–32 King Street, St Helier,
Jersey JE4 8NF

WESTFIELD LONDON
SU1207, Ariel Way, Westfield London
London W12 7HT

WESTFIELD STRATFORD CITY
157 The Street, Westfield Stratford City,
Montfichet Road, Olympic Park, London
E20 1EN

WINCHESTER
30 High Street, Winchester SO23 9BL

YORK
26–28 Stonegate, York YO1 8AS

DUBLIN
72 Grafton Street, Dublin,
Ireland DO2 Y757

KILDARE
Unit 65, Kildare Village, Nurney Road,
Kildare Town, County Kildare,
Ireland R51 R265

NEW YORK
155 5th Ave, New York, NY 10010, USA

SHORT HILLS
Suite B–106, The Mall at Short Hills,
1200 Morris Turnpike, Short Hills,
NJ 07078, USA

NORDSTROM PARK MEADOWS
8465 S Park Meadows Center Drive
Lone Tree, CO 80124 USA

NORDSTROM VALLEY FAIR
2400 Forest Ave., San Jose, CA 95128, USA

NORDSTROM BREA
500 Brea Mall, Brea, CA 92821, USA

Index

— Page numbers in *italics* refer to photographs —

254

Author's Acknowledgements

I would like to express my biggest thanks to the owners of all the wonderful houses featured in this book, along with their architects and designers – thank you so much for letting us into your homes and sharing why you, too, love white so much.

I also can't thank enough the incredible team who have worked so passionately to make this book happen: Mark Winstanley, David MacLeary, Hannah Meredith and Lizzie Burdge from The White Company; Alison Starling and Jonathan Christie from wonderful Octopus Publishing; Dominic Bradbury for all your great interviews; Chris Everard for your perfectionism and beautiful photography; and Elkie Brown for your impeccable styling.

In addition, I would like to thank three wonderful interior designers with whom I have loved working over the years: Rose Uniacke, Ann Boyd and Nicky Dobree. Thank you for making every project so special, but also for helping me to grow and gain new perspectives.

To my incredible team at The White Company today, as well as the teams over the years, it simply wouldn't be possible to do what we do without you. You are all amazing and you all play such a vital role in bringing The White Company dream to life.

To my family, my incredible mum Rosie, my dad Anthony, my stepfather Simon and stepmother Jane. How lucky I am to have all four of you! To my Granny Rucker, who left me the shares that I sold to start the business.

To my incredible husband Nick and my wonderful sister-in-law Susie – if we hadn't met and had that breakfast, this may never have happened. To my gorgeous sister Jo, who helped me in the first year.

And to my children, Tom, Ella, India and Bea. You are my constant inspiration and you mean the world to me. I could not have done this without your unending support, love and also wise counsel at some critical times.

Thank you all, you are my dream team.

Chrissie X

Also published in Great Britain in 2019 by Octopus Publishing Group Ltd., a Hachette UK Company.

FOR THE LOVE OF WHITE.
Text and photographs copyright © 2019 by The White Company.

Published in 2019 by
Harper Design
An Imprint of HarperCollins*Publishers*
195 Broadway
New York, NY 10007
Tel: (212) 207-7000
Fax: (855) 746-6023
harperdesign@harpercollins.com
www.hc.com

Distributed throughout North America by
HarperCollins Publishers
195 Broadway
New York, NY 10007

ISBN 978-0-06-295586-9

Printed and Bound in China

22 23 24 25 10 9 8 7 6 5

Contributing Editor: Dominic Bradbury
Photographers: Chris Everard (except pages 62, 63 [right] Polly Wreford)
Photographic Stylist: Elkie Brown

Publisher: Alison Starling
Creative Director: Jonathan Christie
Copyeditor: Helen Ridge
Senior Production Manager: Katherine Hockley

For The White Company:
Head of Creative Operations: David MacLeary
Shoot Producer: Hannah Meredith
Chief Creative Officer: Mark Winstanley